To Ann
Dec
22 19
Xen

AMERICA AS ART

AMERICA AS ART

JOSHUA C. TAYLOR

with a contribution by
JOHN G. CAWELTI

Published for the
NATIONAL COLLECTION OF FINE ARTS
by the Smithsonian Institution Press
City of Washington

1976

Cover: Unidentified Artist, *A Woman Rescued from the Jaws of a Catamount and Fangs of a Serpent*, woodcut. From *Davy Crockett's Almanack*, 1838.

Acknowledgments for photography are as follows:

Edward Abrahams, New York, N.Y.: *The Young Husband: First Marketing*, p. 62.

Adams Studio, Inc., Washington, D.C.: Saucer from Benjamin Lincoln Cincinnati Tea Set, p. 11.

E. Irving Blomstrann, New Britain, Conn.: *The Cascades, Pinkham Notch, Mt. Washington*, p. 121; *The Pool*, p. 123.

Lillian Bristol: *Factory*, p. 200.

Will Brown, Philadelphia, Pa.: *Neglected Corner of a Wheat Field*, p. 119.

Rudolph Burckhardt: *Australia*, p. 275; *Blam*, p. 298; *Brillo*, p. 294; *Forget It! Forget Me!*, p. 297.

Geoffrey Clements: *Baptism in Kansas*, p. 231; *Cabin in the Cotton III*, p. 226; *Fisherman's Last Supper*, p. 239; *Gas Tanks*, p. 198; *#22*, p. 278; *'61 Pontiac*, p. 305; *Twenty-Cent Movie*, p. 241; *Woman*, p. 272.

Eeva-Inkeri, New York, N.Y.: *Canadian Club*, p. 309.

John A. Ferrari, Staten Island, N.Y.: *Improvisation of New York City*, p. 196.

Frick Art Reference Library, New York, N.Y.: Study for mural, *The Transatlantic Cable (Telegraph)*, p. 15; *Columbia Welcoming the South Back into the Union*, p. 15.

Greenberg, Wrazen & May, Buffalo, N.Y.: *100 Cans 1962*, p. 294.

Sherwin Greenberg, McGranahan & May, Inc., Buffalo, N.Y.: *Numbers in Color*, p. 293.

Helga Photo Studio, New York, N.Y.: *Mountain Landscape*, p. 113; *Peter Stuyvesant Watching Festivities on the Battery*, p. 74; *Westward the Star of Empire Takes Its Way—Near Council Bluffs, Iowa*, p. 149.

Bruce C. Jones, New York, N.Y.: *Cooper Union Trash*, p. 307.

Lubitsch & Bungarz: *Early Autumn, Montclair*, p. 129.

Peter Moore: *Great American Nude #43*, p. 301.

O. E. Nelson, New York, N.Y.: *Main Street*, p. 242; *Number 7*, p. 269; *On the Street*, p. 245.

William A. Newman: *Friends: Man and Bear*, p. 87.

Karl Obert, Santa Barbara, Calif.: *The Bridge*, p. 197.

Edward Peterson: *Lady at Table*, p. 311.

Piaget, St. Louis, Missouri: *Crude Clay for Architects*, p. 194; *Lure of the City*, p. 193; *Night in the Science Zone*, p. 191.

Eric Pollitzer, Hempstead, N.Y.: *Art*, p. 286.

John D. Schiff, New York, N.Y.: *Cityscape*, p. 209.

Gerald Stableski: *New York*, p. 203.

Studio Nine, Inc., New York, N.Y.: *The Power of Music*, p. 55.

Soichi Sunami: *The City Rises*, p. 189.

Malcolm Varon, New York, N.Y.: *City Night*, p. 186.

Herbert P. Vose, Wellesley Hills, Mass.: *Ichabod Crane and the Headless Horseman*, p. 72.

A. J. Wyatt: *Barn Abstraction*, p. 214.

Unfortunately, several of the photographs could not be acknowledged because they were received after this publication had gone to press.

ISBN 0-87474-900-x

© 1976 Smithsonian Institution

Library of Congress Cataloging in Publication Data
Taylor, Joshua Charles, 1917—
America as art.
(Smithsonian Institution Press publication; no. 6236)
1. Art, American. 2. United States in art. I. Smithsonian Institution. National Collection of Fine Arts. II. Title.
N6505.T37 709'.73 76-4482

Contents

Preface

This publication was produced to complement the exhibition of the same name mounted at the National Collection of Fine Arts during the year of the Bicentennial of the American Revolution. Most of the works reproduced here were a part of the exhibition, although the exhibition included also many additional examples. The works were chosen from all parts of the country, from large and small museums, libraries, historical societies, and private collections, many of them to be shown for the first time in a major exhibition. Richard Murray, the coordinator of the exhibition, has traveled to almost every state in the union in his search for works, and we are tremendously grateful to the many directors, curators, and other scholars who have shown enthusiasm for the project and helped to arrange loans during this year in which many institutions have wanted, understandably, to keep their American works at home.

An exhibition of American art that includes no works by Copley, Homer, Eakins, or Sargent? This study is in no sense a survey of established artistic highlights of American art. Rather, as with many of the National Collection's exhibitions, it concentrates in most of its segments on works and aspects of art in America that are less well known. The nineteenth-century parts of the exhibition have been prompted by much the same spirit underlying another major Bicentennial project of the National Collection of Fine Arts, the Bicentennial Inventory of American Painting Executed before 1914. The inventory, which will be available to scholars by the summer of 1976, has been a part of our effort to look impartially at the entire range of paintings created in America, to understand better the full texture of American art as it has developed throughout the country over its formative years.

In a way, then, the present study serves in some areas as a complement to the better-known achievements of American artists. There is a usefulness in such an approach, not only because it provides many unexpected pleasures, but because it furnishes a context intimately related to popular think-

ing and general cultural concepts that can help to expand the meaning and appreciation of artists and works we already know. This presentation is meant to be a joy to the eye and a "thinking about" exhibition as well, on the assumption that thinking about the identity of art with our cultural past and present affords an additional pleasure of its own. In this regard I am particularly grateful to John G. Cawelti, professor of English and Humanities, University of Chicago, for his illuminating essay on a central element in the American imagination, the ambivalent preoccupation with the American native, and the spirit of the frontier.

Such a project as this has depended on the support of all departments of the museum and, in addition, on Mr. Murray, who has most effectively coordinated all aspects of the exhibition and publication. I wish to express my appreciation to the entire staff for their creative part in this Bicentennial venture.

Joshua C. Taylor
Director,
National Collection of Fine Arts

Introduction

When Europeans first discovered the Americas, a new source of imagery was added to Western art. At first the new land afforded simply a free play of the imagination, an exercise in improvisation on an unknown clime, but little by little, as reports and some few artifacts from the newly discovered outside world began to impinge on the European consciousness, imagination was directed into new and specific channels. The Americas quickly came to mean excitement, wealth, expansion, and every kind of exoticism. But even so, for all of its stimulation of European thinking, the new West was chiefly seen for a long time as a projection of old thought. What the new countries provided were a broader canvas and more abundant natural materials for realizing in expanded form the ideals and aspirations that had been harbored for centuries.

Although on the one hand economically exploited in a most material way, the Americas were, on the other hand, the embodiment and in some instances the proof for the European of idealistic philosophical abstractions that had never before met the test of actuality. Underlying the European invasion of the Americas was a complex body of positive, directive ideology, the success or failure of which for a long while obscured the actual nature and potentialities of the new environment and the society that it was, willy-nilly, developing. For the most part, in spite of their protestations, the leaders of those who came to settle were less concerned with the discovery of the new than with the maintenance and expansion of the culture they already possessed. America promised a fulfillment on a new, heretofore unimagined, scale.

This was no less true in the area that was to become the United States than in the earlier settlements to the south. Only gradually did the new terrain begin to assert itself, demanding to be seen in its own terms. Even then, however, the view of the country was likely to be symbolic or weighted more by considerations of resources and quantities than of beauty or character. Unlike Mexico, where the existing culture, although treated brutally, was allowed to penetrate the European importation in various ways and

eventually had an impressive impact on the new amalgamated culture that was to emerge, the settlers of the north showed remarkably little interest in the native people and their mores, other than to consider them as useful subjects for the exercise of their own moral and political virtues. America meant opportunity in both symbol and fact: economic, religious, and political. No one asked the new continent to contribute anything of its own other than to make these opportunities real.

So far as the United States is concerned, there were really two discoveries of America by Europe. The first was the discovery of a new world rich in materials for the expansion of existing European ideas and institutions. Later, however, came the new discovery that America provided a fresh source of ideas and imagery, a distinct environment that had its own character and defined a new beauty. This second discovery was probably no less a surprise than the first. It was very late in coming—for the most part not until well into the nineteenth century—and it was slow in being recognized, even by Americans, for what it was. Nor was the discovery of the new cultural entity looked upon as necessarily a good thing. It underlay a political revolution and provoked a series of inner conflicts that were never laid to rest. In the United States it fostered an avid nationalism, a raucous boosterism and downright chauvinism that misled many to assume that the new culture was nothing more than a lapse in taste. But beneath what seemed in the early nineteenth century simply overblown American rhetoric and bluster was, in fact, a new character in the process of being born.

Ironically, over the years it was often Europe that first singled out what would be embraced as an American image. Americans, often enough, pretended to be what they were not and apologized for being what they were. Once the possibility of a national cultural identity was broached, there was the inevitable argument as to whether national or universal standards should prevail—or whether, indeed, either could exist without the other. Awkward, however, as the matter might be, coming so late in the history of western civilization, the emergence of a recognizable, distinctive character, lying both outside and within the western tradition, provided a new protagonist in the arena of thought.

Artists were not quick to recognize themselves as part of the American image. For a great many reasons art was slow to take root in the new society. There was not, as in the Latin countries, a supporting institution like the church for which art was considered an indispensable element. Art was not an integral part of any of the original basic assumptions about social organization that held forth in the English colonies or the newly formed United States. It had to create its place. This it eventually did by making itself useful in a number of ways. The struggle was not easy. The identification of art with America was never to be assumed as a natural occurrence. It came as a surprise to the American public even in the mid-twentieth century—possibly not a wholly agreeable surprise—that the products of the country's artists had become a positive factor in the American identity.

By no means was all of the art produced in America, once that entity was consciously accepted, in celebration of the native image, nor, for that matter, was such a celebration always looked upon as artistically valid. Even while some critics and artists early in the nineteenth century were beginning to judge works of art on the scale of their being more or less American, others were insisting that aesthetic standards were universal and thus beyond all limitation of local import. This problem of judgment was as crucial in literature as in the visual arts. The universal standards of Poe could stand in opposition to the sophisticated colloquialism of the young Lowell. From the late eighteenth century, most artists born in America who could went abroad to study, or at least to make firsthand contact with the great traditions of Western art. Sometimes they boasted that Europe had nothing to teach them, that America had enough talent and raw material to create its own traditions. Yet to Europe they went, some to remain, some to come back determined to create a comparable world of art on these shores. Some few set out to create an art in defiance of traditional European standards. This was all taking place at the very time that the history of Western art was being looked at for the first time in a systematic, orderly fashion. One talked of schools, of styles, of developments. With this long history spread out in well-codified sequence, what was left for the American artist to contribute? Or what special content could the peculiarities of America itself add to this dazzling repertoire? Looked at in terms of art, in other words, what was America? America as art?

It is to this latter question that the present study addresses itself. Quite apart from America's contribution in commerce and science, what are some of the aspects associated with America that have, over the past two hundred years, become identified with specific artistic concepts or directions in art? Simply for an artist to picture America is not enough to bring his art into this consideration. The face of America might serve any number of artistic purposes. What these eight studies set out to examine are the varying ways in which some ideas and attitudes about America became inseparable from the country's art and, conversely, how in some instances art itself became an identifying mark of America.

This is really a very narrow way of looking at American art. Omitted from consideration, of course, are many of those notable achievements by which American artists won their place in the language of an international idiom. But this study is not intended in any sense as a comprehensive study of art in America. On the other hand, neither is it one more speculative enquiry into what is American about American art. It offers only an analytical look at eight moments in which art and the identity of America came close, either in the eyes of her citizens or in those of the outside world. Certainly, other moments could be cited. These few simply offer the clue to a somewhat different way of looking at the history of American art.

America As Symbol

ALLEGORICAL

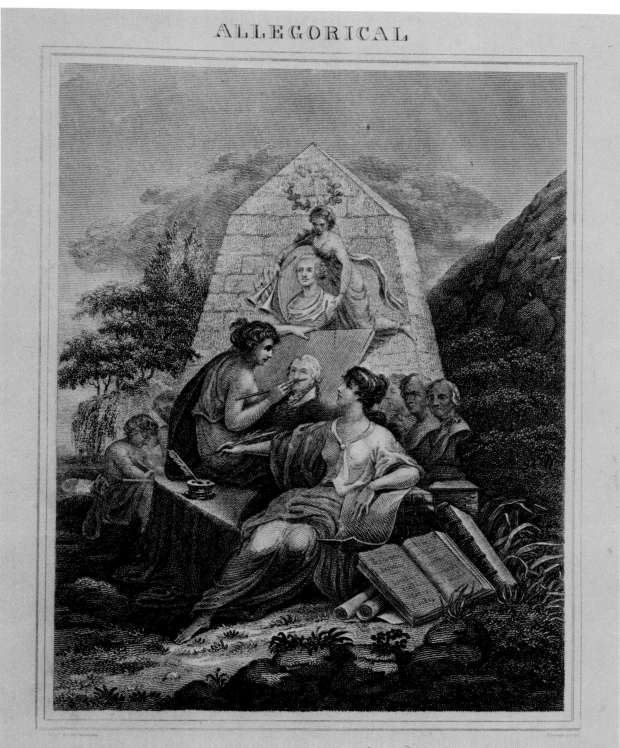

American Literature & Fine Arts, Rewarding Patriotism & Virtue.

America As Symbol

Francis Kearney after Gideon Fairman, *American Literature and Fine Arts Rewarding Patriotism and Virtue*, 1815, engraving, 9 x 5 11/16. From *The Port Folio*, 3d ser., 6 (1815). Historical Society of Pennsylvania, Philadelphia.

The dimensions given in the legends to the illustrations are in inches unless otherwise specified. Height precedes width and depth.

A sign or symbol can wield tremendous power. It can hold a nation together or break a culture apart. Often a symbolic image has become the rallying point for a gathering unity, standing for the mythic, invulnerable whole as distinct from the divisible and uncertain part. A star, a cross, or a fleur-de-lis might galvanize whole nations and more. Although each person might define it differently, justifying his belief in his own terms, a true public symbol has some special meaning for everyone who recognizes it. A simple form or figure that always means more than itself, the popularly embraced symbol can become the point of focus for a wide range of beliefs and loyalties that find a common denominator in its simple form.

Just why certain figures exist as symbols and what gives them unifying power has been much speculated upon. Many savants of the late eighteenth century believed that forms themselves held the key to a universal means of communication, that the human mind responded intuitively to certain configurations that speak directly to a substratum of belief or knowledge. After all, the Bible states that before the tragic incident of the Tower of Babel all men spoke the same language. Possibly a careful study of forms and symbols, some believed, might lead to the rediscovery of a unifying human discourse comparable to or the same as that existing before the tower collapsed. Certainly, there seems to be something magical about a word, a shape, or a figure which by its very compactness stands apart, yet signifies a complex family of meanings that spring to mind whenever it is encountered.

Of course, a national symbol defines a less ambitious unity and rarely comes about through purely metaphysical promptings. Adopted for immediate and practical purposes, it acquires power as it makes its way through history. Yet, for public symbols to exist, there must be a predisposition on the part of the public toward symbolizing, a desire to understand things in general, synthesized terms. To be sure, we quickly associate particular signs —a family crest, an industrial trademark—with a given activity or product, but the product for which a public symbol stands is more abstract, its values

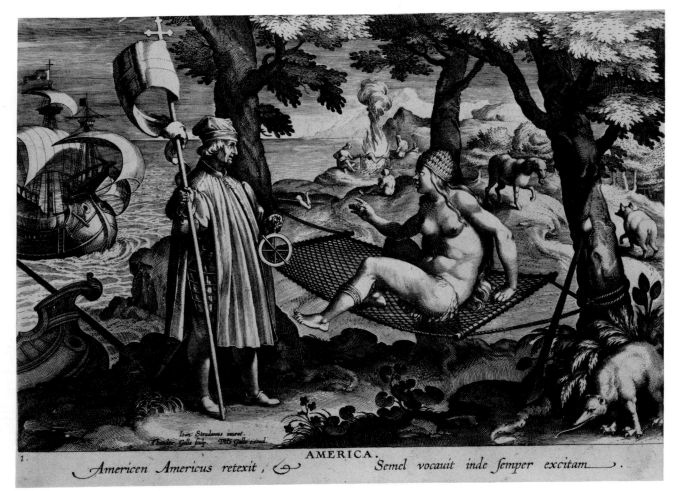

1. Americen Americus retexit, & AMERICA. Semel vocauit inde semper excitam.

Theodore Galle after Jan van der Street (called "Stradanus"), *The Arrival of Vespucci in the New World,* circa 1600, engraving, 9⅞ x 10⅝. Library of Congress, Washington, D.C.

more deeply buried in the mind. It does not simply stand for a known fact, but is part and parcel of the thinking that makes the fact a reality. One could argue that the fleur-de-lis, once simply part of a family crest, was not just adopted to signify France but through history became an element in the very definition of France, helping a varied population to see itself as a spiritual and political unity. The symbol, in other words, is not just a label for an existing situation but is born with the publicly held concept for which it stands.

There were few periods in the past so inclined to think in terms of public symbols, to believe in synthesized formulations of an almost mathematical clarity, than that in which the American Revolution was formulated and took place. Public rhetoric was based on the extolling of law and general principles, of universal rights and truths. Capitalized nouns—Truth, Liberty, Justice—seemed to take on more importance than active verbs. Yet America was slow to see itself in symbolic terms, just as it was slow to see itself as an independent unity. In fact, it tended to be a unity in the eyes of the Europeans before it had a clear image of itself.

During the period of exploration and colonization, the Americas, however, had little specific focus in the minds of Europeans. Although the newfound countries piqued the imagination with their previously unheard of climes, exotic products, and strange people, and promised risks to the politically ambitious, pictorially the Americas emerged personified by a moderately dark young woman clad in feathers or tobacco leaves. Sometimes the image was not particularly attractive, as in Jacob van Meurs's print of 1671 in which she clutches a cornucopia and scatters gold. She was often accompanied by a crocodile and shaded by a palm tree, suggesting a lush tropical environment provocative to the European imagination but quite unrelated to any particular aspect of the New World. America was the source of dreams, whether of material abundance and financial success or of ideologies and sensuous fantasy. Although there was much speculation about the native cultures and an interest in new flora and fauna, America was chiefly seen as an extension of the European mind. When they were not regarded as sons of the devil, the Indians were seen as rampant Apollos and Venuses,

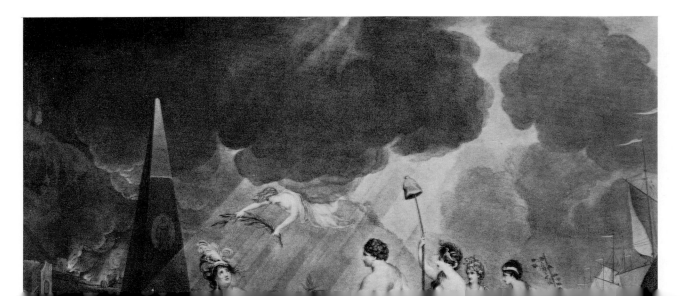

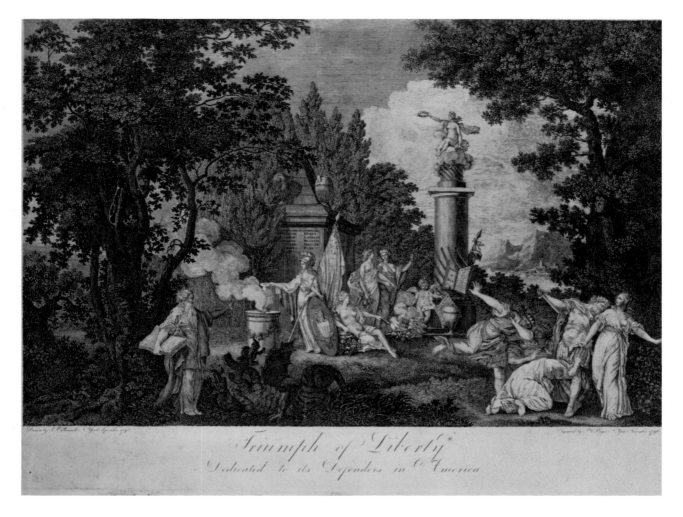

Triumph of Liberty
Dedicated to its Defenders in America

Peter C. Verger after John Francis Renault, *Triumph of Liberty*, 1796, engraving, 11¾ x 18¼. Library of Congress, Washington, D.C.

image has been called,[1] gave way not to a new symbol for place but to personified virtues: Independence, Freedom, Wisdom. When the figure of America, or Columbia as she was often called, eventually developed, she belonged not to geography or a particular race, but to the family of personified virtues. With the Revolution, America in symbol stood for a social ideal or a cluster of ideals, and the symbol was recognized as such both at home and abroad.

To people educated on the literature of Greece and Rome, it seemed natural to define the abstract qualities in which they believed in terms of those ancient cultures. Not only a complete pantheon but an established cast of heroic virtues thus existed to be summoned in support of a contemporary idea, person, or event that needed to be detached from local circumstances as a collective principle. To call an orator Demosthenes was to

1. E. McClung Fleming, "From Indian Princess to Greek Goddess: The American Image, 1783-1815," *Winterthur Portfolio* III (1967): 37-66. See also the same author's "The American Image as Indian Princess," *Winterthur Portfolio* II (1965): 65-81.

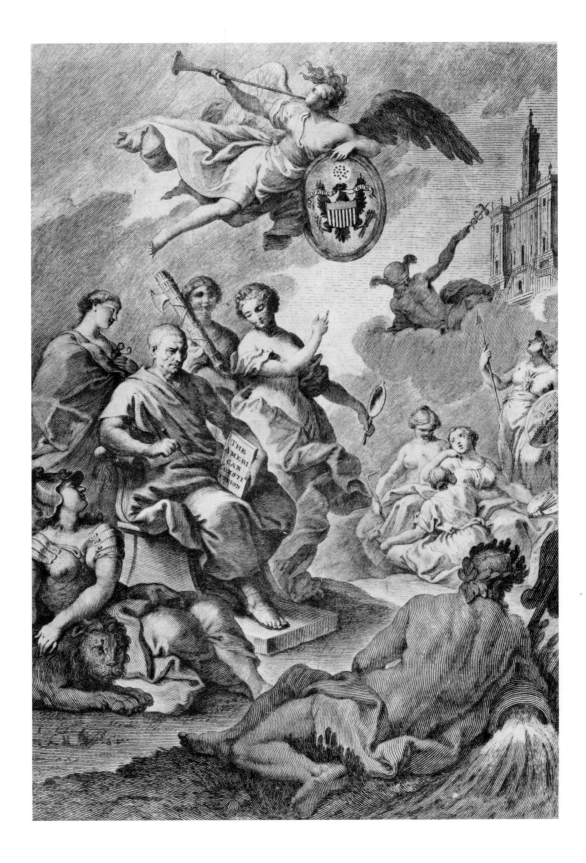

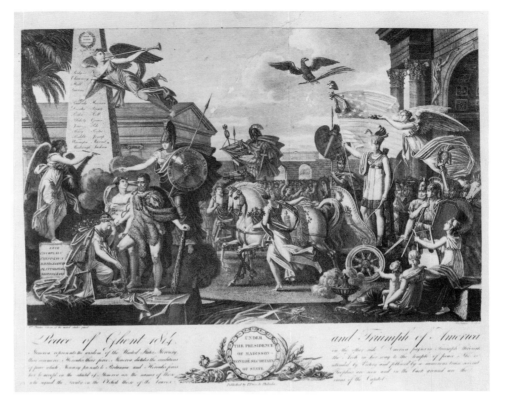

[Alexis?] Chataigner after Mme. Anthony Plantou, *Peace of Ghent 1814 and Triumph of America*, engraving, 14 x 16¾. The Library Company of Philadelphia, Pennsylvania.

Unidentified artist, *Washington Giving the Laws to America*, engraving and etching, 7⅞ x 4½. The New York Public Library, New York.

9

suggest an elevated stature that needed no explaining, even though he might be preoccupied only with local politics. To be Athenian was to believe in culture and democracy. The issues of a town meeting took on greater importance if the hall was called a forum, the meeting place of the Roman populace. Although the dimensions in which the image of the United States was conceived were ideological rather than ethnic or geographical, its forms belonged to the ancient world, which, as seen in the late eighteenth century, was a kind of timeless utopia peopled by principles rather than by corporeal beings.

But the growth of this symbolic thinking took time. When the first medals to be officially commissioned were designed in the 1780s, their composition was placed in the hands of the French *Académie des inscriptions et belles-lettres*. Not surprisingly, the first four medals show America in accordance with the traditional European image of the dignified young Indian woman with plumed headdress and feathered shirt. America was still thought of chiefly as a place, and quite possibly the American statesmen in charge of commissioning the medals felt that this, as yet, was the safest definition of it.

An official flag was adopted by the Continental Congress in 1777 and a committee had been appointed in 1776 to devise an official seal for the country newly declared as independent. Three committees worked on the problem before a design was accepted in June 1782. It was to be an eagle, the ancient personification of Zeus—and, by extension, supreme authority—

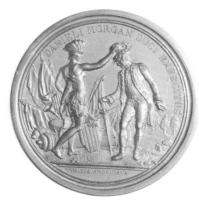

Augustin Dupré, Medal of
Brigadier-General Daniel
Morgan, 1789, bronze, diam-
eter 2⅜. National Museum
of History and Technology,
Division of Numismatics,
Smithsonian Institution.

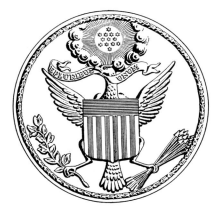

*Great Seal of the United
States of America*, 1782. The
National Archives,
Washington, D.C.

Mary C. Nelson, Quilt, cot-
ton appliqué, 1846, 74 x 88.
National Museum of History
and Technology, Smith-
sonian Institution.

often used by European states. This time, however, it was to be the Ameri-
can bald eagle, a nice adaptation of a classical symbol to the fauna peculiar
to the New World. Hatched in the midst of war, the eagle clutched arrows
in one claw but an olive branch in the other.

With the Treaty of Paris of 1783 establishing the independence of the
country as fact in the eyes of the world, symbols of unity began to appear
with increasing frequency. The American eagle became a dominating ele-
ment of decoration, in furniture, architecture, and all reaches of the applied
arts. Busy housewives worked the eagle into designs for quilts, it took to the
seas as an authoritative embellishment of American ships, and no document
seemed binding without an eagle somewhere in its design. The Society of
the Cincinnati used the eagle in 1783 in the design of its insignia, and both
local and federal coinage began to use the eagle in the late 1780s. Somehow,
possibly through coinage, the eagle found its way into the China trade, and
American households were delighted to buy Chinese export ware with the
eagle of the United States, in one interpretation or another, emblazoned on
its surfaces. The Society of the Cincinnati arranged for its own special
patriotic ware to be made in China. European manufacturers also were quick
to accept the symbol of America and decorated their products for export
with the new emblem of patriotism. The eagle quickly reached around the
world.

Although the mighty eagle was a comforting symbol of unity and

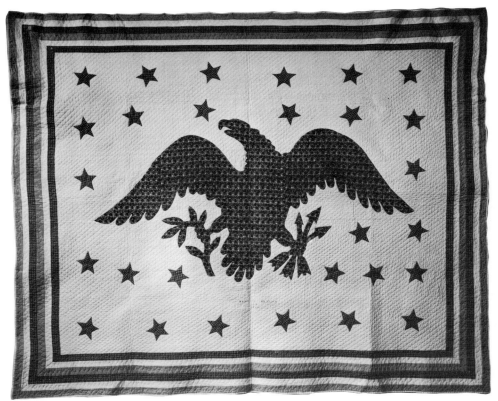

10

United States Five Dollar Gold Piece, 1797, gold, diameter 25 mm. National Museum of History and Technology, Division of Numismatics, Smithsonian Institution.

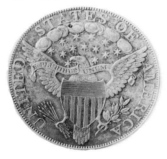

United States One Dollar Silver Piece, Series 1797-1808, silver, diameter 39.5 mm. National Museum of History and Technology, Division of Numismatics, Smithsonian Institution.

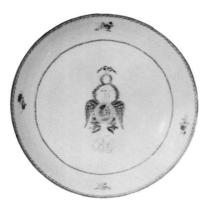

Saucer from Benjamin Lincoln Cincinnati Tea Set, circa 1790, porcelain, diameter 14 cm. Society of the Cincinnati, Washington, D.C.

power, it did not occupy the field alone. Literary references rarely use the eagle as standing for the new country. It was the family of goddesslike personifications of social virtues that remained the most persuasive images of what the new United States signified.

In 1796 Edward Savage published a print in Philadelphia of his large painting that shows the eagle hovering over a comely young woman who offers it a cup of nourishment. Fashionably dressed in contemporary garb, the young woman bears nonetheless the attributes of her sister goddesses. Savage explained that she was Liberty, in the form of the Goddess of Youth, "giving support to the Bald Eagle." In the background the flag floats from Liberty's staff, which is topped by the traditional cap of liberty. Combining as it did the seductive feminine charms of Liberty with the power of the domesticated eagle, the print enjoyed wide popularity, appearing in various naïve adaptations—embroidery, amateur paintings, and even Chinese paintings on glass—for many years.

It has been suggested that the representation is really an adaptation of William Hamilton's painting of Hebe, the Goddess of Youth, bearing a cup to Zeus in the form of an eagle, but to American eyes the eagle now belonged to the United States. Mrs. Frances Trollope, in her alarming book *Domestic Manners of the Americans* (1832), gave an account of a gentleman in Cincinnati who, on being told that a drawing (evidently like the beauty by Hamilton) depicted Hebe, replied indignantly, "What the devil has Hebe to do with the American eagle?" By the 1830s, the antique images had long since been thoroughly Americanized.

The lovely lady who in one way or another was to be identified with the United States appears with various appellations. As Liberty or Freedom she is simply and elegantly dressed and is accompanied by a staff on which is displayed the cap that traditionally symbolized liberty. Sometimes, as in the Savage print, she tramples on the symbols of monarchy or oppression: the key to the Bastille, a crown, shackles, and the like. With a plumed helmet she is transformed into Minerva, the goddess of wisdom, because Freedom, as seen by the philosophers of the Enlightenment, was the product of rationality and law. In a London engraving of 1789, Freedom-Minerva, with her foot on the head of the conquered British lion, is simply called "America." That was now what America meant to optimistic Europeans and proud inhabitants of the United States.

Symbols work in many ways other than through personifications and agreed-upon signs. Reason, as personified by Minerva, could express itself through the visual environment as well as through social organization. Exactly during the years of the American Revolution, a change of taste was making itself felt in Europe, not just a stylish fancy but a fundamentally different way of looking at the world. Clarity, justice, order, and harmony might apply either to moral standards or to visually perceivable form, and in the late eighteenth century the link between formal order and moral values was close. Accordingly, the light and fanciful forms of the earlier

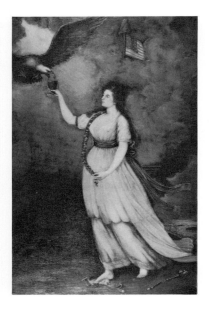

Samuel Lovett Waldo, *Goddess of Liberty Feeding the Eagle*, circa 1805, oil on canvas, 40 x 26. Lyman Allyn Museum, New London, Connecticut.

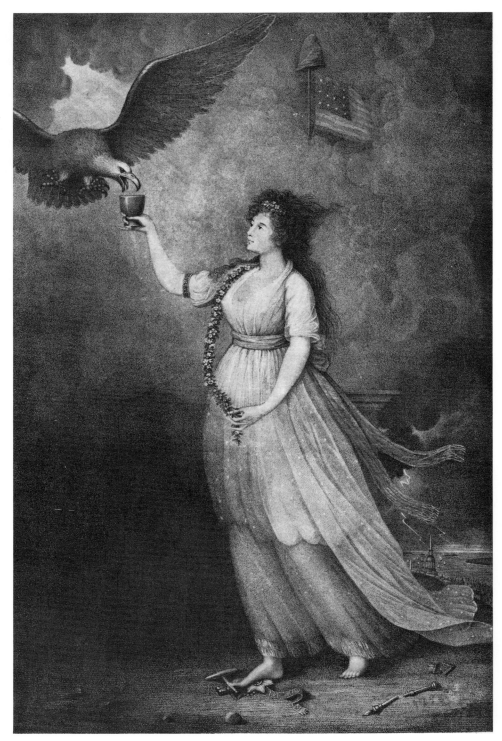

Edward Savage, *Liberty as Goddess of Youth*, 1796, stipple engraving, 24¾ x 15. Library of Congress, Washington, D.C.

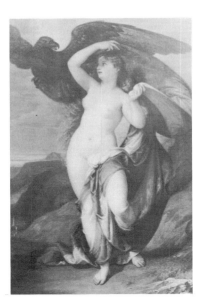

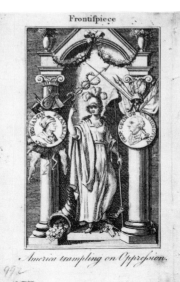

Henry Peters Gray, *The Birth of Our Flag*, 1874, oil on canvas mounted on plywood, 72 x 48. National Academy of Design, New York, New York.

Unidentified Artist, *America Trampling on Oppression*, 1789, etching, 5¼ x 3. From Samuel Cooper, *History of North America*, 1789. The New York Public Library, New York.

Benjamin Tanner after John J. Barralet, *America Guided by Wisdom*, circa 1815, engraving, 17¾ x 32⅛. Historical Society of Pennsylvania, Philadelphia.

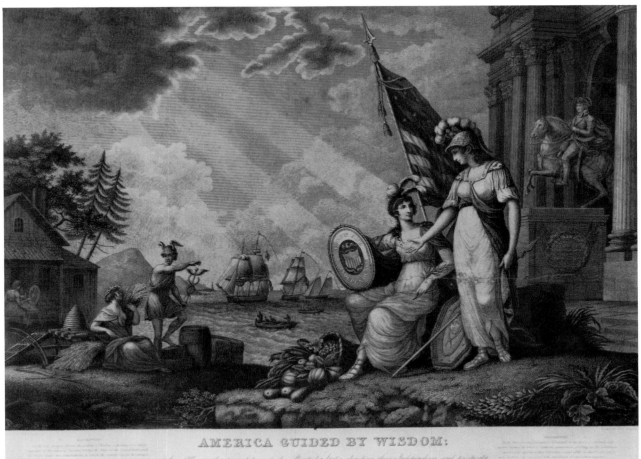

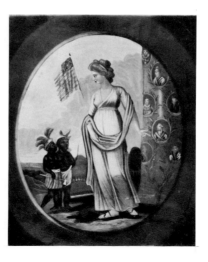

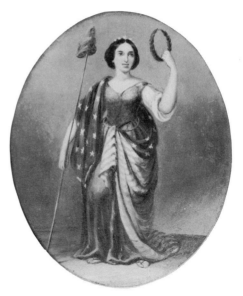

Unidentified Artist, *America*, 1801, mezzotint, 13¾ x 9¾. The New York Public Library, New York.

Unidentified Artist, *An Emblem of America*, 1798, mezzotint, 13½ x 9⅞. The New York Public Library, New York.

Unidentified Artist, *Miss Columbia*, circa 1855, oil on panel, 6 x 8. American Museum of Fire Fighting, Hudson, New York.

eighteenth century with their rococo fantasies and sensuous charm were looked upon with increasing disapproval as symbols of a misdirected society. The contorted curves and decorated surfaces distracted rather than clarified the mind. Once the eye was taught to see form as having mental significance—and it was the duty of man to develop a just and well-ordered mind —what was formerly graceful and charming became an insult to the intellect and had to be replaced. Capricious forms were, quite simply, immoral. Winckleman, for one, made clear where corrective models were to be found: in the art of antiquity. Only there did the measured form and perfection of line mirror the nobility of mind that must be society's goal. So hand in hand with the gods and goddesses of ancient Greece and Rome came a sense of formal order, a style, which also was a symbol for the new directions of thought.

The spare and simple style that found its inspiration in the ancient past appealed to self-consciously republican taste. There was a plainness about it that spoke of practicality and disciplined craftsmanship, standing in contrast to the elaborate confections associated with monarchy and aristocratic society. It was this ostentatious plainness that, from the late 1780s on, began to associate itself with the new political and social organization of the United States.

In 1785, when Jefferson was called upon to provide a design for the Virginia State Capitol in Richmond, he developed a modified version of the Roman Temple of Nîmes. When it came time to lay out the capital city in

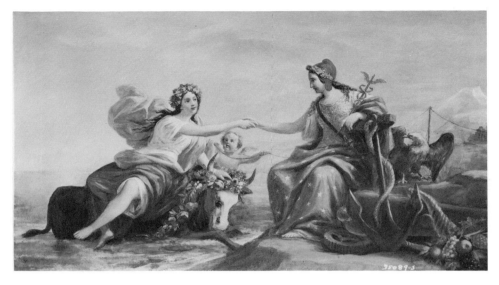

Constantino Brumidi, study
for mural, *The Transatlantic
Cable (Telegraph)* [in United
States Capitol building, circa
1876], oil on canvas, 14⅛ x
24⅛. Mrs. McCook Knox,
Washington, D.C.

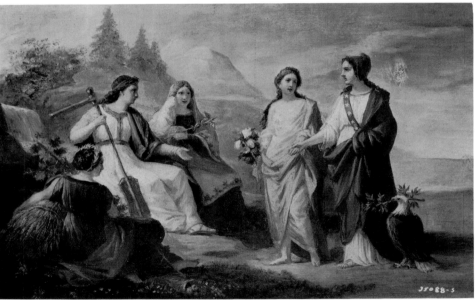

Constantino Brumidi, study
for mural, *Columbia Wel-
coming the South Back into
the Union* [in United States
Capitol building, circa 1876],
oil on canvas, 10¾ x 16⅝.
Mrs. McCook Knox, Wash-
ington, D.C.

the District of Columbia, Major L'Enfant, following the best principles of
the new rational taste, created a plan that both symbolized in its layout the
separate functions of government and provided a spacious, measured envi-
ronment that would be conducive to clear thinking and dignified conduct.
Washington was slow to develop and never had a chance to come close to
the effect L'Enfant had in mind, but the intention was there to make the
capital city of a democratic nation a symbol of the balance and rationality
on which such a society should depend. There was little question about the
style of buildings for Washington. From the beginning the state buildings,
making no reference at all to the traditional brick structures of nearby Alex-

15

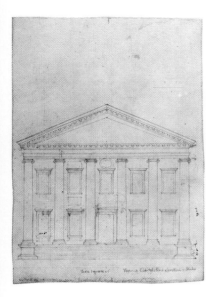

Thomas Jefferson, Elevation of the Virginia State Capitol, 1785, pencil on paper, 16½ x 10¼. Massachusetts Historical Society, Boston.

andria and Georgetown, were self-consciously classical in reference and were made of marble—or appeared to be. The Capitol building and the White House, and then the Treasury and the Patent Office buildings and many following works, were conceived in the style that came to signify the new society. The Treasury and the Patent Office are even bolder and simpler than the earlier buildings, taking for inspiration the architecture of Greece rather than that of Rome.

There were complex reasons underlying the arguments promoting a recognizable sense of style, and in the association of that style with Greece. Benjamin Henry Latrobe, one of the architects of the Capitol, was quite aware of the problem facing the arts in America when in 1811 he addressed the Society of Artists of the United States in Philadelphia. Since there had been no public tradition in the fine arts in the colonies, now the United States, he noted in his address (published in *The Port Folio* for 1811) that there was little comprehension of the unity of public expression that the arts represented. In fact, he felt that there existed—and he was doubtless correct —a suspicion of the arts in general. "For we cannot disguise from ourselves," he said, "that, far from enjoying the support of the general voice of the people, our national prejudices are unfavorable to the fine arts. Many of our citizens who do not fear that they will enervate our minds and corrupt the simple and republican character of our pursuits and enjoyments, consider the actual state of society as unfit for their introduction; more dread a high grade of perfection in the fine arts as the certain indication of the loss of

Pierre Charles L'Enfant, Detail of *Plan of the City of Washington*, 1791 (engraved 1886), engraving, 32 x 46. The National Archives, Washington, D.C.

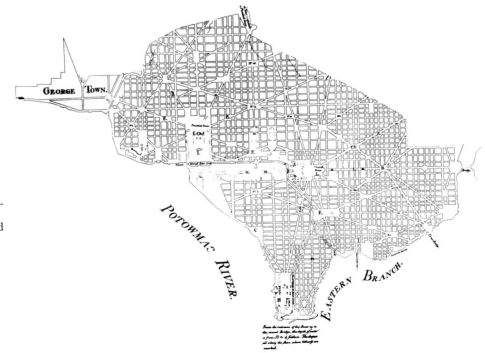

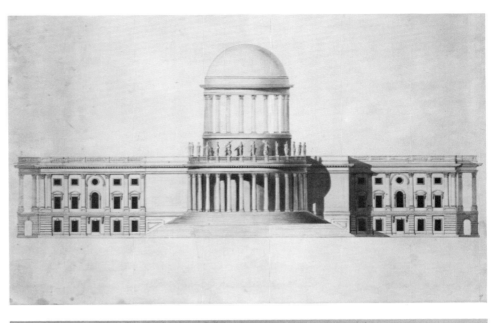

William Thornton, Elevation of the West Front, United States Capitol, pen, ink, and wash on paper, 15 x 24½. Library of Congress, Washington, D.C.

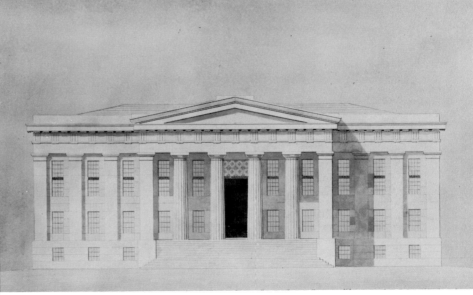

Alexander Jackson Davis, Detail from *Design for a Patent Office, Washington, D.C.,* 1834, pen, ink, and wash on paper, 27¼ x 19½. The Metropolitan Museum of Art, New York, New York; Harris Brisbane Dick Fund, 1924.

political liberty, and of the concentration of wealth and power in the hands of a few."

He set out to prove these fears unfounded by citing the evidence of Greece, attributing her greatness in art to the simple fact that "Greece was free." "The Apollo of Phidias," he said, "the Venus of Praxiteles, the group of the Laocoön, are in fact monumental not more for the arts, than of the freedom of Greece; monuments which are not more perfect as examples to architects, than as lessons to statesmen, and as warnings to every republican to guard well the liberty that alone can produce such virtues."

In his way Latrobe was insisting that art had an important symbolic

17

value for the republican community. When it could be associated with the Grecian style it could be the badge, as well, of freedom. He was not inclined in a public address to defend art as art, but art seen as the fruit of a free society. He was emphasizing the need to symbolize in order to support art and to provide that unity of style that he considered central to taste. "It is in your power," he told his audience, "to make your own amusements the foundation of all the eminence to which the most sanguine of us expect to attain; and, as the fair past of this assembly once did in adopting the Grecian dress, to stamp with the sanction of fashion, that which good taste recommends."

The identification of art with antique virtue was not new. Just a few years before Latrobe's address, in 1807, a new building had been dedicated in Philadelphia for the Academy of Fine Arts, designed in a simple style that was considered classic. Remarked the editor of *The Port Folio* of the building and its contents (a collection of casts from the antique), "How grateful to avert the offended eye from the loathsome objects of common life, and to expatiate over all the charms of Grecian and Roman beauty!" Art in its elevated style provided the realm of virtues and high thought.

The new style and its symbolism were not identified with the central government alone, even though Washington City attempted to adopt them as its own, but with the new society as a whole. They were applicable to markets, theaters, commercial exchanges, and private homes. In 1805 Latrobe designed his monumental Baltimore Cathedral in the classical manner, reminiscent in its clear open space of the Pantheon at Rome. There was little place in this way of thinking for "the dim religious light" of Gothic churches (although Latrobe prepared an alternate Gothic plan for his cathedral just in case). Of all institutions to gain public sanction by its architectural style, the most persistent was the bank. The Second Bank of the United States by William Strickland, for example, in the form of a Doric temple, provides just that image of reassuring strength that was needed to assure public confidence. Although private in organization, the bank took on the aspect of a public institution, fulfilling its role in the new social image. So effective was this association that until recent years few banks would dare to declare themselves to the public without at least a classical portico to attest to their stability.

To deviate from the style that had come to signify the new nation, whether in its official or more general aspects, seemed almost unpatriotic, although there was discussion over the virtues or folly of being strictly archeological in antiquarian reference. When new towns were started in the spreading country, not only were they likely to take on the names of ancient cities or personifications—Athens, Rome, Sparta, Columbia—but even their hastily built structures made some reference to the unifying classical taste. It mattered little whether the structure was a modest house or a city hall, a nod in the direction of the classical was a recognition of the new social identity.

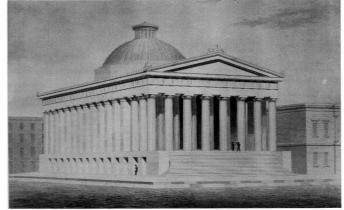

Benjamin Tanner after John
J. Barralet, Building for the
Pennsylvania Academy of
the Fine Arts, 1809, engrav-
ing. From *The Port Folio*, n.s.
2 (1809).

Alexander Jackson Davis,
*Premium Drawing for the
U.S. Customs House, New
York*, 1833, pencil, pen, and
watercolor on paper, 30 x 38.
Museum of Fine Arts, Boston,
Massachusetts; M. and M.
Karolik Collection.

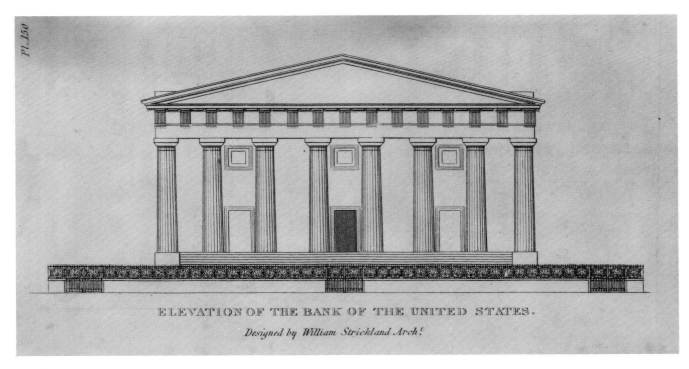

ELEVATION OF THE BANK OF THE UNITED STATES.

Designed by William Strickland Arch!

Samuel Honeyman Kneass after William Strickland,
Elevation of the Second Bank of the United States, Phila-
delphia. From *The Port Folio*, 5th ser., 12 (1821).

The combined power of a simple republican—or intellectual—style and the reference to an established great ancient civilization was sufficient to create a special world of thought. Its dimensions were qualitative, not subject to space or time, and its values were unequivocal and permanent. The keeper of the vision of this world was the artist, who could bestow the blessing of style, and thus of history and ancient virtue, on even the most mundane subject. He could give the promise of permanence to a transient document or of stability to a speculative bank. His task was to make of the visual world an allegory of pure virtue.

The visual arts have the capacity, thus, to collapse space and time in order to bring to bear on a single incident the weight of various memories and traditions. For example, when the New York Mechanick Society wished a certificate of membership that would establish clearly for its members its importance and function in the New World, it commissioned Abraham Godwin, an engraver from New Jersey, to create an appropriate document. Florid with old style adornments and improvisation, it weaves together in its artistic fantasy the allegorical images of Liberty and Industry arriving in America, a charitable member of the society bringing money to a widow and her children, and the actuality of the various branches of the mechanical arts as developed in the new country. The hardy man tilling in the wilderness while a remarkable beaver fells a tree exists in the same realm of thought as the comely Liberty becoming acquainted with a rustic Indian America. They all belong to one way of thinking about things, in this case about the dignity of the mechanical arts in the free air of America.

This rather cumbersome assembly of literally different parts was shortly to be simplified through a new kind of form-language that became itself a part of the allegory. John James Barralet, an Irishman who settled in Philadelphia late in the eighteenth century, understood the new requirements well. Appropriately, it was he who was commissioned to draw the design for the membership certificate of the Hibernian Society "for the relief of emigrants from Ireland," which was then engraved by his countryman H. H. Houston in a stipple technique unusual in America. Although there are heaps of significant objects—Agriculture on one side and Commerce and Domestic Industry on the other—they are held together by smoothly curved contours and a rhythmic interplay of parts. The protecting American eagle somehow manages to hold together arrows, olive branches, oak leaves, and shamrocks without losing his place in the harmonious design. Within the circle three allegorical females on a classical porch receive a newly arrived sister from Ireland with an embrace and a bag of money. Commingled are the shield of the state of Pennsylvania and the Irish harp. To the literal minded they might make a strange contrast with the modern ship with the American flag in the background and its overloaded launch making its way to the shore. But the generality of style and its classical suggestions are enough to blend idea and actuality, even when, paradoxically, the ideal and the actual seem to exist in the same physical space. This merger of act and

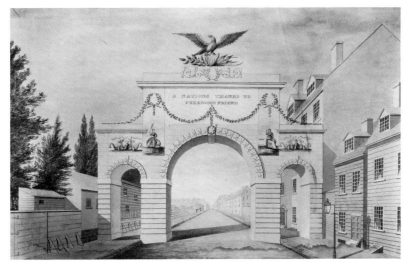

Samuel Honeyman Kneass, *Lafayette Triumphal Arch*, 1824, watercolor, 30 11/16 x 21 13/16. Independence National Historical Park Collection, Philadelphia, Pennsylvania.

Abraham Godwin, Certificate of the New York Mechanick Society, circa 1785, etching and engraving, 10¼ x 11⅞. Historical Society of Pennsylvania, Philadelphia.

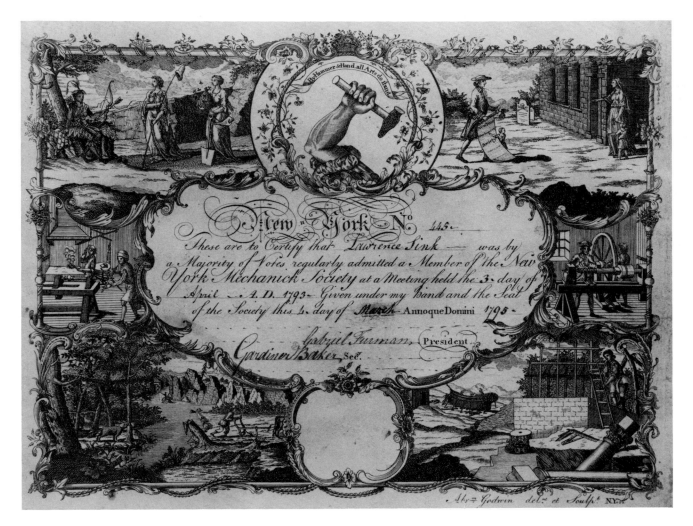

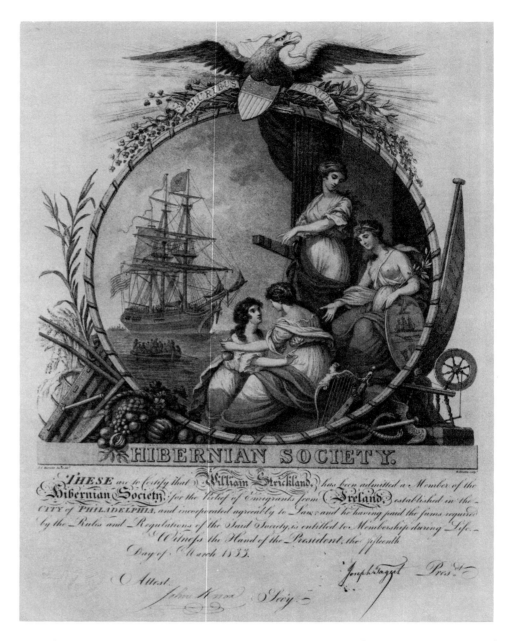

H. H. Houston after John J.
Barralet, Certificate of the
Hibernian Society, circa 1796,
stipple engraving, 17½ x
13 13/16. Historical Society of
Pennsylvania, Philadelphia.

significance is a way of thinking about a situation that gives it a special
value and importance. The aid to emigrants becomes a noble act recognized
as a basic and established virtue.

By the time that Samuel Seymour of Philadelphia, following a drawing
by Thomas Birch, engraved his membership certificate for the "Society for
the Relief of the Distressed and Decayed Pilots, their Widows and Children"
about 1810, the language of style had become even more persuasive. He
established first of all a clean, uncluttered image that accorded well with the
simple, functional style that was at that time giving identity and credibility

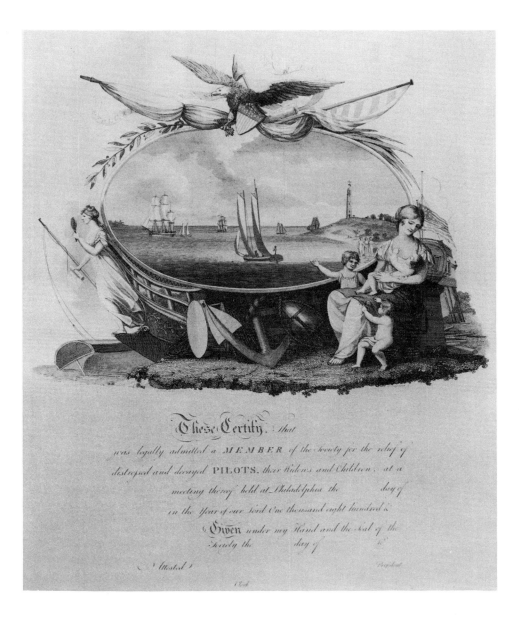

These Certify, that
was legally admitted a MEMBER of the Society for the relief of
distressed and decayed PILOTS, their Widows and Children, at a
meeting thereof held at Philadelphia the day of
in the Year of our Lord One thousand eight hundred &
Given under my Hand and the Seal of the
Society the day of

Attested President

Clerk

Samuel Seymour after
Thomas Birch, Certificate
of the Society for the Relief
of Distressed and Decayed
Pilots, circa 1810, etching
and engraving, 24⅛ x 18⅞.
The Library Company of
Philadelphia, Pennsylvania.

to civic structures and banks. The reassuring clarity and lucidity are con-
firmed by the hovering presence of the federal eagle and the liberty cap,
with the palm of martyrdom added to the olive branch of peace. The busy
boats under sail exist within the awareness of larger truths: the faith of
pilots and the pathos of the fatherless family. The family is grouped as the
traditional symbol of *caritas,* which elevates the situation from a possible
sentimental particularity to a general pious concept. The noble calling of
the sea, expressed in the figurehead with the chart and mirror, and the
domestic victims are complementary thoughts that follow the ships into

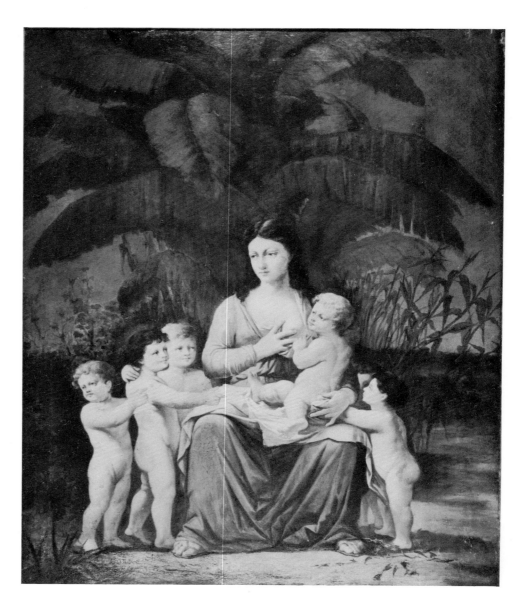

Dominico Canova, *Mother
Louisiana*, oil on canvas,
45 x 27. Mr. and Mrs. W. E.
Groves, New Orleans,
Louisiana.

the bay. No matter how small or large the association was, it could see itself
as a public entity with the blessing of society, in its governmental form, and
the support of a timeless moral tradition.

Once an allegorical state of mind is established, only a slight clue is
needed to draw the earthly image into the realm of idea. Somehow one
knows perfectly well that Dominico Canova's matronly figure surrounded
by six children is not a simple country scene. A solidly rooted figure in
simple draperies, she offers her breast in the traditional manner of Charity,
and recalls in her simplified features a range of artful faces from the
Lemnian Venus to Raphael. In spite of the great banana tree and tropical

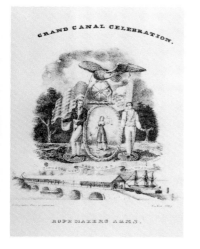

Dominico Canova, *Grand Canal Celebration, Rope Maker's Arms*, circa 1825, lithograph, 6⅛ x 6. National Museum of History and Technology, Smithsonian Institution; Harry T. Peters "America on Stone" Lithography Collection.

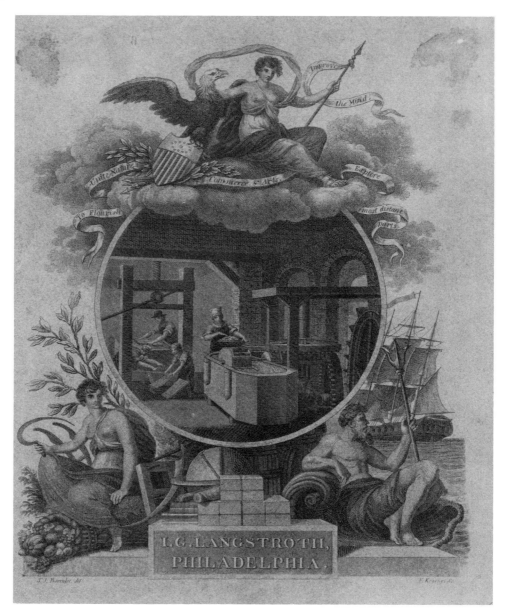

Francis Kearney after John J. Barralet, Trade Card for I. G. Langstroth, circa 1810-15, engraving, 10⅝ x 8⅝. Historical Society of Pennsylvania, Philadelphia.

foliage, she and her infants exist in the same community as the pilot's family and the welcoming Hibernians. Canova called his painting, it is said, *Mother Louisiana*.

This may be the same Canova who, a few years earlier, executed lithographs for Anthony Imbert in honor of the Erie Canal celebration. His arms for the ropemakers, dated 1825, enlists the aid of the American eagle to give official dignity to what might be thoughtlessly considered a humble manufactory. It is wise not to think of what happens when the ropemaker's wheel turns with the eagle perched on the rim, but then, this dignified formulation exists in a realm of abstract meanings and physical non sequiturs in

spite of the literalness with which each part is treated. By virtue of this kind of allegorical thinking, however, a pride in industry and a kind of spiritual guaranty of the product are attested to.

For some years, in fact, the American eagle and its allegorical friends had been summoned to give authority to manufactory. In about 1810, for example, Barralet designed a trade card for the paper manufacturer Langstroth in Philadelphia in which the friendly bird is embraced by a genius who recommends:

> To Flourish Unite Nature,
> Commerce & Arts.
> Improve the Mind,
> Explore most distant parts.

The drudgery of papermaking is quite literally depicted in the central rondel, but it floats in the more glamorous atmosphere of agriculture, overseas commerce, and national approbation. There was no doubt, it would seem, in the mind of Mr. Langstroth that his manufactory was well placed in an estab-

George A. Bauer after E. A. Floyd, *Hailing the American Eagle,* 1857, woodcut, 9⅜ x 11⅞. Library of Congress, Washington, D.C.

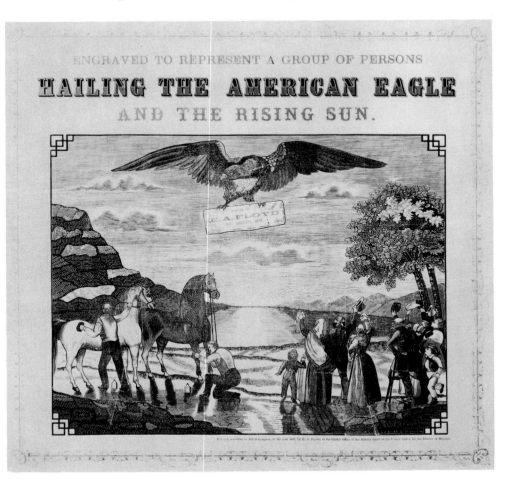

lished culture. The eagle, the classical style, the allegorical rhetoric were as much for his use as they were for the use of the statesman and political organizer.

The personal association with the symbolic eagle, however, was rarely carried to the point of one E. A. Floyd of St. Louis, Missouri, who in 1857 designed a woodcut, executed by George A. Bauer, extolling his own talents. The "group of persons hailing the American eagle and the rising sun" confront in the eagle's talons a sizeable plaque bearing the legend: "Designed by E. A. Floyd, St. Louis, Mo." How could one doubt his talents with such respectable patronage? By evoking the eagle Mr. Floyd took his place in the mythic America united by symbol.

Somewhere between the 1820s and the 1860s the nature of the symbol in America changed. Not that the eagle and Columbia with her liberty cap ceased to appear, nor no longer stood for virtue and the state: the "American Union" lithograph published by Middleton, Strobridge & Co. in 1861 has all the familiar figures. But somehow the aura of myth, the unquestioning belief in the unifying realm of the symbol, is lacking. Stylishness there is, but no pervading, idealizing style to wrap all in a convincing world of thought, as in the engravings by Barralet. In a way it relates more closely to the late eighteenth-century engraving by Abraham Godwin in the way it compartmentalizes the individual scenes, but in this print the symbolic figures are treated differently from the views of Washington and the plantation or the frontier and the Indians. There is a world of symbols and a world of actuality; the relationship between the two is established by a kind of rational agreement, but there is no confusing their distinctive natures. In contrast to the allegorical figures, each scene is spelled out quite literally as an actual glimpse into history or the life of the present-day farm. The conscious effort to build them into a symbolically significant whole, uniting them with allegory, results more in an effect of sentimentality, of wishful rumination, than in a visual expression of union. Possibly the moment in which America could quite unselfconsciously see herself as symbol had passed.

The year was important for such a print as this. In 1861 Abraham Lincoln was beginning a presidency dedicated to union but doomed to civil war. More than simply modes of perception had changed. The culture of the United States of America would not again in its two hundred years be conceivable as a single, unified symbol.

In 1876, on the first centenary of the American Revolution, there were many efforts to synthesize once more the image of America. The great exhibition held in Philadelphia to celebrate the Centennial both looked back over one hundred years of history and assessed the present state of industry and the arts. But when art set out to deal with the occasion it did so in an accumulative way. A commemorative lithograph produced by T. J. Berry is characteristic of the contemporary literalness of thinking. It is a collection of signs more than symbol, more a compilation of history than a discourse on moral philosophy. America now was seen in pragmatically definable

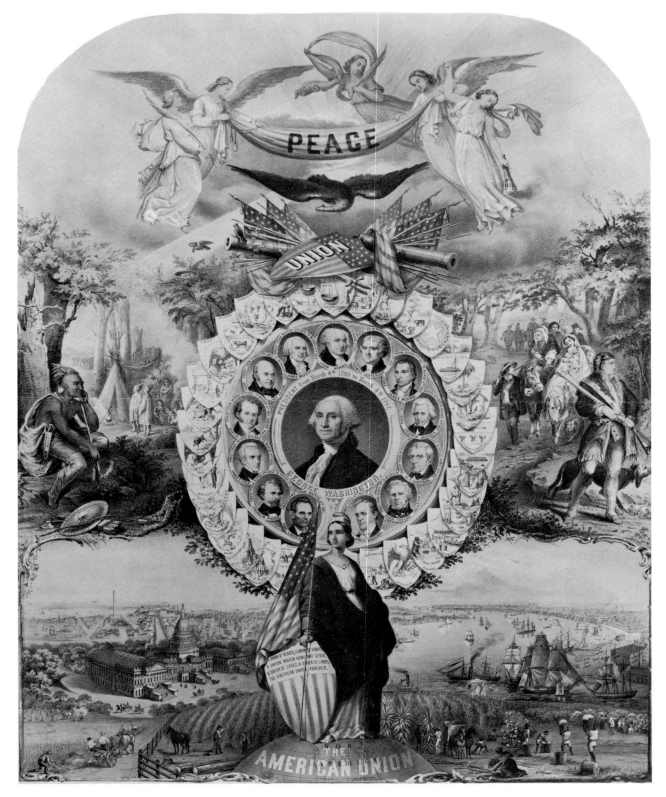

T. J. Berry after [?] Loag, *Memorial to 100 Years a Republic*, lithograph, 24½ x 18¾. Library of Congress, Washington, D.C.

terms, not as a living symbol of a moral ideal. Ideality, the artists could say, exists only in the guise of the provably real.

To go back, for a moment, to the beginning, it is interesting to note the impact of symbolic consciousness on the image of the American hero. Throughout the last decades of the eighteenth century, likenesses of military and political heroes were popular and were produced in a great variety of forms and materials, from prints and plaques to idealized busts. As often as not the features of the famous man were coaxed to lead in the direction of classical regularity and the frock coat was replaced by a neutral piece of Romanish drapery. With the death of George Washington in 1799, almost a cult developed over the departed hero, and Washington himself became a kind of allegorical image for republican virtues.

Barralet made a drawing of Washington (engraved by Field) in 1793, the year of Washington's second inauguration, that showed him in a not uncharacteristic symbolic fashion. The American eagle, yoked with the scales of justice, supports the likeness; and above, the liberty cap is hung upon a sword surrounded by a laurel wreath. The whole image floats in the clouds. The fact that the features in the portrait were not especially like those

Unidentified Artist, *Peace*, 1861, lithograph, 23½ x 18½. Library of Congress, Washington, D.C.

Robert Field after John J. Barralet, *George Washington*, 1793, stipple engraving, 14½ x 10⅝. Historical Society of Pennsylvania, Philadelphia.

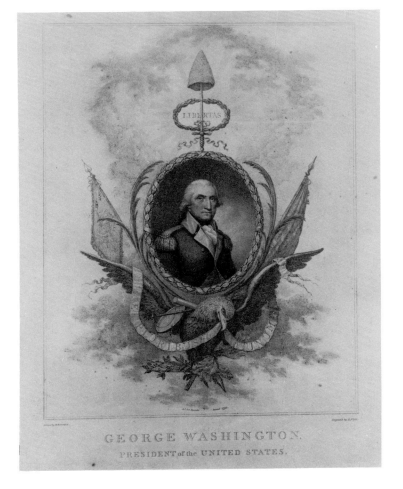

GEORGE WASHINGTON.
PRESIDENT of the UNITED STATES.

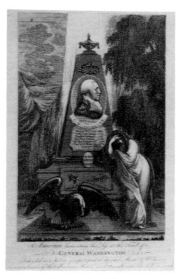

James Akin and William Harrison, Jr., *America Lamenting Her Loss at the Tomb of General Washington*, 1800, engraving, 13⅜ x 8¼. The New York Public Library, New York.

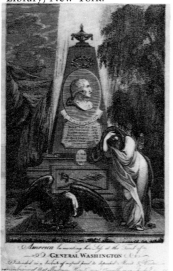

James Akin and William Harrison, Jr., *America Lamenting Her Loss at the Tomb of General Washington*, 1800, engraving, 13⅜ x 8¼. Historical Society of Pennsylvania, Philadelphia.

of other representations seems not to have been important—popular likenesses of Washington varied enormously, yet carried some germ of character that established identity. Here the symbolic trappings established the likeness more tellingly than the face.

At his death, George Washington was already a consecrated hero of classical stature, and it was only fitting that he be commemorated in antique fashion. Akin and Harrison published in 1800 a characteristic mourning picture in which the grieving figure of America, a symbol now well established, joins the mourning American eagle at the base of a classically designed tomb. Even the background trees mourn for the lost hero. There seems to have been some doubt about how the hero should be represented since there are two versions of the print, one in which Washington is shown in uniform, the other in which he is shown as a disembodied figure on a Roman cameo. In either case, he is a symbol, mourned by symbols in a rhetoric appropriate to the day.

A weeping soldier, a goddess, and personifications join together to pay homage in the painting by John Coles, Jr., engraved by Enoch G. Gridley in about 1810. Around the classical tomb-monument flit geniuses with the liberty cap, the mirror of truth, the laurel wreath, and other pertinent symbols, and Minerva herself, who had been counseling America in prints for some years, holds the portrait plaque. Columbia sits mourning on the tomb while Fame proclaims Washington's major victories and bestows a wreath designating him father of his country. Although the technique may be naïve, there is no questioning the artist's capacity to think in elevated terms. The language of symbol was a common, not a rarefied, means of communication.

Washington was not the only hero to be mourned as symbol. Alexander Hamilton's imaginary classical tomb is flanked by Freedom and the Minerva image of America in a print by John Scoles, a New York engraver, executed in 1804 or shortly thereafter. But these are only a few examples. Any great political or military figure identified with the country was translated by style and antique references into a timeless hero. His personal peculiarities were somehow sloughed off in the act of elevation.

The commemoration of national heroes, especially Washington, pulled at the sentiments of many of those who turned their hand to mourning pictures. Although they often referred to deceased members of the family, these affecting compositions are often principally sentimental laments on the theme of mourning itself. The setting is usually idyllic, with weeping willows and silent nature in attendance, and the female figure who mourns or decorates the monument is at once a muse, a virtue, and a fashionable young woman. Margarett W. Smith, who painted her delicate watercolor *Sacred to Washington* in 1822, twenty-three years after the first president's death, could choose him as the object of her pious thoughts because he lived on as a symbol, as detached from his personal historical context as Margarett Smith's landscape is from the actualities of her daily life. To mourn for a hero was to visit for a moment in Elysium.

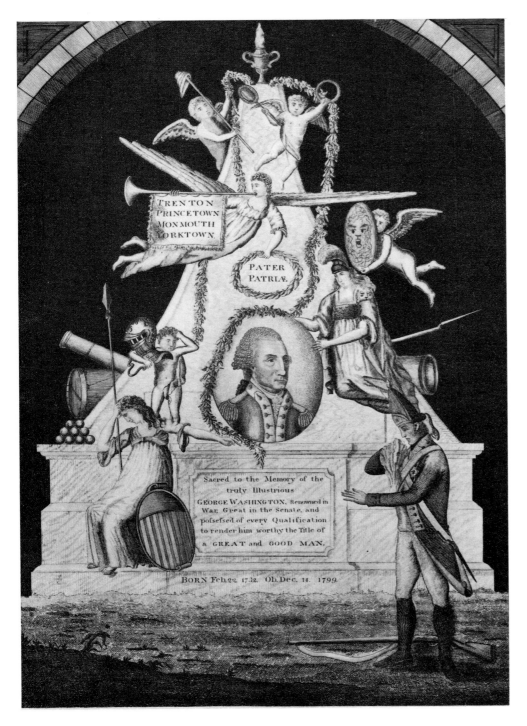

Enoch G. Gridley after John Coles, Jr., *Memorial to Washington*, 1810, intaglio, 13¼ x 9⅛. National Collection of Fine Arts; Museum purchase.

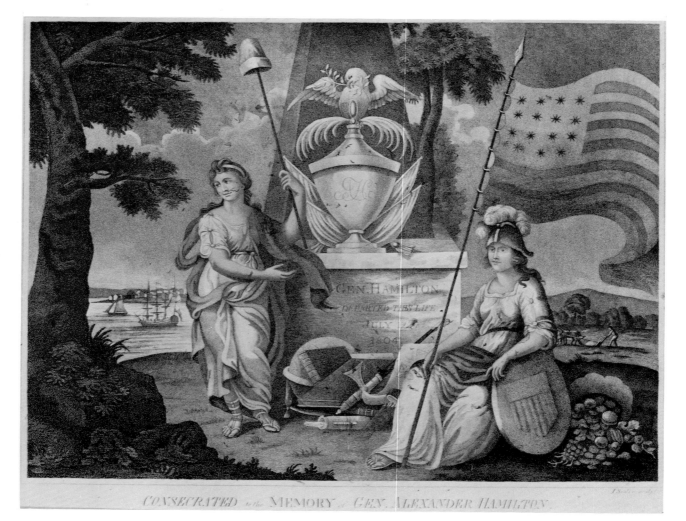

CONSECRATED to the MEMORY of GEN. ALEXANDER HAMILTON.

John Scoles, *Consecrated to the Memory of General Alexander Hamilton*, circa 1804, stipple engraving, 15½ x 20⅛. Library of Congress, Washington, D.C.

It was only a short step from seeing the hero as the earthly embodiment of virtues to his moving into the realm of the virtues themselves. In William Woolley's somber mezzotint after his own painting, the portrait of Washington is surrounded by mourning America, including an Indian, Liberty, Justice, and a virtue with a heavenly crown who points to the hero's celestial home. Barralet is more direct. While Liberty, the American eagle, and an Indian mourn, Washington is borne to the land of heroes in a dramatic apotheosis. It is a startling image, made more so by the familiar Gilbert Stuart likeness in the midst of the generalized beauty of Barralet's classically inspired forms. Many years later the same composition served for the apotheosis of another national hero, Abraham Lincoln, in a lithograph published by William Smith. The paraphrase is doubtless of deliberate significance, but it is noteworthy that the artist had to find his image of apotheosis in an earlier moment of visual thought. The persuasive, elevating style was no longer easily his, any more than it served the artists of *Emancipation Procla-*

Francis Anone, *Virtue Weeping Over the Tomb of G. Washington*, circa 1800, mezzotint, 14⅛ x 10. The New York Public Library, New York.

Margarett Smith, *Sacred to Washington*, 1822, watercolor on paper, 20¼ x 16½. The Baltimore Museum of Art, Maryland; Gift of Edgar William and Bernice Chrysler Garbisch.

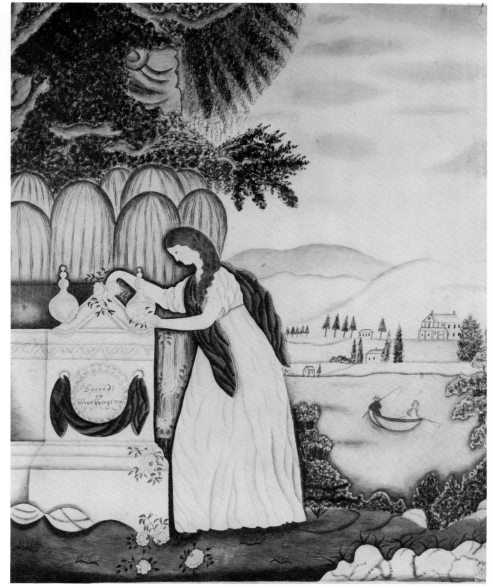

mation, a chromolithograph on a similar theme. Their people simply try to be symbols in an unsymbolic world.

America, to be sure, was not the only country to see its new order as symbol in the late eighteenth and early nineteenth century. It was a Europe-wide phenomenon. Napoleon carried the specific political symbolism of a classical style wherever his conquests led him. English artists and theorists spoke of the grand and heroic style, and developed a visual vocabulary to elevate the image of their statesmen to a place of glory. For America, however, newly formed politically and struggling for a unifying awareness of political identity, to see itself in symbol held a most particular significance. It was the first step in a liaison between American consciousness and art.

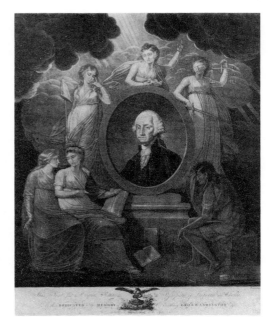

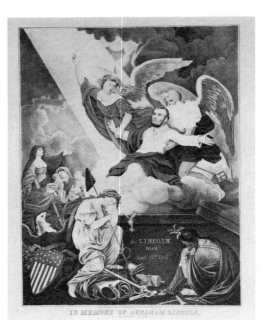

John J. Barralet, *Sacred to the Memory of Washington*, circa 1800, stipple engraving, 27 5/16 x 20⅞. Historical Society of Pennsylvania, Philadelphia.

William Woolley, *Dedicated to the Memory of His Excellency Geo. Washington*, circa 1800, mezzotint, 23 x 18½. Historical Society of Pennsylvania, Philadelphia.

Unidentified Artist, *In Memory of Abraham Lincoln*, circa 1865, lithograph, 30⅛ x 24 1/16. The Library Company of Philadelphia, Pennsylvania.

Alexander and Moritz Kann, *Emancipation Proclamation*, 1863, chromolithograph, 23 x 28½. Library of Congress, Washington, D.C.

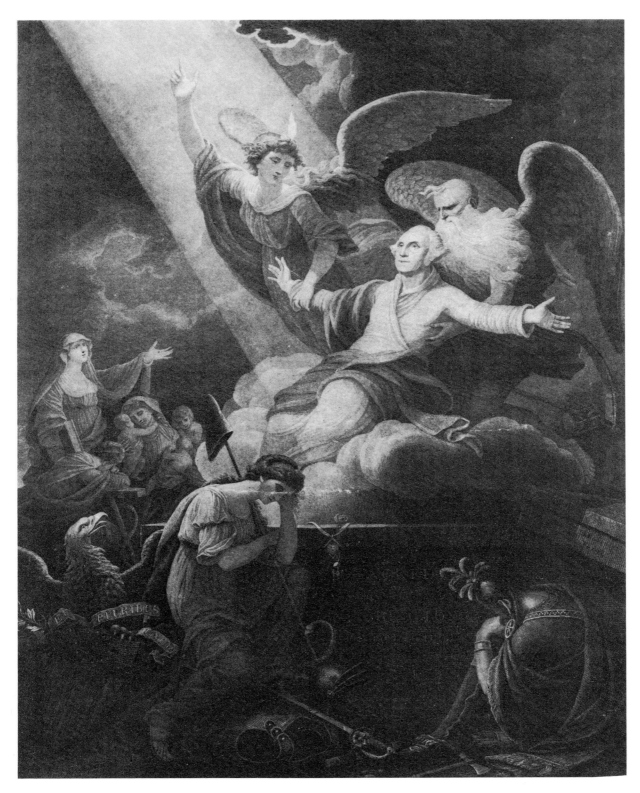

The American Cousin

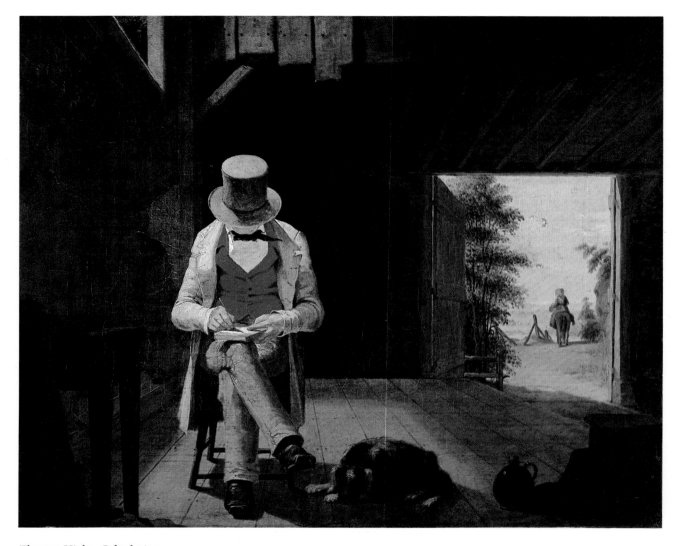

Thomas Hicks, *Calculating,*
1844, oil on canvas,
14 x 16¾. Museum of Fine
Arts, Boston, Massachusetts;
M. and M. Karolik Collec-
tion.

The American Cousin

O The Folks Down Home

On the fateful evening of April 14, 1865, that President Abraham Lincoln went to Ford's Theatre in Washington, he had chosen to relax by seeing a favorite play, Tom Taylor's *Our American Cousin*. Written by a British playwright, the broadly played comedy had been immensely popular in America since its first performance in New York in 1858, chiefly because of its forthright American hero, Asa Trenchard, as played by Joseph Jefferson, and the contrasting foolish Englishman, Lord Dundreary, played to extraordinary acclaim by E. A. Sothern. Clearly the American audience liked to see itself reflected in the rough but honest and good-hearted character of Asa, who scandalized his English relatives by his colorful speech, his unconventional ways, and his capacity for hard liquor. His local dialect and outlandish behavior, which supposedly shocked conventional Englishmen, had become a source of native pride, even though a generation or so before, such deviation from the norms of polite society might have been considered embarrassing evidence of a faulty education. The "original," the character who seemed to spring wholly from his native environment without benefit of international polish, had become by the late 1850s, for better or for worse, a symbol for America. The constantly whittling Yankee with his horsetrading shrewdness and pungent, colorfully phrased aphorisms was eventually to be perpetuated in that favorite image of countless cartoonists, Uncle Sam.

By the time that Tom Taylor wrote his play, the "Yankee" character was well established in literature and on the stage; in fact, it had become something of a stereotype that would shortly be superseded. Although it was probably the influx of middle-class American visitors to London for the "Crystal Palace" exhibition of 1851 that prompted him to devise his comedy, which played on all those traits that an English audience associated with their visiting "American cousins," Taylor was drawing on a tradition going back well into the 1820s. There was even a much earlier example, Royall Tyler's play *The Contrast*, of 1787. *The Contrast*, considered to be the first native American play, portrayed a rural Yankee named "Jonathan"—a name

Unidentified Artist, *Joseph Jefferson as Asa Trenchard in* Our American Cousin, hand-colored photograph, 11¾ x 8¼. Hoblitzelle Theatre Arts Collection, University of Texas, Austin; Davis-Kendall Collection.

that was to become identified with the Down Easterner (and, by extension, the American), who stood out in contrast to less-admirable city dwellers. But it was in the 1820s that an interest in local types with their specific dialects and mannerisms began to preoccupy some serious writers and many popular entertainers. As early as 1815, David Humphrey included a glossary of "Yankee" speech in the publication of his play *The Yankee in England*. How accurate it was is hard to say, but it showed an awareness that colloquial speech was not simply a matter of error and ignorance but had a color of its own. Subsequent authors followed his lead in trying to imitate the curious mixture of archaisms, invented words, and distinctive accent that came to typify American characters. A whole convention of speech developed that probably fed back into popular usage as much as it had drawn on actual custom in the first place. Many of the formulations have remained a part of American speech.

The rough manners and colloquial speech of what were singled out as peculiarly American habits served by turns as cultural embarrassment and as rallying points for a new national consciousness. The embarrassment came chiefly in response to criticism by European visitors, mostly English. Although some found the speech quaint and amusing, they considered it simply a product of ignorance. They were not at all amused, however, by the arrogance of what they persisted in referring to as the lower classes; ignorance might prove amusing, but when ignorance was flaunted as a virtue it was not to be tolerated. The ignorant person should recognize his inferior place in society. Moreover, European visitors not infrequently pointed out acidly that there was a notable discrepancy between high-flown American rhetoric extolling freedom and democracy, engaged in by ignorant and intellectual alike, and the sharp-dealing opportunism and tight-minded prejudice they encountered on their American travels.

When Mrs. Trollope published her *Domestic Manners of the Americans* in 1832, Americans were scandalized at her observations gathered during her residence in Cincinnati and travels in the East. American manners she considered generally to be barbarous and pathetically provincial. She found little in the conduct of society that either supported the constant protestation of personal independence or that was persuasive evidence that such independence—as distinct from an agreed-up code of manners—was a thing to be desired in the first place. The concentration on the local, and the extraordinary value placed on local achievement, she considered to be simply a matter of ignorance. Speaking of a chance conversation about painting conducted with a gentleman whom she deemed intelligent, she recalled,

> At length he named an American artist, with whose works I was very familiar, and after declaring him equal to Lawrence . . . he added, "and what is more, madam, he is perfectly self-taught."
> I prudently took a few moments before I answered; for the equalling our immortal Lawrence to a most vile dauber stuck in my

Auguste Hervieu, *Ancient and Modern Republics*, 1832, lithograph. From Frances Trollope, *Domestic Manners of the Americans*, 1832.

throat; I could not say Amen; so for some time I said nothing; but, at last I remarked on the frequency with which I heard this phrase of self-taught *used, not as an apology, but as positive praise.*

"Well, madam, can there be a higher praise? . . . Is it not attributing genius to the author, and what is teaching compared to that?"

Although Mrs. Trollope could not understand the importance to an American of qualities that seemed to be solely the product of the artist's own genius, the idea of the "self-taught" ran as a deep current in much that had to do with culture in American life during the 1820s and '30s. The newly studied local dialects, for example, with their elaborately coined words and phrases, could be looked upon not as the language of ignorant bumpkins but as a highly creative and original expression that afforded insights not possible in standard English. In fact, to coin words and catchy phrases was a respected and overexploited pastime in America. A folk hero such as Davy Crockett could never be quoted other than in some obviously original form of speech, as often as not with little relationship to the way the actual David Crockett spoke. The fact that eloquence was achieved in other than standard English was clearly, in the eyes of many, a mark in a

Nicolino Calyo, *Reading Room of the Astor House*, circa 1840, watercolor on paper, 9⅜ x 12¼. Museum of the City of New York, New York.

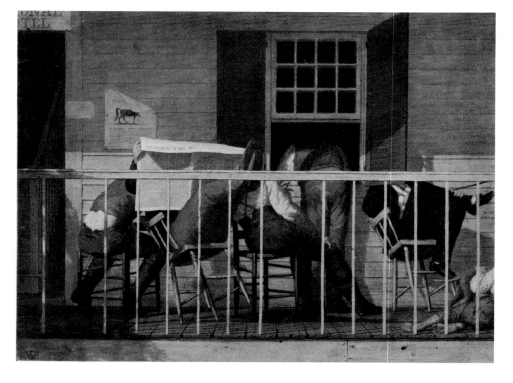

Enoch Wood Perry, Jr., *The True American*, circa 1875, oil on canvas, 11⅞ x 16⅛. The Metropolitan Museum of Art, New York, New York; Arthur H. Hearn Fund.

James Goodwyn Clonney, *Mexican News*, 1847, oil on canvas, 26⅝ x 21¾. Munson-Williams-Proctor Institute, Utica, New York.

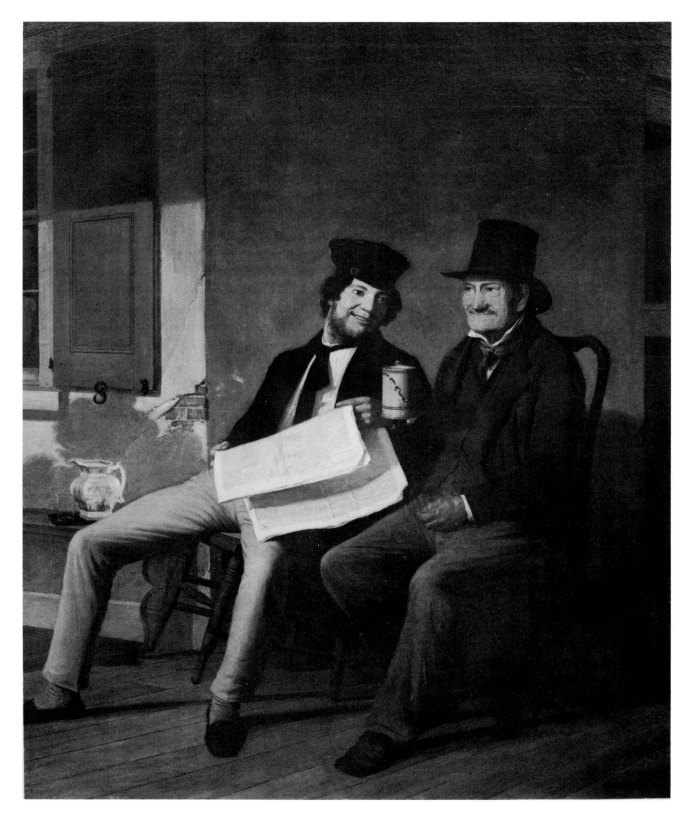

writer's or an orator's favor. It marked him as an "original," which meant a true American. There was nothing especially colloquial about the paintings of Chester Harding (doubtless the painter Mrs. Trollope referred to), but the idea that he could best Lawrence—in local estimation—through the force of his own genius, unhelped, gave him a special status.

Although it is hard to justify those particular habits repeatedly criticized by Mrs. Trollope—such as never sitting properly on a chair and spitting indiscriminately in public places—as products of original genius, they do illustrate the similar studied defiance of established norms that apparently was so important also in the consideration of more elevated activities. Like vernacular speech, some habits came to be considered American habits and, much to the distress of many, became a kind of symbol standing for the country at large. To be sure, after Mrs. Trollope's book, people who behaved with elaborate disregard for their fellows were decried as "trollopes," a word that had a different meaning for the American ear than the venerable English word "trollop." Yet the public took a certain evident pleasure in recognizing American traits, even when their expression was crude.

Paradoxically, to be universally American in these terms was to be local—people liked to think that this meant individual—and regional characteristics seemed to give the stamp of authenticity to any national portrayal. That is, there was no synthesized American. To be American one had to have or adopt the manners and speech of a particular locale, preferably rural. In a kind of reversal of an earlier attitude toward America that looked with optimism toward a new and unified culture, this point of view—which also had its political overtones—saw the country as a federation of relatively isolated and fiercely independent locally distinct cultures. This was just as deliberate and sophisticated an attitude as that which recommended the transcendence of regional differences. In fact, the cultivation of the vernacular was a program carried on by highly literate writers and artists, usually city dwellers. Just as it is today, it was a conscious way of thinking about America, not simply a reflection of what America was.

While many self-conscious American artists and writers, then, were dreaming of creating the great American masterpiece on universal artistic terms, other actors, playwrights, and popular authors were busy defining the heterogeneous cast of characters that to them—and obviously to their audiences—spelled, in their collective differences, America. Even in this, however, they had some help from abroad.

In 1832 William Dunlap noted in his *History of American Theatre* that of the 275 plays presented in the United States, only about one-fourth dealt with native characters or themes. Although this proportion quite probably never reversed itself, Dunlap was writing at a moment of change, for the impact of those that were emphatically local was to increase tremendously. The plays themselves were of less importance, quite probably, than some shrewd characterizations of local types that were to catch the fancy of the public and be developed into a whole chain of theatrical presentations.

Cephas G. Childs and Henry Inman, *The Trollope Family*, 1832, lithograph, 8½ x 10½. National Museum of History and Technology, Smithsonian Institution; Harry T. Peters "America on Stone" Lithography Collection.

Often popularity was based on the performances of actors who became identified with particular roles, becoming themselves representative types of American character.

The English actor Charles Mathews made a trip to the United States in 1823 to appear on the stage, but while in this country he made careful note of the types he encountered on his travels, which he hoped to be able to use for future presentations. He was not happy with much that he found in the United States, but his actor's eye was not disappointed in the range of definable types to be seen. Back in London in 1824, he presented an evening of monologues based on his American observations, calling the presentation *A Trip to America*. The presentation met with great success. The cast of characters was broad, and Mathews employed not only changes of costume and manner but dialect as well. The same year he produced another work, *Jonathan in England*, which, among others, expanded on his voluble character Agamemnon, a black slave who was both comic and appealing and who discovered in England a freedom not accorded him in America. The play was withdrawn, but Agamemnon as a character remained.

Inspired by Mathews, the American actor James H. Hackett in 1827 tried his hand, in London, at portraying a Yankee character in a long monologue. His dialect was probably more accurate than that of Mathews, but the London audience had little interest in authenticity and was not beguiled by Yankee rhetorical convolutions as such. They preferred the more amus-

Unidentified Artist, *The Mathew-orama for 1824. Charles Mathews in his roles in* Trip to America, *lithograph, 10¾ x 8¾. Hoblitzelle Theatre Arts Collection, University of Texas, Austin; Davis-Kendall Collection.*

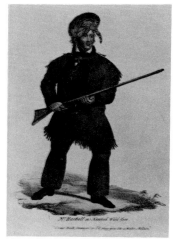

Edward W. Clay, *James H. Hackett as Nimrod Wildfire in* The Kentuckian, *or* The Lion of The West, *lithograph, 10 5/16 x 7 1/16. Harvard Theatre Collection, Harvard University, Cambridge, Massachusetts.*

46

ing interpretive form of Mathews, which accorded with their preconceptions. Hackett returned to the United States, however, and became one of the first in a long line of actors devoting themselves almost wholly to American types. He became famous as Rip Van Winkle, Nimrod Wildfire, Industrious Doolittle, and others. American audiences were now ready to see themselves and their kin with an appreciative eye.

Even more thoroughly identified with the Yankee role was George H. Hill, known as "Yankee" Hill, who played such roles as Hiram Dodge in *Yankee Pedlar* and Jebadiah Homebred in *The Green Mountain Boy.* Dan Marble was another, playing Jacob Jewsharp in *Yankee in Time,* and personating Sam Patch, the legendary Rhode Islander who in the 1820s became famous by jumping into rivers and ultimately—and fatally—over Niagara Falls. And there were many others.

In 1825 Samuel Woodworth presented in New York his consciously American play, which was to become famous, *The Forest Rose* (or *American Farmers*), introducing the stalwart character of Jonathan Ploughboy. Fascinated by the "Down-East" speech of the New Englander, Woodworth exploited the "American" nature of his leading character. From this point on the twang of the Yankee was heard frequently throughout the land.

The Yankee farmer or small townsman, it would seem, was the first of a variety of types to be identified with the United States as a whole, both in America and abroad. "Brother Jonathan" embodied many traits that most could feel superior to, yet admire. First of all he was completely independ-

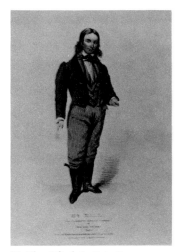

Unidentified Artist, *George H. Hill as Hiram Dodge in Yankee Pedlar*, 1838, aquatint, 16¾ x 11 9/16. Harvard Theatre Collection, Harvard University, Cambridge, Massachusetts.

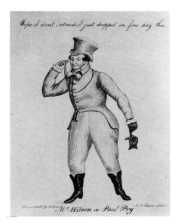

M. Williams after M. Parisen, *Mr. Hilson as Paul Pry*, lithograph, 8¼ x 6. Library of Congress, Washington, D.C.

ent, refusing to accept any given line of conduct without redoing it on his own terms. This meant that the most ordinary matter had to be argued from scratch; there was never the possibility of a simple answer. Because of his supposed ignorance of city ways and European customs, he could satirize many of them by simply calling attention to their lack of Yankee reason. For all his vaunted want of sophistication, Jonathan was always basically honest and just, embodying those moral virtues that have traditionally been associated with the rural environment. He often emerged as the one person with a true sense of values who, with his self-assurance and common sense, could bring order out of a chaotic situation. He was the naïve original who could save the world.

There was another side to the Yankee type that was just as celebrated. This was his shrewdness in driving a bargain. Whittling as he carried on his prolonged discussion filled with homely saws and helpful diversions, he rarely emerged the loser. Quite early the Yankee was identified as the itinerant peddler who traveled from place to place with a load of useful and exotic items—sometimes not what he purported them to be—that he sold at a handsome but hard-won profit. He was known as "Nutmeg" in the unbelievably complicated play *The Pedlar,* which Alphonso Wetmore wrote in St. Louis in 1821, and "Hiram Dodge" in the popular *Yankee Pedlar.* His most expressive name was probably "Solomon Swap" in *Jonathan in England,* although in this he was not actually a peddler.

Always indirectly a commentator on social matters, Jonathan entered politics in the writings of Seba Smith in 1833. "Major Jack Downing of Downingville, Maine," was created by Seba Smith, the editor of the *Portland Courier* of Portland, Maine, and began writing letters in his local brand of English to express his views on all manner of customs and Jacksonian politics. The letters were tremendously popular and were widely republished. In fact, they started such a vogue that many "Jack Downing" writings appeared that had nothing to do with Seba Smith. The "major" observes the legislature of Maine and the vagaries of the party system in operation, then moves to Washington to follow the activities of the president and Congress. Although initially a supporter of Jackson, he becomes wary when the presidency seems to take on too much authority. He became the personification of the doubting and questioning public, resisting the forces of powerful political organizations that lost sight of the impact of their activities on the individual citizen. Like the stage Yankee, his resistance to sophistication was looked upon as a means for getting at the true value of things, the true meaning of actions once the conventional rhetoric was brushed aside. A newspaper creation, Jack Downing gained credibility by damning even the medium that gave him birth: "I think these newspapers are dreadful smokey things; they are enough to blind any body's eyes any time. I mean all except the *Daily Courier* and *Family Reader,* that I send my letters in; I never see much smoke in them. But take the rest of the papers, that talk about politics, and patriotism, and republicanism, and fed-

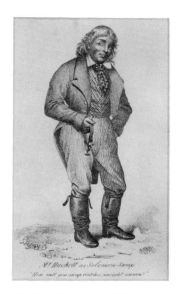

Unidentified Artist [Edward W. Clay?], *Mr. Hackett as Solomon Swap*, lithograph, 8½ x 5½. Hoblitzelle Theatre Arts Collection, University of Texas, Austin; Davis-Kendall Collection.

John L. Magee, *Yankee Locke*, 185?, lithograph, 21 x 16½. Library of Congress, Washington, D.C.

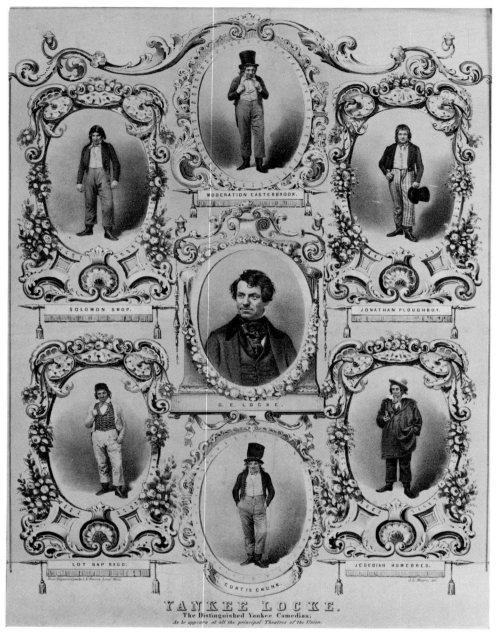

eralism, and Jacksonianism, and Hartford Conventionism, and let any body read in one of 'em half an hour, and his eyes will be so full of smoke he can't see better than an owl in the sunshine; he wouldn't be able to tell the difference between a corn-stalk and the biggest oak tree in our pasture."

Jack Downing was just one of many such "homebred" critics who set out to correct the tendency of treating all in terms of generalities and using grandly formulated issues to obscure the actuality of a given situation. More caustic even than Jack Downing was James Russell Lowell's "Hosea Biglow," who, beginning in 1846, was quick to point out the falseness in rhetoric

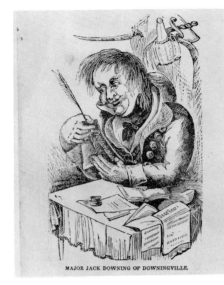

David Claypool Johnston, *Major Jack Downing Entering the Cabinet with his Axe*, 1833, wood engraving. From Seba Smith, *The Life and Writings of Major Jack Downing, of Downingville, Away Down East in the State of Maine*, Boston, 1933.

David Claypool Johnston, *Major Jack Downing Entering the Cabinet with his Axe*, 1833, wood engraving. From Seba Smith, *The Life and Writings of Major Jack Downing, of Downingville, Away Down East in the State of Maine*, Boston, 1833.

Unidentified Artist, *Major Downing Queling the Riot in the Kitchen Cabinet*, lithograph, 10½ x 15¼. National Museum of History and Technology, Smithsonian Institution; Harry T. Peters "America on Stone" Lithography Collection.

49

William T. Mathews, *Pre-Civil War Episode*, oil on canvas, 17⅛ x 14⅛. The Massillon Museum, Ohio.

of politicians of every style. In a letter written supposedly to Hosea from the front in the Mexican War, his correspondent writes of Mexicans:

> *I'd an idee thet they were built arter the darkie fashion all,*
> *An' kickin' colored folks about, you know, 's a kind o' national;*
> *But wen I jined I worn't so wise ez thet air queen o' Sheby,*
> *Fer, come to look at 'em, they ain't much diff'rent from wut we be,*
> *An' here we air ascrougin' 'em out o' thir own dominions,*
> *Ashelterin' 'em, ez Caleb sez, under our eagle's pinions,*
> *Wich means to take a feller up jest by the slack o' 's trowsis*
>
> *Wal, it does seem a curus way, but then hooraw fer Jackson!*

An' walk him Spanish clean right out o' all his homes an' houses;
Wal, it does seem a curus way, but then horaw fer Jackson!
It must be right, fer Caleb sez it's reg'lar Anglo-saxon.
[*The Biglow Papers*, 1848.]

In a way, these writers were creating a style of discourse that was against style. Distrusting eloquence as they distrusted the organizations it upheld, they suggested that ineloquence was the badge of truth. Although Lowell did not persist in this idea later in his career, it did survive in the public consciousness, to surface periodically as a self-consciously American notion. Although the dialect may change, from the Down Easterner, to the Westerner, to the Hoosier, to the Southerner and the Texan, the vernacular statement has more readily been accepted as true—and American—over the years than the elegant formulation. To appear unsophisticated was to become an ultimate mark of sophistication.

The significance of this "vernacular" thinking was not lost on the artist. Although his earlier goals were to paint the monumental and permanent aspects of man and nature, he too began to suspect the existence of another definition of truth. Prior to the 1820s few painters had been tempted to concentrate on American traits and the local scene. Since the goal of art, so he had been taught, had to do with spiritual transcendence and moral beauty, there was little to be gained by traversing the city sketchbook in hand. The basic study for the painter were casts from antiquity, of which there were sets in New York, Philadelphia, and Boston, not the motley types that were being caricatured in literature and on the stage. Furthermore, art to the patron meant the European tradition, of which there was small representation in America, and he preferred copies or imitations of the works of past masters to visual reports on the society around him. By 1830, however, artist and patron alike were ready to find satisfaction in the local, to redefine art in national rather than international terms. As with the stage and vernacular literature, the voice of truth came predominantly from the country, not the city.

The first hero in art of this attitude was William Sidney Mount. Born on Long Island in 1807, Mount started out in New York to become a painter of dramatic religious scenes, such as *Saul and the Witch of Endor* and *Christ Raising the Daughter of Jairus,* but by the early 1830s he had given up this high ideal of art to paint anecdotal works using local types. He returned with satisfaction to his home in Stony Brook and there produced his highly successful paintings, gradually allowing his interest in character to overshadow explicit storytelling. His Long Island farmers whittle as they bargain for a horse, swap yarns around a stove, raffle a goose, or stand entranced by country music. Every characteristic detail was important to Mount and he painted it with rapt attention, at the same time retaining a surprising justness of artistic unity. Nothing is inharmonious in Mount's rural world, neither his people nor his forms. His shrewd country types seem not the image but the origin of the Yankee characters appearing on

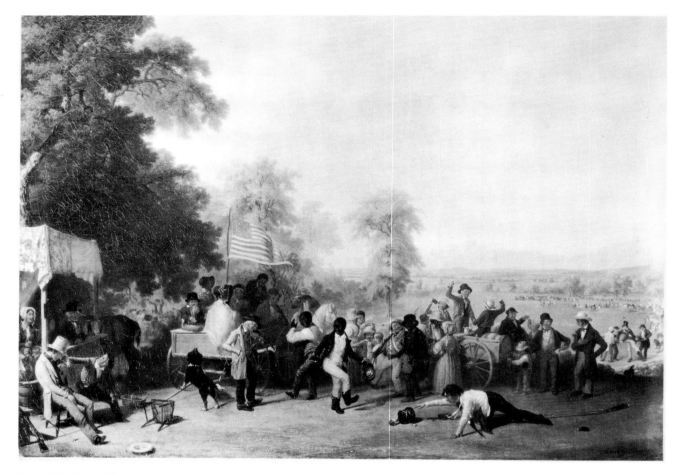

James Goodwyn Clonney, *Militia Training*, 1841, oil on canvas, 28 x 40. Pennsylvania Academy of The Fine Arts, Philadelphia; Bequest of Henry C. Carey, 1879.

James Goodwyn Clonney, *Negro Boy Dancing*, drawing for figure in *Militia Training*, 1839, wash on paper, 19½ x 15½. Museum of Fine Arts, Boston, Massachusetts; M. and M. Karolik Collection.

James Goodwyn Clonney, *Fiddler*, drawing for figure in *Militia Training*, circa 1839-41, wash on paper, 19½ x 15½. Museum of Fine Arts, Boston, Massachusetts; M. and M. Karolik Collection.

Louis-Emanuel Soulange-Teissier after William Sidney Mount, *Coming to the Point*, 1855, lithograph, 19⅜ x 23¼. National Museum of History and Technology, Smithsonian Institution; Harry T. Peters "America on Stone" Lithography Collection.

William Sidney Mount, *Farmer Whetting His Scythe*, 1848, oil on canvas, 24 x 20. The Museums at Stony Brook, New York.

stage. They formed a kind of middle road between the overdrawn theatrical types and the polite standard, and as such were gratefully received by those who accepted the premise of the vernacular but did not want to give up the niceties of art. As for Mount himself, he had confidence that he could create an art of his own out of the materials at hand that would be comparable in quality to anything produced abroad. His characters pointedly have their music, dance, and Virgilian pleasures without benefit of European tutelage or city manners. They project the American myth of rural simplicity and goodness.

A necessary complement to rural innocence and goodness was urban sophistication and falseness, and yet within the cities' boundaries there were aspects of fascination. Although principally regarded as places where people take advantage of others and where ostentation takes the place of honest values, the growing cities were nonetheless a source of pride. The Yankee's astonishment at the number of people, the width of the streets, the mixed nature of the population, was laughed at with a sense of superiority. After all, most theatergoers were city people, even though city dwellers represented a small percentage of the population. But there were city types, just as there were country types. The harbors provided seagoing characters and the exciting turmoil that surrounds vessels bound for far places. Street mer-

William Sidney Mount, *Sportsman's Last Visit*, 1835, oil on canvas, 21½ x 17½. The Museums at Stony Brook, New York; Melville Collection.

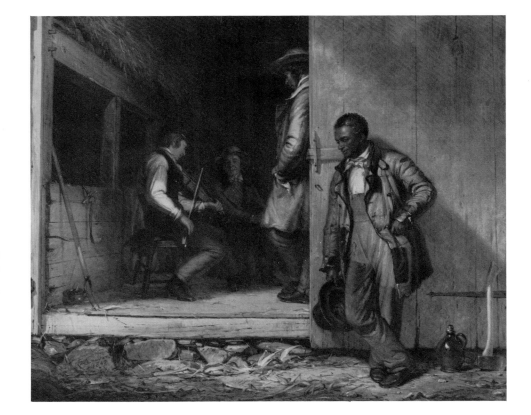

William Sidney Mount, *The Power of Music*, 1847, oil on canvas, 17⅛ x 21. The Century Association, New York, New York.

55

Otis A. Bullard, *Barn Scene in Genesee County*, 1845, oil on canvas, 19⅛ x 25¼. The Parrish Art Museum, Southampton, New York; Littlejohn Fund.

J. Denison Crocker, *Barn Scene*, 1847, oil on canvas, 24⅞ x 29¾. The Brooklyn Museum, New York; Dick S. Ramsay Fund.

56

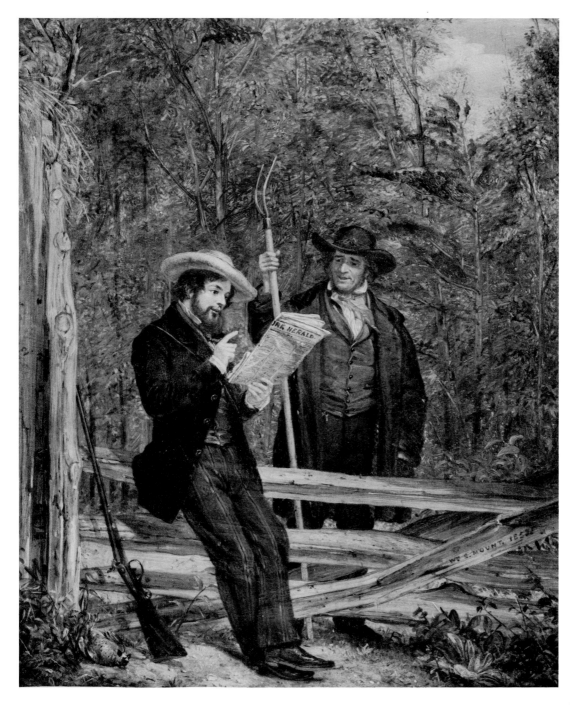

William Sidney Mount, *The Herald in the Country*,
1853, oil on panel, 17 x 13. The Museums at Stony
Brook, New York; Melville Collection.

Frank Blackwell Mayer, *In-dependence, Portrait of Squire Jack Porter*, 1858, oil on paperboard, 12½ x 16. National Collection of Fine Arts; Bequest of Harriet Lane Johnston.

Ernst Georg Fischer, *Country Life*, 1850, oil on canvas, 15 x 20. Maryland Historical Society, Baltimore; Gift of Ruth Katz Strouse.

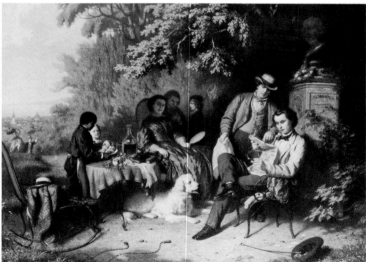

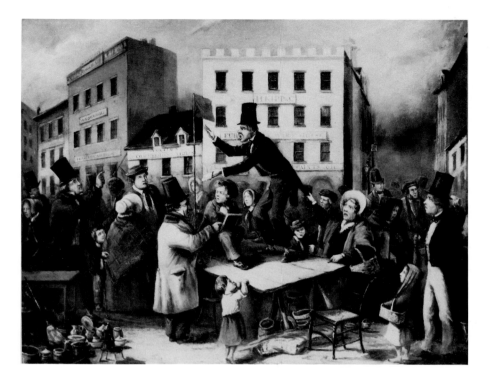

E. Didier, *Auction in Chatham Street*, circa 1840, oil on canvas, 22 x 27½. Museum of the City of New York, New York.

Nicolino Calyo, *Auctioneer in Public Streets*, circa 1840, watercolor on paper, 10⅛ x 14. Museum of the City of New York, New York.

chants hawking their wares often suggested the struggling countryman in the city. Especially characteristic, in referring to the city, was the young man, probably of humble country origin, who cared more for dress and appearances, for the comme il faut, than for anything else other than money. All of these jostle about in Charles Briggs's popular novel of 1839, *The Adventures of Harry Franco, A Tale of the Great Panic*. Although Harry Franco, a young man from the country, falls victim to a whole succession of city evils, the novel nonetheless shows a new fascination with the city as such. Land speculators, flashy salesmen, conniving politicians, scandalous news-

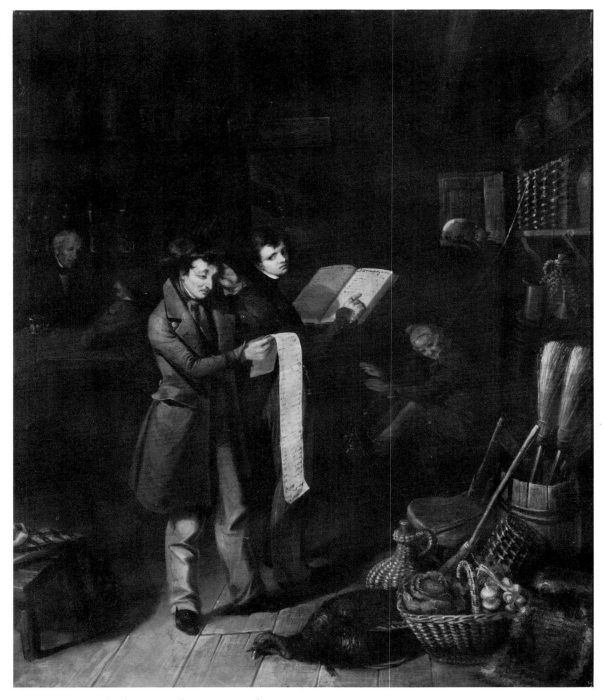

James Henry Beard, *The Long Bill*, circa 1840, oil on
canvas, 30⅜ x 24¾. Cincinnati Art Museum, Ohio;
Gift of Mrs. T. E. Houston.

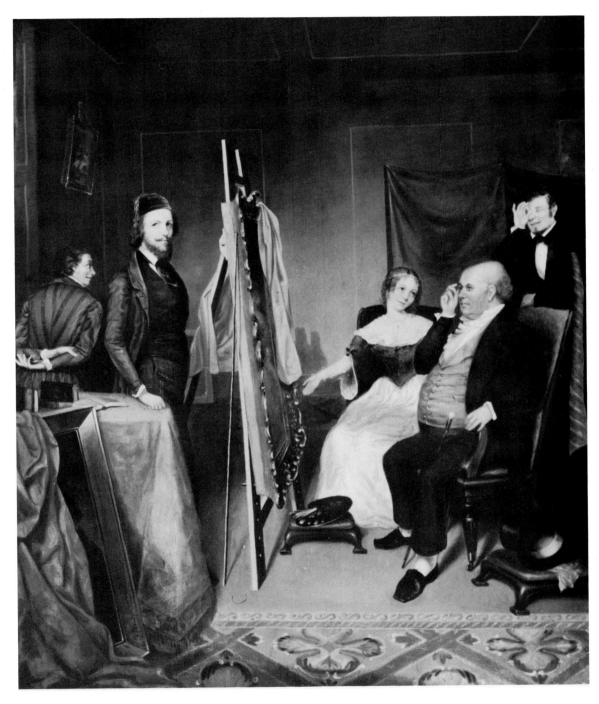

Sanford Thayer, *The Connoisseurs*, 1845, oil on canvas,
30 3/16 x 25¼. Onondaga Historical Association,
Syracuse, New York.

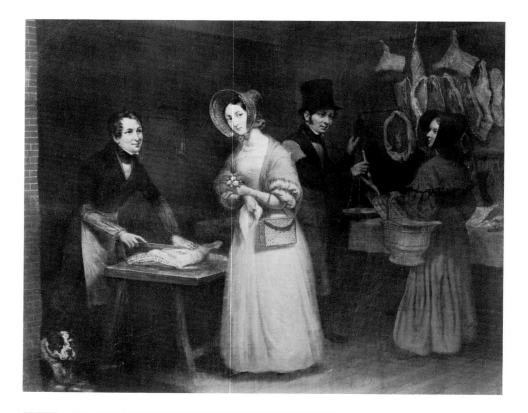

Unidentified Artist, *Interior of a Butcher Shop*, 1837, oil on canvas, 28 x 30¼. The Newark Museum, New Jersey.

Lily Martin Spencer, *The Young Husband: First Marketing*, 1854, oil on canvas, 29 x 24½. Mr. and Mrs. Edward E. Abrahams, New York, New York.

David G. Blythe, *Street Urchins*, oil on canvas, 26½ x 22. The Butler Institute of American Art, Youngstown, Ohio.

62

papers make up a challenging kaleidoscope of activity. It should be noted, however, that once Franco was successful in the city he returned to live in his original hometown.

The city was eventually to have its own representative heroes to take their place in the American repertory along with the rural Yankee and the frontiersman, although they appeared significantly later on the scene. Mose the Bowery Boy, who made his appearance on the stage in New York in 1848, was a product of the city itself, of its hard, competitive, brutalizing life. He countered the stylized vocabulary of the stock Yankee with a new dialect, no less American, to be identified with the new city culture. In this he marked the ascendency of New York, the competitive commercial city, as representative of America.

Mose was one of the city fire fighters like those described by Briggs as taking their heroic position with ostentatious seriousness. These organizations—fraternities, in effect—were closeknit social groups that divided their time between the lavish embellishment of their fire-fighting apparatus and socializing. Some enjoyed a rather elevated social standing; others, like that with which Mose was associated, prided themselves on being rough and ready for anything. The fire-fighting "machine" was the center around which Mose and his gang gathered. "I love that ingine better than my dinner," Mose remarked. It was a good urban symbol, because city fires were a characteristic and major threat to metropolitan existence. Thus established as belonging to the vital life of the city, Mose could be as crude and combative as he liked. He was always "spilin for a muss," and in successive adventures took on other big-city toughs, Indians, and a fair representation of English society. Like most American popular heroes he had at some point to confront Europe directly.

The character of Mose was created by the actor Frank Chanfrau, who, like the "Yankee" actors, became thoroughly identified with the part, which was first introduced in Benjamin A. Baker's *A Glance at New York*. In the beginning the play was intended to look at New York in the way that some writers were looking with fascination at the seamier side of London, with a Dickensian preoccupation with the down-and-out. But Mose took on a life of his own that seemed to his followers strictly American. He became the center of all manner of stage productions, including even an elaborate dream pantomime that combined spectacle and fantasy with the otherwise sordid aspects of the city. He and his friends had an effect on both the American language and the native image, and after his appearance, representations of the city and city types could not be seen in the same complacent way.

What was glorified about the city, then, was not its elegance or monumental impressiveness—although there was a good deal of boasting about size and costliness in the general descriptions—but the fact that it was a defiant center of falseness, trickery, and the survival of the fittest, yet symbolized, ironically, heroic toughness, commercial prosperity, and national progress. The city loved its vices and liked to think that underneath the

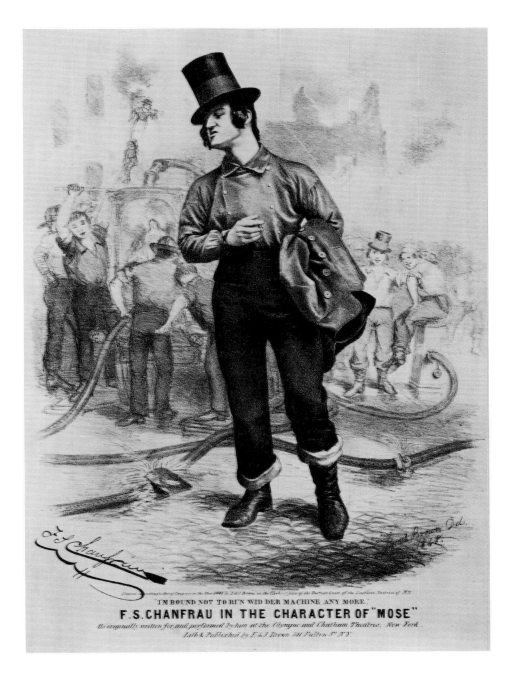

I'M BOUND NOT TO RUN WID DER MACHINE ANY MORE.

F.S. CHANFRAU IN THE CHARACTER OF "MOSE"

As originally written for and performed by him at the Olympic and Chatham Theatres, New York.

Lith & Published by E. & J. Brown 141 Fulton St. N.Y.

Eliphalet M. Brown, Jr., and
J. Brown after James Brown,
F. S. Chanfrau in the Character of "Mose," 1848, lithograph, 12 7/16 x 9 5/16. Library of Congress, Washington, D.C.

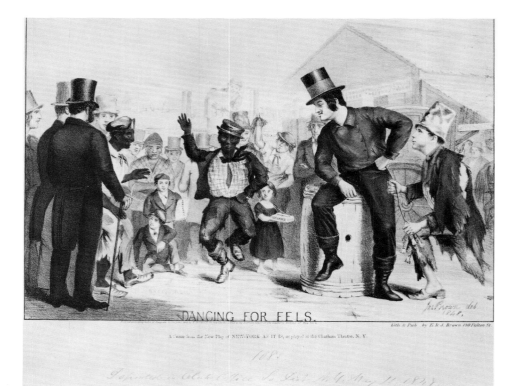

Eliphalet M. Brown, Jr., and J. Brown after James Brown, *"Dancing for Eels," A Scene from the Play NEW YORK AS IT IS, as Played at the Chatham Theatre, New York,* 1848, lithograph, 9¼ x 13⅜. Library of Congress, Washington, D.C.

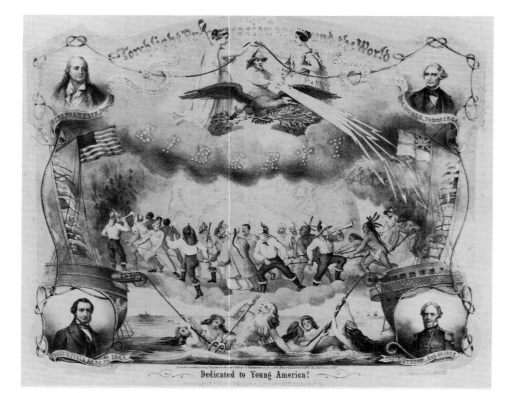

Adam Weingaertner, *Torchlight Procession Around the World,* 1858, lithograph, 14⅛ x 18 3/16. National Museum of History and Technology, Smithsonian Institution; Harry T. Peters "America on Stone" Lithography Collection.

66

James Baillie after John L. Magee, *Mr. F. S. Chanfrau "As Mose" in the New Piece Called "A Glance at New York,"* circa 1848, lithograph, 13 x 6⅞. Library of Congress, Washington, D.C.

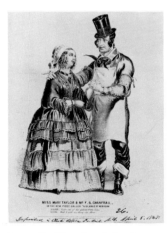

James Baillie after John L. Magee, *Miss Taylor and Mr. F. S. Chanfrau "As Mose" in the New Piece Called "A Glance at New York,"* 1848, lithograph, 11½ x 8. Library of Congress, Washington, D.C.

violence and vulgarity a special virtue was to be found. For all his combativeness, Mose was a defender of helpless women and made a specialty of saving babies from burning buildings.

Charles Briggs, the author of *Harry Franco,* under which name he wrote for some years, was himself a thoroughly urban type who was stimulated by the tempo of commercial expansion in New York, even though he recognized the potential evils. This active environment, he thought, suited the American artist, who had no business, according to his way of thinking, of dreaming of classical utopias or imitating the genteel art of old masters. At one point he attacked Reynolds's *Discourses,* long a kind of Bible to artists, as having been a nefarious influence. "Perhaps no book that ever was published has done more to create false ideas on this subject than Reynolds' discourses." He asserted in 1843 that an artist would profit more from studying a head of cabbage than drawing from a cast of the Apollo Belvedere.

Lurking behind the vernacular concerns, it is evident, was a whole shift in aesthetic principle that could place art in America in a new light. Instead of being a primary means for maintaining the continuity of tradition, it might destroy both the language and imagery of the past to emphasize the characteristic, the new, and the particular. To be sure, no artist or critic supported in the long run the exaggerations of the popular types—there was still a fear of being vulgar—but emphasis on eccentric characteristics and outlandish language was a means of freeing the mind from the bonds of a conventional rhetoric, whether verbal or visual. The exaltation of the local, the "original," the self-created, no matter how vulgar or shocking to European eyes, was an effort to feel culturally independent, to foster a national consciousness quite distinct from that dependent on political institutions and their imagery. "We must be proud of Americanisms, (I do not mean by that, words and phrases, peculiar expressions, but views, and feelings, and criticisms,) if we would be relieved from thraldom, and take the place art is so rapidly taking," said J. T. Headly in 1845, addressing patrons of art in New York. The wider public responded enthusiastically to the effort, for an appreciation of these cultural heroes and the art that gave them being demanded no preparation beyond an acquaintance with contemporary life. A few years later Baudelaire would discuss the peculiar virtues of this kind of newly situated art in his essay on Constantine Guys in *The Painter of Modern Life.* But in America it had a national as well as an aesthetic dimension. The American artist with his eyes turned to the people around him could recreate the history of art from his own environment. He could look upon the European tradition as less a source than a complement.

In 1838 a new kind of institution for the arts was established in New York that eventually became known as the American Art-Union. It was, so one of its defenders said,

. . . an American association, founded on American principles,

Julius Gollmann, *An Evening at the Ark,* 1859, oil on canvas, 38 x 53¾. Western Reserve Historical Society, Cleveland, Ohio.

fashioned by experience after American views, sustained by American patronage; and our aim shall be to promote the permanent and progressive advance of American art. While learning of other climes and other schools, all of good they undoubtedly possess, let us not, with a slavish admiration, submit to what of evil is too often their accompaniment. Truth, the foundation, ay, the very life and lesson of Art, can as well be secured, yes, enchained to our soil, as enslaved amid the tottering ruins of an antiquated world; and here she will find, in future ages, together with all that ennobles humanity, her more congenial home. [Transactions of the American Art-Union, 1848.]

The plan of the American Art-Union (known before 1843 as the Apollo Gallery and the Apollo Association) was to sell memberships to the public and to buy with the money thus raised as many works of art as possible, which would then be distributed by lottery at the end of the year. Although the scheme had already been tried in Europe, its effect on artists and collec-

DISTRIBUTION OF THE AMERICAN ART-UNION PRIZES.

Francis D'Avignon after Tompkins H. Matteson, *Distribution of the American Art Union Prizes*, 1848, lithograph, 16 x 20¾. National Museum of History and Technology, Smithsonian Institution; Harry T. Peters "America on Stone" Lithography Collection.

tors in the United States, where artistic patronage had been rare, was of particular importance. For the first time artists had encouragement to create works of popular appeal. Portraits, obviously, had little place in the Art-Union. Furthermore, those who headed the Art-Union, such as William Cullen Bryant and Prosper Wetmore, were strong supporters of native themes. Wetmore, in addition, had little sympathy for "art language" and was impatient with any suggestion that only artists understood art. He was certainly behind William J. Hoppin's resolution to the group in 1847, which, in answer to complaints from the artists, asserted:

> *It is the quality of the incidents in the story which is to be told on canvas—the humor and the pathos—the grandeur or the beauty of the ideal—the truth to nature of the actions and the characters described— that we should consider in making up our opinions, as much as the mere* language *of the narration, the tones and the tints, the glazing and the scumbling. Of all this a well instructed connoisseur can judge as well as an artist.* [Transactions of the American Art-Union, 1847.]

Although many artists were not at all enthusiastic about this attitude toward their judgment, most responded eagerly to the idea of meeting the demands of a widely distributed public. One such was a painter who divided his attention between art and politics, George Caleb Bingham. He was

[?] Gautier after George Caleb Bingham, *Stump Speaking*, 1856, engraving, 22⅜ x 30¼. National Collection of Fine Arts; Gift of the IBM Corporation.

brought up in Missouri, took an early interest in politics (in which he was not successful), and systematically developed an art that was just as atuned to the public as he wished his political overtures to be. In art he was triumphant, defining the crudities and idiosyncracies of the West in a placid, Poussinesque order, without losing the particularities—the vernacular—that the public seemed eagerly to want. Although criticized by sophisticated observers for mixing artistic modes, being too true for some and not true enough for others, he spoke a language understood by the Art-Union patrons. Furthermore, many of his paintings were intended to be reproduced as engravings, to reach a public even beyond that of the Art-Union subscribers, who by 1848 had reached a number well over 16,000.

A *The Creation of an American Mythology*

t the same time that a consciousness of regional types was developing, with its concern for unconventional language and homely morality, another kind of image was evolving that complemented the mundane vision of the American with a rich background of myth. It was a matter of transporting the center of American historical and legendary image from Europe to the United States. The effort got underway through the creative efforts of Washington Irving, who decided to give the growing, heterogeneous settlement of New York a cultural vision of itself. In the person of the venerable Dietrich Knickerbocker, he published his *History of New York* in 1809. Not content to begin with the Founding Fathers, the fabulous Mr. Knickerbocker took a universal view and initiated his history with a discussion of the creation of the world. Spiraling down from the cosmos, Irving arrived at a beguiling cast of eccentric characters, not much appreciated by some of the old Dutch families, to be sure, whose shades would forever after people the valleys, hills, and harbors of New York. It was a matter of identifying an appealing kind of history, both actual and imaginary, with well-known local places and institutions in a way that was sufficiently persuasive to change people's view of themselves and their otherwise ordinary environment. Dietrich Knickerbocker, with his Dutch antecedents and his total attachment to the mythos of the local scene, took his place with the shrewd New Englander Brother Jonathan as an American spokesman.

With the first publication in 1819 of his *The Sketch Book* (written, interestingly enough, in England), Irving added further to his American mythology. Centering his tales among the Dutch along the Hudson, he produced a memorable cast of folk types: Rip Van Winkle, Ichabod Crane, and the ghostly survivors of Henry Hudson's crew, who bowled in the haunted reaches of the Hudson River valley. There was a new interest in Europe at this moment in traditional folk tales, particularly among the Germans. The brothers Grimm brought out their fairy tales between 1812 and 1815 and the Danish Hans Christian Anderson began to publish his fanciful stories in 1835. With Irving, the United States had its own folk tradition, attached to American places and local people. The immediate and continuing popularity of Irving's characters attests to the eagerness of the public at this moment to find an imaginative inheritance to complement their now legendary military and political past. When Washington Irving returned to the United States in 1832, he was himself almost a folk hero.

Irving's characters quickly were translated into visual form. Several major artists, eager to establish their art as American, depicted scenes from the *History of New York* and *The Sketch Book.* Both Washington Allston

F. O. C. Darley, Frontispiece to *Knickerbocker's History of New York*, 1850, wood engraving, 7⅜ x 5¼. Cooper-Hewitt Museum of Design, Smithsonian Institution, New York, New York.

F. O. C. Darley, Illustration from *Knickerbocker's History of New York*, 1850, wood engraving, 6 9/16 x 4 15/16. Cooper-Hewitt Museum of Design, Smithsonian Institution, New York, New York.

Charles Loring Elliott, *Anthony van Corlear*, 1858, oil on canvas, 12⅛ x 10. Walters Art Gallery, Baltimore, Maryland.

George W. A. Jenkins, *Ichabod Crane and the Headless Horseman*, 1838, oil on canvas, 27¼ x 34. Allston Jenkins, Philadelphia, Pennsylvania.

John Quidor, *Peter Stuyvesant Watching Festivities on the Battery*, circa 1860, oil on canvas, 83½ x 129¾. Raymond Acampora, Darien, Connecticut, and Post Road Antiques, Larchmont, New York.

James Hamilton, *Scene on the Hudson*, 1845, oil on canvas, 37 x 58¼. National Collection of Fine Arts; Museum purchase.

F. O. C. Darley, Illustrations from *Rip Van Winkle*, specially printed for members of the American Art-Union, 1848. Lithographs, 8⅝ x 11¼. Library of the National Collection of Fine Arts and National Portrait Gallery, Smithsonian Institution.

Asher Brown Durand, *Wrath of Peter Stuyvesant*, 1835, oil on canvas, 24¼ x 30¼. The New-York Historical Society, New York.

and Asher Brown Durand tried to catch some of the fantasy of Irving's abundant descriptions, but their artistic training and a chaster vocabulary than Irving's rather undermined their efforts. The only one to develop a visual style comparable to the enthusiastic overstatement of Irving's superbly contrived prose was John Quidor. Beginning in 1828 with his *Ichabod Crane Pursued by the Headless Horseman*, he created an extraordinary series of paintings in which, in a way not unlike Irving, he mixed humor, absurdity, and a lurking terror. The frenzy of the brushstrokes confuses itself with the gestures of the characters to create a tense, agitated atmosphere bordering on madness. As in the reaches of Sleepy Hollow, anything might appear from the shadows of a Quidor painting. He created an ambiance in which the overstressed and fantastic were the expected, a threateningly active natural hyperbole.

A mythology of a different kind was being created by James Fenimore

Cooper. Like Irving brought up in the state of New York and devoted to its history and its natural charms, Cooper saw his landscape peopled not by canny Dutchmen but by the Indian and the hunter. Although Cooper's first-hand acquaintance with Indians was slight, they afforded him the medium through which he could live the life of nature, animating the country around him with historical memories and philosophical revelations. A generation earlier a French painter had said that landscape had little charm unless it contained a tree in which a dryad might dwell or a spring in which a nymph might bathe. Cooper had little interest in dryads and nymphs, yet his forests and prairies were to a degree mythical in the way they spoke of the fabulous existence and the tragic passing of a noble race. They were instinct with a believable but exotic way of life. To a reader of Cooper, any forest might seem the haunt of the Deerslayer, and a secluded woodland stream might hold the suggestion that Natty Bumppo could have passed that way.

Cooper's *The Spy,* set at the time of the American Revolution, was published in 1821; *The Pioneers,* with its vivid description of pioneer life, in 1823. *The Last of the Mohicans* came out in 1826. The popularity of his novels, which he continued to produce through the 1840s, was worldwide, creating a magical window through which Americans and Europeans alike could view the American landscape and the country's past. As accurate as he tried to be in the details of his novels, Cooper was not recording history so much as building a present, since it was his generation that first felt the need to discover or create deep mythical roots in their own land. For all we know, the early pioneers did not think like Natty Bumppo or Leatherstocking, or respond as they did to the freshness and beauty of unspoiled nature, nor possibly did the Indian see his lands in the way so persuasively described by Cooper. But this is of little point. The Americans of the 1820s and '30s and for many years to come saw their land enriched by these thoughts and were a different people because of them. Nor did the success of Cooper abroad hurt the impact of his work at home; it is reported that by 1833 each new novel was published simultaneously in thirty-four European cities. This helped to justify and deepen in the eyes of the local public the new image of their land.

Cooper's characters are not at all those of the Down-East Yankee or the city brawler. In Cooper's novels the Americans emerge as basically honest and good-hearted. They work hard and help each other. It would be hard to reconcile them with the city types in Harry Franco or the people encountered by Mrs. Trollope, who saw America without the benefit of local mythology. But his were people of the woods and the frontier, and usually of an earlier generation. For all their action, Cooper's novels provoke a nostalgia that might be considered precocious, given the new land yet to be explored. It seems not to have been too soon, however, to talk of the old days as bearing the quintessence of America. Cooper was viewing the country from a highly sophisticated, urbane point of view that had little to do with the actual life

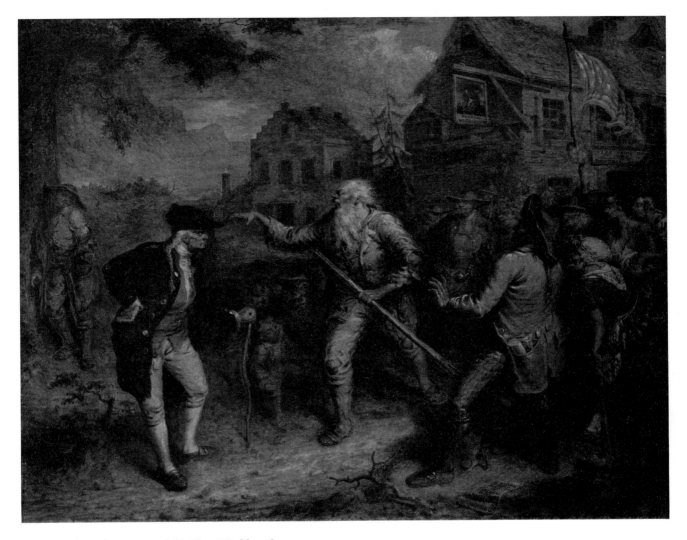

John Quidor, *The Return of Rip Van Winkle*, oil on canvas, 39¼ x 49¾. National Gallery of Art, Washington, D.C.; Andrew Mellon Collection, 1942.

Thomas Cole, Scene from
The Last of the Mohicans,
circa 1827, oil on canvas, 25 x
35. New York State Historical
Association, Cooperstown.

F. O. C. Darley, Frontispiece
to *The Pathfinder*, 1860,
engraving. Courtesy George
Peabody Division, Enoch
Pratt Free Library, Baltimore,
Maryland.

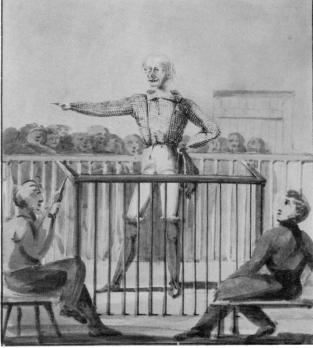

John H. B. Latrobe, *Pionneers* [sic]: *Leatherstocking on the Chace*, watercolor on paper, 9¾ x 8⅝. Maryland Historical Society, Baltimore.

John H. B. Latrobe, *Sketch: Leatherstocking in Court, defending himself, Pionneers* [sic], watercolor on paper, 9¾ x 8⅝. Maryland Historical Society, Baltimore.

on the frontier. When he wrote *The Prairie,* which takes place on the Great Plains, he had not been to the West. It is just as well. Although it was criticized by those who knew the land, it was an accurate evocation of what eastern America—and Europe too—wanted to feel about the western movement.

Partially in imitation of Cooper, authors in various parts of the country began to look at their surroundings in terms of past exploits, to give a legendary existence to the close at hand. In particular, William Gilmore Simms of South Carolina, who published his *The Partisan* and *The Yamassee* in 1835 and his best-known work, *Woodcraft,* in 1852, had an extensive following, possibly even larger in Europe than in the United States. Some writers concentrated on the more recent or contemporary scene. Augustus Baldwin Longstreet's *Georgia Scenes* of 1835, although it does not emphasize dialect, dwells with irony but affection on local types and manners. There was hardly an area that did not begin to look at itself as having a special character, if not a particular virtue. Not the least favorite subject of regional authors was the law court. With the settling and distribution of the lands in western Tennessee and beyond, and the frantic land speculation—described with no admiration at all by Charles Dickens in *Martin Chuzzlewit*—lawyers and judges had a busy time. The endless argument, which seems to have been a mixture of horse-trading technique and an incongruous but high-minded application of classical law, provided a rich load of stories for writers and painters alike.

John Quidor, *Leatherstocking Meets the Law*, 1832, oil on canvas, 27½ x 34¼. New York State Historical Association, Cooperstown.

F. O. C. Darley, *"Lay Down the Piece,"* illustration for *The Prairie*, pencil and brown wash on board, 19½ x 15½. Museum of Fine Arts, Boston, Massachusetts; M. and M. Karolik Collection.

Christian Mayr, *Kitchen Ball at White Sulphur Springs*, 1838, oil on canvas, 24 x 29½. North Carolina Museum of Art, Raleigh.

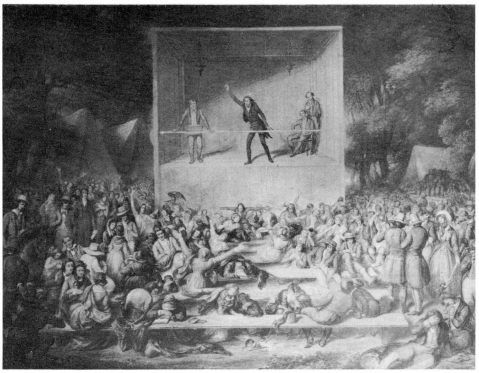

J. Maze Burbank, *Religious Camp Meeting*, 1839, watercolor on paper, 27 x 27. New Bedford Whaling Museum, Massachusetts.

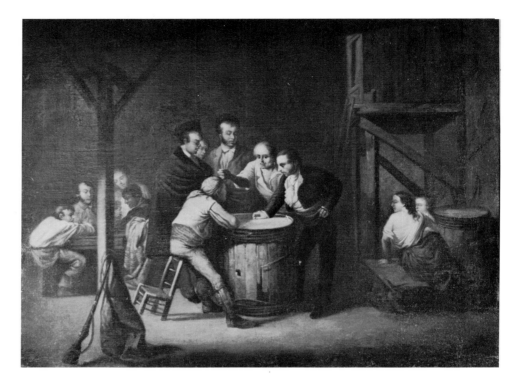

Unidentified Artist, *Gambling Scene*, oil on canvas, 27 x 35. Mr. and Mrs. W. E. Groves, New Orleans, Louisiana.

Totally different from the highly literary mythology of America developing principally in the East was a far more rough-and-ready strain that had its origins on the contemporary frontier itself. It was at once capitalized on by eastern writers and publishers—to say nothing of political organizations—but it carried with it none of the nostalgia and philosophical wonder of Cooper, nor the subtle style and humor of Irving. Daniel Boone had been considered nature's gentleman, an image recognized in Europe and America, memorialized in Cooper's Natty Bumppo. No one could call such as Mike Fink a gentleman in anything like conventional terms, and nature for Fink was simply something to be contended with.

By the early 1820s the name of Mike Fink became associated with the fabulous life of the riverboatmen on the Mississippi—fabulous as distinct from the drudgery that the river life must actually have entailed. First mentioned in the complicated comedy by Alphonso Wetmore, *The Pedlar*, produced in St. Louis in 1821, Mike personified the "half-horse, half-alligator" character attributed to the burly men who guided the keelboats up and down the Mississippi. Born in Fort Pitt around 1770, Fink joined the riverboatmen after a career as an Indian fighter. He soon became well known up and down the river as a brawler, marksman, and trickster. "I'm a regular tornado, tough as a hickory withe, long winded as a nor' wester. I can strike a blow like a falling tree, and every lick makes a gap in the crowd that lets in an acre of sunshine." So he was supposed to have described himself. The lan-

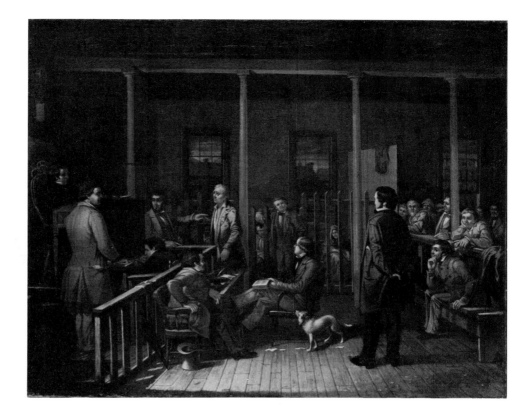

William J. Brickey, Untitled
[Courtroom Scene], 1852, oil
on canvas, 29⅛ x 36. Na-
tional Collection of Fine
Arts; Museum purchase.

Unidentified Artist, *Mike
Fink the Ohio Boatman*,
woodcut. From *Davy
Crockett's Almanack*, 1838.

guage attributed to Mike Fink was rich in surprising and heroic similes and
produced a kind of rude poetry. Filled with imaginative imagery, it was all
nonetheless derived from familiar instances and the local scene.

Although keelboats stopped plying the Mississippi shortly after the in-
troduction of steamboats in 1815, the legend of Mike Fink grew, particularly
after his death in 1823. His habit of taking the law into his own hands,
winning every contest by sheer force or trickery, and boasting a strength
that defied all ravages of alcohol or natural disaster, made him a popular
hero in the minds of those who were restive with the restraints of organized
society and were pleased to think of the American as a bullish, hardy type
whose sense of freedom made him the conqueror of all.

It is not surprising that the legends of Mike Fink should turn up in the
Davy Crockett almanacs that began appearing in the 1830s. He shared with
the Crockett legend the original spectacular language associated with the
mythology of the West and the physical strength and rebellious nature that
characterized the frontier hero. There was, of course, quite a difference be-
tween Davy Crockett of the almanacs and David Crockett, frontiersman and
United States senator, but the image and the reality became confused even
in Crockett's own lifetime. Like Brother Jonathan, Jack Downing, and
Mose, Crockett's language marked him as a self-educated man and, as with

Unidentified Artist, *Horn Boat on the Upper Mississippi*, oil on canvas, 36 x 50. Mr. and Mrs. W. E. Groves, New Orleans, Louisiana.

them, his want of book learning gave popular authority to his statements. Born in Tennessee in 1786, Crockett was a free spirit who kept moving westward to escape the encroachments of the growing settlements, and according to his own accounts, published in his autobiography in 1834, he was blessed with prodigious strength and an uncanny know-how in taming the rough environment. His specialty was hunting black bears, and if his accounts are to be believed he contributed much to the decline of that species in the state. In 1821 he was elected to the legislature of Tennessee, and the stories of his backwoods electioneering are a part of the legend that met the public fancy. He was an ardent supporter of the rights of settlers in western Tennessee and became identified with the defense of the humble homesteader against the inroads of eastern land speculators. Although publicly he was able to effect little good directly, his character became a symbol for the honest, canny, and usually embattled frontiersman.

By the mid-1830s Crockett had practically lost possession of his own name; his image was public property. In a period devoted to the pursuit of folk heroes and a native mythology, the exploits attributed to Crockett be-

Unidentified Artist, *Friends: Man and Bear (Old Grizzly Adams)*, circa 1860, oil on canvas, 17 x 12. Heritage Plantation of Sandwich, Massachusetts.

came the possession of every man and his fabulous existence a part of the American consciousness. Although many of the publications that came out under his name had a deliberate political purpose—he had begun as a staunch supporter of Jackson, then turned against him with such vehemence that he was content to be identified with the Whigs—those that most appealed to the public at large concentrated on the mythic exploits of the frontiersman.

In 1831 James Kirke Paulding's play *Lion of the West* was produced in New York with James H. Hackett, who had made his name as a "Yankee" actor, in the role of Nimrod Wildfire. Although the play was preceded by a careful exchange of letters denying that Crockett was the model for the principal character, the New York public decided otherwise. At one performance, Crockett attended and the two Crocketts—the myth and the reality—were both hailed by the public. Hackett was a great success and trouped for some years as Wildfire. That the legend, however, was more

87

Unidentified Artist, *View of
Col. Crockett's Residence in
West Tennesssee*, woodcut.
From *Davy Crockett's
Almanack*, 1835.

Unidentified Artist, "A Boy Killed by a Wild Cat," woodcut. From *Davy Crockett's Almanack*, 1838.

Unidentified Artist, "Zip Spooner's Encounter with a Black Bear," woodcut. From *Davy Crockett's Almanack*, 1836.

Unidentified Artist, *A Woman Rescued from the Jaws of a Catamount and Fangs of a Serpent*, woodcut. From *Davy Crockett's Almanack*, 1838.

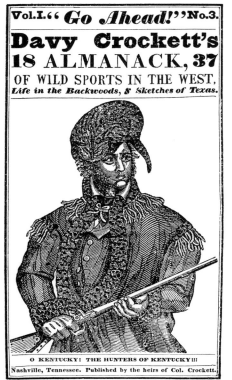

Unidentified Artist, Davy
Crockett, woodcut. From
Davy Crockett's Almanack,
1837.

real the farther it was from the source (Hackett played the part also in England) is suggested by the report of an observer in the West that Hackett's performance was such "as to excite a strong feeling" against the actor; indeed, it "so incensed the 'half-horse, half-aligator [sic] boys' "—known to one another as "the yellow flowers of the forest"—that "they threatened to row him up 'Salt river' if he ventured a repetition of the objectionable performance." (Amos L. Herold, *James Kirke Paulding, Versatile American,* 1926.) Nonetheless, a woodcut of Hackett dressed for his role in coonskin cap and fringed coat was often confused as a portrait of Davy Crockett, and it is Hackett's image that has remained as the true Davy.

Thus, on the cover of *Davy Crockett's Almanack of Wild Sports in the West,* published in Nashville in 1837, it is Hackett's likeness as Wildfire that appears, not that of Davy Crockett. The Crockett almanacs had little to do with the historical man. Although the first issue, published in 1835, was brought out while Crockett was still alive, it is doubtful if he was even consulted in the matter. But they represent the legend, not the man, and in them the fabulous verbal imagery finally took visual form.

In various ways in the years between 1820 and 1860 the "American cousin" took on identity both in the eyes of Europeans and, of more importance, in the eyes of a broad American public. The heterogeneous cast of characters, whether regional stereotypes or legendary heroes, have certain traits in common. For one thing, they all eschew a standard language and defiantly prefer their own formulation of ideas. They speak in a semblance of some local dialect, from New England, New York, or the West. This is less true in the cultivated tales of Irving and Cooper, who formulated American myths in the best English literary tradition; nonetheless, if the principal characters do not actually speak in recognizable vernacular, their manners set them apart as belonging to a special cultural group. Most of the characters have little schooling but are "self-made" men, inventing themselves as they invent their language. The New Englander and the Westerner both go out of their way to do and say things in an unconventional fashion, yet out of their perversity and self-conscious originality there emerged a new series of conventions, in their way no less restrictive than the established ones. Much that has persisted as "typically American" was formulated in this quarter of the century and wholeheartedly embraced by many who were in search of an operational myth on which to base a distinctly American culture. This could go so far as to decree that anything that did not follow the pattern of the colloquial and the self-made was simply not American.

The share that the pictorial arts had in creating the image of America may seem quite subordinate to that borne by literature and the theater, and in a strict sense it was. The style of discourse and the character descriptions were vivid beyond the accustomed scope of most American painters and sculptors. Brought up on the heady idealism of academic theory and taught to draw people by studying casts of antique statuary, they were ill-equipped

Unidentified Artist, *Possum Up a Gum Tree*, woodcut. From *Davy Crockett's Almanack*, 1835.

Unidentified Artist, "*A
Tongariferous Fight with an
Alligator*," woodcut. From
Davy Crockett's Almanack,
1837.

Unidentified Artist, "*A
Narrow Escape from a
Snake*," woodcut. From *Davy
Crockett's Almanack*, 1838.

Unidentified Artist, "A Desperate Fight Between Two Women, One Man, and Two Bears," woodcut. From *Davy Crockett's Almanack*, 1838.

Unidentified Artist, "Fatal Bear Fight on the Banks of the Arkansaw," woodcut. From *Davy Crockett's Almanack*, 1837.

to catch the flavor of the vernacular style. The visual impact was made less through the elevated arts of painting and sculpture than through illustration and prints. These formed the real pictorial galleries for most Americans, and in their own way helped to formulate the point of view from which the more formal arts were likely to be seen. In fact, the expansion of book illustration and the issuance of popularly priced lithographs and engravings coincided with the growth of the self-consciously American image. On several levels the American cousin was the basis for a popular art.

Unidentified Artist, "An Alligator Choked to Death," woodcut. From *Davy Crockett's Almanack*, 1836.

The Virtue of American Nature

The Virtue of American Nature

Over and over the muse of America has been moved to exhort, "Bring me men to match my mountains." This has not been simply poetic indulgence in a persuasive series of alliterations, but the expression of a long-held belief that would associate human character with the natural landscape in which it developed. Why men and mountains instead of men and lakes or rivers? There is an implied assumption that mountains are strong, steadfast, and somehow superior to the plains they dominate. Quite unrelated to one's knowledge of their geological formation or their mineral potentialities, the response to their form and size, their "towering" character as they are "lost" in the clouds, seems to be deeply rooted in human emotion. Curiously enough, the mountain is one of the few natural phenomena that man takes pride in "conquering," as if in scaling a peak the climber absorbed into himself some of the virtues for which mountains have stood.

There have been many theories put forth about man's relationship to his natural environment, and unspoiled nature has been defended in many different ways. A paradoxical situation arises from the fact that as humankind has tamed the wilderness, man has progressively extolled the virtues of the wild as if to recognize that civilization was but the truncating of natural life, that to modify nature was to destroy in it those very qualities that man could not himself generate. As a result, there has been an element of the desperate in the arguments of those who recognize the importance of the perception of nature—or, more strongly, the possibility of identifying with nature—for the spiritual and creative life of man. In many ways the defense of nature has often taken on religious and moral overtones as well as a note of patriotism.

The English gentleman in the mid-eighteenth century began to tour through the countryside, in his own country and on the continent, to look for those views that would have the greatest impact on the mind. Initially he was spurred less by nature than by art. At least it was from discussions of art that he drew his vocabulary and his classifications, and he looked in nature for those combinations of forms that would fit one or another of the

Salvator Rosa, *The Finding of Moses*, 1662-73, oil on canvas, 48½ x 79¾. Detroit Institute of Arts, Michigan; Gift of Mr. and Mrs. Edgar B. Whitcomb.

modes of expression provided by well-known painterly examples from the past. It was as if the paintings of Salvator Rosa or Claude Lorrain had taught nature to be philosophical. The jagged, unfinished forms of Rosa spoke of the power and descriptive change that nature manifests in its most intractable moments, sublimely surpassing the control or rational comprehension of man. Lost in this violent struggle beyond himself, man could recognize his humility before God. The appearance of wild nature was a primary source for this experience of the sublime, a term to be conjured with, and its power increased to the extent that the evidence of man's domination of his environment was absent.

By way of contrast, Claude Lorrain's paintings proved that nature could smile on man and make him feel, if not the master, at least a welcome part of a well-ordered natural world. Claude's open vistas, clumps of trees that had grown without need to struggle, and clear untroubled light, produced that sense of uninterrupted harmony and spiritual calm that man has traditionally associated with the term "beauty."

So the gentleman on his trips could seek out the terror of the sublime, secure in the realization that nature at another moment would reassure him of the underlying harmony of the beautiful. In this way nature was, according to the thoughts of some, not only the exerciser of the emotions but the philosophical mentor who taught man both the terror of his mortal destiny and the promise of human fulfillment and ultimate salvation.

In this moral lesson there was eventually place for a less dramatic mode. As some observed, simply looking at the unexpected and unpredictable complexities of nature had its own reward, not associable with either the sublime or the beautiful. The mind was moved to wonder, to investigate, and sometimes to reminisce, finding satisfaction in the unguided

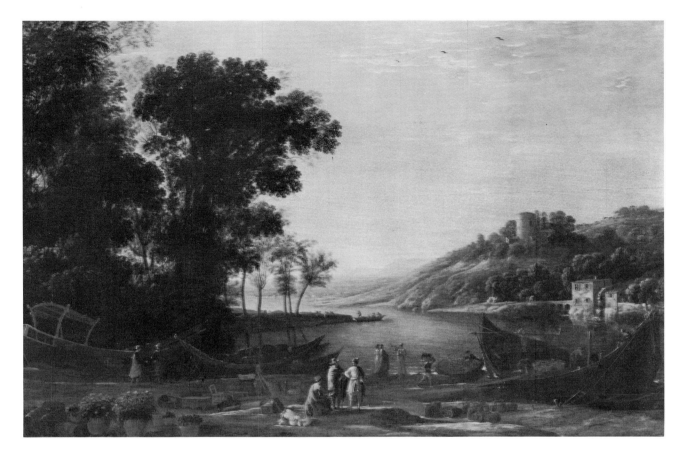

Claude Lorrain, *Landscape
with Merchants*, circa 1635,
oil on canvas, 38¼ x 56½.
National Gallery of Art,
Washington, D.C.

nature of its wanderings. Uncommitted to any particular emotional state, the tangled scene of nature was simply to be regarded as picturesque—as fascinating to the mind as a suggestive but unconfining, possibly unfinished, painting.

This language of modes, so firmly developed by the late eighteenth century, was useful to Americans in discovering values in their own landscape once they began to look around them. The sublime aspect of Niagara Falls was early recognized, and their importance was such that the falls figure in many of the early symbolic representations of America. Their tremendous size and power were regularly described in highly emotional terms, and a visit to the falls was regarded as something akin to a religious experience. The rather quick commercialization of the falls as a tourist haunt was looked upon as a defamation, and frivolous behavior about them was frowned upon as being in bad taste. Europe could boast of no cataract quite so sublime as Niagara, and every European visitor had to make a trip to be bathed in the spray.

To learn to read the landscape of America in spiritual terms, however, was to take time. European visitors, in fact, not concerned with the physical problems of creating a productive livelihood in a new land, were initially

Alvan Fisher, *Niagara Falls*, 1820, oil on canvas, 34¼ x 48⅛. National Collection of Fine Arts; Museum purchase.

more appreciative of the particularly rugged aspects of American nature than were the local inhabitants. In 1809 the editor of *The Port Folio* in Philadelphia published a modest engraving of *Buttermilk Falls* with the note:

> *It is our intention to devote a plate in each number of the Port Folio to the description of American scenery. To the pencil our country affords an inexhaustible abundance, which, for picturesque effect, cannot be surpassed in any part of the old world. We invite the artist and the amateur to furnish us with sketches and accompanying descriptions.*

To judge from the modest views published in later issues of the magazine, he was not flooded with examples of the sublime, although some are doubtless picturesque. Niagara remained the prime example of American landscape virtue, and it was to Niagara that almost every artist with leanings in the direction of landscape painting went. To be sure, there were other cascades—the Great Falls of the Potomac and Trenton Falls, for example—

George Murray, *Buttermilk Falls*, 1809, engraving. From *The Port Folio* n.s. 1 (1809).

but for some years it was only Niagara that could hold its place in the international hierarchy of the sublime. America initially could recognize no mountains of her own to match her men.

As Americans took the grand tour of Europe, they followed the repertory of sublime and picturesque experiences, never failing to remark on the awesome majesty of the Alps, noble Soracte, and the melancholy voice of history to be heard whispering in the Roman campagna. When one spoke of lakes they were Lake Nemmi or Como; of rivers it was the Rhine with its castles and steep gorges. The Bay of Naples reflecting the brilliant sun was the common image of dazzling, hopeful natural beauty, enhanced when seen from Capodimonte or from the grotto of the Posilipo. The value of these views was sanctioned by an extensive literature; they had the overtones of history to enhance the site and a ready-made vocabulary for describing their effects. Washington Allston, in his early landscapes painted in Italy between 1804 and 1808, skillfully combined the Alps, Roman pines, and campagna vistas in the most approved international fashion. He was hailed in Rome as a major young landscape painter who provided not a record of place but a well-balanced presentation of experiences in nature. One wandered through his paintings as if exploring the expressive range of nature itself. Almost a generation later, George Loring Brown became so noted for his idyllic Italian views, following for the most part the mode of the beautiful, that he was known as "Claude" Brown. Both Allston and Brown painted some scenes in America, but especially in the case of Allston, it is not always easy to recognize the scenery as local. For them and many

Unidentified Artist, *Upper Falls of Solomon's Creek*, 1809, engraving. From *The Port Folio* n.s. 2 (1809).

others, landscape, and nature in general, were to be thought of in accordance with the universal principles of human response, so convincingly detailed by the English theorist Archibald Alison, rather than as specific personal encounters with a familiar locale.

It is not unnatural that travelers returning—or those who had only made the journey through books and prints—should be disappointed not to find a match for the great European models on viewing the landscape of the United States. Nature here was crude and new, with little to commend it as humanly significant. It took the writings of the well-traveled Washington Irving and James Fenimore Cooper to people the American countryside with legend and appealing history, and the nature poetry of young William Cullen Bryant to stimulate Americans to look upon their own surroundings as a source of artistic experience and spiritual learning.

Bryant's famous poem "Thanatopsis," written when he was sixteen, was published in 1817, eight years after Irving's *History of New York* and four years before Cooper's *The Spy*. It was not Bryant's principal role to invest American scenery with incident and a memorable cast of characters, as did Irving and Cooper, although some of his later poems did just that. Following the eighteenth-century tradition, he found in the American wilderness a healing lesson for the soul. Moved by seasonal change, the vision of decay

Washington Allston, *Italian Landscape*, 1805-08?, oil on canvas, 39 x 51. Addison Gallery of American Art, Phillips Academy, Andover, Massachusetts.

George Loring Brown, *Italian Scenery*, 1846, oil on canvas, 40⅞ x 54¼. National Collection of Fine Arts; Museum purchase.

and continual rebirth afforded by nature, he could accept the fact of human mortality with equanimity:

> To him who in the love of Nature holds
> Communion with her visible forms, she speaks
> A various language; for his gayer hours
> She has a voice of gladness, and a smile
> And eloquence of beauty, and she glides
> Into his darker musings, with a mild
> And healing sympathy, that steals away
> Their sharpness, ere he is aware.

In a much-quoted line he admonished:

> Go forth, under the open sky, and list
> To Nature's teachings. . . .

Although there is nothing in these youthful statements from "Thanatopsis" that would of necessity change the existing generalized attitude toward nature, Bryant made it clear in his poetry that, with all due respect to favorite European scenes, he was talking about the untouched nature of America. Cooper-like, he could be nostalgic about a vanishing race that left its shades to enrich the natural experience, but the most significant aspect of his writing was his deistic apprehension of God in the natural fact. Every leaf, every tree in its unmutilated state presented evidence of God's hand. In nature God was everywhere. In his "Forest Hymn," in which he asserts "The groves were God's first temples," he goes on to address the Deity:

> These dim vaults,
> These winding aisles, of human pomp or pride
> Report not. No fantastic carvings show
> The boast of our vain race to change the form
> Of thy fair works. But thou art here—thou fill'st
> The solitude. Thou art in the soft winds
> That run along the summit of these trees
> In music; thou art in the cooler breath
> That from the inmost darkness of the place
> Comes, scarcely felt; . . .

● ● ●

> Be it ours to meditate,
> In these calm shades thy milder majesty,
> And to the beautiful order of thy works
> Learn to conform the order of our lives.

Bryant in no sense disparaged the well-known European scenes, but, said he in a much-quoted sonnet addressed to the painter Thomas Cole on his going to Europe in 1829, fair as these scenes may be, one finds "everywhere the trace of men." America he liked to think of as

Lone lakes—savannas where the bison roves—
Rocks rich with summer garlands—solemn streams—
Skies where the desert eagle wheels and screams—
Spring bloom and autumn blaze of boundless groves.

Out of such an attitude could be distilled a theory that American nature might very well be spiritually superior to that of Europe, since it offered so many vistas untouched by man. Quite nicely, traditional values that would require some hint of the existence of man for a landscape to have a requisite historical sense, a meaningful content, were exactly reversed: the hint of man obscured the image of God in nature and thus hindered pure spiritual communication. If this were accepted as true, it could be argued that Americans had a more potent force for high thinking and development than the Old World. An artist confronting European climes and cultures, then, should, as Bryant admonishes Cole, "keep that earlier, wilder image bright." The image of American nature could be a corrective to the human-conscious (as opposed to God-conscious) art and landscape of Europe.

Although Bryant and those who thought in a similar direction did not proclaim this view outright, it was an underlying theme that seems to have been taken for granted by many. Art itself was suspect in many quarters, and European art with its nudity and sensuous excesses was often remarked upon as totally unacceptable to American morality and purity of thought. Already by the 1820s it was considered risky to send American artists abroad to study, since they might be led into vicious habits of life as well as misguided directions in art. In popular literature, Europeans, especially Frenchmen and Italians, were regularly shown as affected and mannered, serving in such decorative positions in society as dancing masters or pastry cooks. A belief in the virtues of wild nature was not only a means of freedom from these unpalatable models but served as the basis for a competitive self-righteousness. It was popular to think that Europe was in a state of some decay and that the roots of the future were deeply imbedded in the virgin soil of America. With increasing frequency through the 1830s, orators suggested that the destiny of the human race lay in the hands of the inhabitants of the New World.

The idea that art and culture should repeatedly begin anew, throwing off all traces of immediate tradition, was not peculiar to the United States at this moment. In fact, it may have been looked upon with more suspicion here than abroad since the links with established traditions were at times tenuous in the newer culture and many struggled hard to maintain them. The self-consciously naïve theories of European purism, beginning at the onset of the century in France and Germany, developing in Italy and moving finally as well to England, insisted that each generation—and by extension each artist—must begin again for itself, starting as children to confront the world. Traditional achievement was there to be respected and even to

Thomas Cole, *In the Cats-
kills*, 1827, oil on canvas,
18⅝ x 27 7/16. Arnot Art
Museum, Elmira, New York.

serve as a model, but it could never stand in lieu of native experience. For
the artist this meant, of course, that he must begin directly from nature,
which was the great constant. Blessed was he who had not been trained in
the schools since he had fewer false conceptions standing between himself
and truth.

There is little evidence to indicate that the niceties of this theory
spread to the United States until well on in the century, but the attitude
was natural for artists with more nature at hand than masterpieces of art.
The word "naïve" would have been received with defensive misgivings in
America, and yet it was a belief in the virtue of naïveté that sustained the
American argument for moral primacy. "The lover of nature," wrote Emer-
son, "is he whose inward and outward senses are still truly adjusted to each
other; who has retained the spirit of infancy even into the era of manhood."
[*Nature,* 1836.]

In the 1820s the high moral notions about America and the natural
environment began to coalesce and make sense to the artist in terms of his
home surroundings. Townscapes and topographical views gave way to the

poetic reassessments of the local scene. The initial stimulus was not a belief in a kind of spiritual geology such as that of Goethe or Carus, nor in the "natural philosophy" of Constable. It was, instead, a desire to realize in views of the American landscape the spiritual content that, one assumed from readings in English theory, landscape could provide; to celebrate in pictorial terms the moral impact of the natural bounty of the new land. So at about the time that Constable and other English painters were stirring the artists in France and just a few years before Théodore Rousseau went off to paint the mountains in Auvergne, Thomas Cole began to explore the Hudson and the vistas of the Catskills.

Thomas Cole, when he began to study nature in the Catskills in 1825-26, was not creating a new art. Rather, he was discovering in American scenery the power he had learned to expect from traditional attitudes toward landscapes. In a way, he was recreating a drama of nature that his European colleagues had, for the most part, given up, but with a very significant difference. He was historiating an environment that never before had belonged to art. Furthermore, he was carried along by a passion borne jointly by religious conviction and a pent-up desire for personal expression. Nature would be the study that could break the molds of hieratic strictures based on past art. In his forays through the countryside, Cole made detailed notes and sketches; he observed natural phenomena with a sharp and analytical eye. But this was not an end in itself. It was, rather, a method that served

Thomas Cole, *Landscape,* oil on canvas, 37½ x 47½. Private collection.

to expand his expressive vocabulary, a vocabulary he needed to feel was his own, because Cole was concerned with the education of the soul through a visual impact on the emotions, not in a simple recording of the natural fact. He in no sense turned his back on the high purposes of art, extolled in the abstract by orators on every occasion, but wished to rediscover these qualities for himself and his contemporaries in the characteristically wild American nature.

Quickly acclaimed by those who understood his purposes—although rejected by critics who were offended by his lack of restraint and unabashed enthusiasm—Cole, with persuasive pictorial vigor, succeeded in identifying the actual scenery of the countryside with a spiritual content acceptable to the most avid advocates of high moral purpose in art. Landscape, which in Sir Joshua Reynolds's well-studied hierarchy of values rated low, was to become the major expression, the highest category, for the American artist. As the painter Asher Brown Durand said in memorializing Cole, "He has advanced far beyond the point at which he found it [landscape art] among us, and more than this, he has demonstrated its high moral capabilities, which had hitherto been at best but capriciously exerted." [Letter to Maria Cole, February 18, 1848, New-York Historical Society, Thomas Cole Papers.]

Cole was not a mystic in the sense of Blake or Runge. His religious and moral thinking were quite orthodox by American standards, but his orthodoxy had to be proved through his own experience. Where better could he find himself than in the trackless wilderness? There, with nothing to fall back on but his own perceptions, the artist was forced to react anew, to question his every observation and response. Faced with a formal complexity well beyond the provocative ink blots created by Alexander Cozens a generation before to stir the creative mind, the wilderness painter was thrust back into a state of naïveté that he came to value as a means for spiritual refreshment, a process of spiritual and artistic rebirth. "The painter of American scenery," said Cole, "has indeed privileges superior to any other: all nature here is new to art."

Cole's method in giving content to his natural scenes was generally to dramatize the interplay of closely observed natural forms, opposing strongly emphasized lights and darks and struggling, jagged shapes. His procedure, in other words, was still based in a general way on the associational assumptions underlying the landscape modes of the late eighteenth century. The persistence of this natural vocabulary of form in the United States is quite remarkable. When A. J. Downing published his widely circulated books on landscape gardening and rural architecture, beginning in 1841, he still had recourse to the explanations of the beautiful and the picturesque laid down by Payne Knight. But the landscape painters who joined Cole in going to the Hudson River, the Catskills, and other picturesque sites, although thoroughly in agreement with Cole's new-found spiritual content, were less inclined to engage in Cole's histrionic constructions. Rather than participate in the expressive action of nature, they preferred to contemplate, to

Unidentified Artist, *Family Outing*, watercolor and pencil on paper, 23⅝ x 29⅝. Museum of Fine Arts, Boston, Massachusetts; M. and M. Karolik Collection.

Thomas Doughty, *The Anglers*, 1834, oil on canvas, 27¼ x 34½. The Parrish Art Museum, Southampton, New York; Littlejohn Collection.

109

lose themselves in an endless and impersonal vision. Form-language discovered in nature gave way to a nature-language that purported to have little to do with form as such. Asher Brown Durand, a close friend of Cole's and a devoted follower, took his belief in nature's goodness quite literally and did not presume to use nature for his own expression. He did not for a moment believe that every scene and each object of nature had merit for art, but once an artist discovered a situation in nature that was spiritually moving, he believed he should paint it with the utmost fidelity. What moved Durand and others of his generation was much more serene than that which Cole seized upon. They tended to prefer either the seemingly endless sweep of luminous space or the confounding complexity of a forest glade. In either instance, pictorial structure with its thrusts and balances gave way to infinite and apparently unstructured contemplation. The panoramic view, which defied the eye to see all at once, was a way of giving nature precedence over art.

It is not surprising that Durand, a member of the National Academy of Design, should advise students to study nature in close detail before looking for inspiration in works of art, a procedure in pointed opposition to the academic tradition. To be sure, he believed that the painter was a poet, but a poet because he could point out the beauties in nature, not because he could fabricate something on his own account. The function of art, then, was to teach man to see the beauties of nature. "Painting and sculpture," said Ralph Waldo Emerson in an infelicitous phrase, "are gymnastics of the eye, its training to the niceties and curiosities of its function." ["Art," 1841.]

There is much of Emerson's attitude toward the experience of nature in this contemplative phase of American landscape. In a famous paragraph he wrote:

> In the woods, we return to reason and faith. There I feel that
> nothing can befall me in life,—no disgrace, no calamity (leaving
> me my eyes), which nature cannot repair. Standing on the bare
> ground,—my head bathed by the blithe air and uplifted into
> infinite space,—all mean egotism vanishes. I became a
> transparent eyeball; I am nothing; I see all; the currents
> of the Universal Being circulate through me; I am part and parcel
> of God. [Nature, 1836.]

Asher Brown Durand, *Early Morning at Cold Spring*, 1850, oil on canvas, 59 x 47½. Montclair Art Museum, New Jersey; Lang Acquisition Fund, 1945.

In characteristic American fashion he had, in "The American Scholar," his Phi Beta Kappa address of 1837, placed nature as "first in time and the first in importance of the influences upon the mind," preceding the "mind of the past," as represented in literature, art, or institutions. But Emerson does not justify this importance through associational explanations. Nature did not speak to Emerson through the drama of forms, miming the struggle or salvation of man, but because it allowed him to lose himself in a large and complex system that substituted a super mind for the individual ego. A

Frederic E. Church, *Sunset*,
1856, oil on canvas, 24 x 36.
Munson-Williams-Proctor
Institute, Utica, New York.

Henri Lovie, *View West of
Bald Face Creek: The Ohio
River Valley Looking Toward
Thomas Yeatman's Resi-
dence*, circa 1850, oil on
canvas, 42½ x 55¾. Cincin-
nati Historical Society, Ohio.

OPPOSITE:
William Sonntag, *Mountain
Landscape*, 1854, oil on can-
vas, 51¼ x 41⅛. National
Collection of Fine Arts;
Museum purchase.

William Mason Brown, *Landscape with Two Indians*, circa 1850, oil on canvas, 31½ x 41½. The Tennessee Fine Arts Center, Nashville.

William C. A. Frerichs, *Storm Over the Blue Ridge*, circa 1855, oil on canvas, 30 x 48. Lent by North Carolina Museum of Art, Raleigh; Gift of Mr. and Mrs. George D. Finch.

storm or a brilliant sunset, rouse as they might the stronger emotions, in a way were less conducive to this state of mind than nature in her humble aspects. "In the tranquil landscape, and especially in the distant line of the horizon, man beholds something as beautiful as his own nature." In fact, the emotional response to nature was more likely the projection of the mind than a provocation of natural form. Because of a particular state of mind—joy, anxiety, sorrow—the character of the landscape could seem to change, or actually to be obscured. But the presence of nature would eventually purge the mind of transient states and allow the soul to expand in its free environment.

From this standpoint, a totally different kind of landscape study might be envisaged. In the first place, it would have no obvious structure nor emphasize a single definable emotional effect. Furthermore, it would do justice to each part of nature without distorting emphasis. As to the nature depicted, there would be no reason for its needing to be grand or exotic. "Man is surprised to find that things near are not less beautiful and wonderous than things remote," said Emerson in "The American Scholar." "The near explains the far. The drop is a small ocean. A man is related to all nature." In fact, Emerson went much further than this, stating in a famous passage: "I ask not for the great, the remote, the romantic; what is doing in Italy or Arabia; what is Greek art, or Provençal minstrelsy; I embrace the common, I explore and sit at the feet of the familiar, the low." The study of the lowly, the fragment, the isolated but familiar part was not only of pos-

Frederic E. Church, *Study of a Rock*, circa 1845, oil on paperboard, 10 x 14. Cooper-Hewitt Museum of Design, Smithsonian Institution, New York, New York.

115

Andrew Warren, *Long Island Homestead*, 1859, oil on board, 13 x 24¼. National Collection of Fine Arts; Given in memory of Mr. and Mrs. I. A. Lipsig.

sible value, it offered a sounder foundation of experience than the great and the grandiose. Of course, this would direct the eyes of the American painter not to Rome or Athens but to the humble aspects of his own surroundings.

It is doubtful how much direct effect Emerson's writing had on landscape painters outside of his Concord-Boston circle, but beginning in the later 1840s a kind of landscape art did develop that could be thought of almost as antiart. It was not concerned with arousing other than what might be called a "landscape emotion," a pleasurable state of mind that encouraged an endless rumination in a natural environment without logic or direction, and yet with a positive sense of spiritual satisfaction. The sobriety of the scene and the lack of obvious fabrication were enough to provide the assurance of truth, which might be defined as that feeling of security one senses in identifying the just rendering of the familiar. As in Durand, it was an easy truth, taken somewhat for granted; veracity was not labored.

As if to reinforce this attitude that would hold the view of nature, notably local American nature, as of higher spiritual significance than art, there began to appear in 1843 a series of writings "by an Oxford graduate" that would make immediate sense to some American landscape painters. John Ruskin's first volume of *Modern Painters* quite suited American taste on several counts. Written as a defense of Turner, it was really an exaltation of nature over art. Condemning Claude Lorrain and other models from the past for calling more attention to their art than to the nature they depicted, he praised Turner for giving himself over wholly to the observable effects of nature itself. In support of his roundly criticized volume he wrote:

Landscape art has never taught us one deep or holy lesson; it has not recorded that which is fleeting, nor penetrated that which was hidden, nor interpreted that which was obscure; it has never made us feel the wonder, nor the power, nor the glory, of the universe; it has not prompted to devotion nor touched

Jasper H. Lawman, *Coal Tipple*, 1854, oil on canvas, 31 x 40. The Butler Institute of American Art, Youngstown, Ohio.

with awe; its power to move and exalt the heart has been fatally abused, and perished in the abusing. That which ought to have been a witness to the omnipresence of God, has become an exhibition of the dexterity of man, and that which should have lifted our thoughts to the throne of the Deity, has encumbered them with the inventions of his creatures. [Preface to *Modern Painters*, volume 1, 2d edition revised, 1844.]

As for the celebrated paintings of landscape, he said, "Multitudes will laud the composition, and depart with the praise of Claude on their lips,—not one will feel as if it were *no* composition, and depart with the praise of God in his heart."

Not only could Americans appreciate the rolling prose, which suggests the King James version of the Bible, and the high moral tone, but those who were talking of a new American art could accept with no difficulty the

William Trost Richards,
*Neglected Corner of a Wheat
Field*, 1865, oil on canvas,
13⅞ x 12¼. Mr. and Mrs.
John W. Merriam, Wynn-
wood, Pennsylvania.

premise that art should be based on nature rather than on past art. To be
sure, the most glowing and vivid part of the book had to do with a descrip-
tion of the Alps, which had provided Ruskin with his first overwhelming
experience in nature. As various essayists were in the habit of pointing out,
the United States, so far as was generally known at the time, had nothing
quite so spectacular to offer. When Frederic Church was seized with the
desire to paint nature's grandeur in America he had to go to South America
and Mexico. To respond to this aspect of Ruskin's inspiration, artists had to
wait for the opening of the West, the exploration of the Rockies and the
Yellowstone. Once these grand images were made available, from about
1858 to the end of the century, artists could boast of a wild American
majesty of mountains, light, and primal air that could match anything the
established imagery of Europe had to offer. In the 1840s and '50s, however,
it was the emphasis on visual truth and natural morality, more than the
drama of natural grandeur, that the Americans found reassuring. Little by
little, Ruskinian phrases began to creep into essays and criticism, and when
the art periodical *The Crayon* was founded in January 1855, its editorial pol-
icy leaned heavily on the proselyting attitude of one of its two editors,
William J. Stillman, who had already been to England to meet Ruskin.

William Trost Richards, *Neglected Corner of a Wheat Field*, oil on canvas, 13⅞ x 12¼. Mr. and Mrs. John W. Merriam, Wynnwood, Pennsylvania.

Unlike Emerson, Ruskin was not a philosopher steeped in German and Far Eastern philosophy, and there was no complex, organized system underlying his writings on art. He was motivated by a rather orthodox Protestant Christianity on the one hand, and a highly emotional response to nature on the other, a combination quite understandable to the basically untheoretical American artist. Although he saw God in every leaf as well as in every breaking of the clouds over the mountains, he was little impressed with the humble scene at his own doorstep. He preferred the thrilling effects of Turner's studies of sun and atmosphere to Constable's placid green fields. An explication of the spiritual meaning of the less imposing American scene depended on the writings of Emerson, Thoreau, and Walt Whitman.

Although Asher Brown Durand, whose son was coeditor and then editor of *The Crayon*, felt comfortable with Ruskin's writings and superficially, at least, his own pronouncements on landscape seem not to have been in conflict, a younger generation of painters found Durand's understanding of truth quite inadequate. These young men, who eventually gathered around the English painter Thomas Charles Farrer, a devoted follower of Ruskin who came to New York in 1860, were moved to interpret Ruskin's writings in terms of the English Pre-Raphaelite painters, some of

Aaron Draper Shattuck, *Leaf Study with Yellow Swallow Tail*, circa 1859, oil on canvas, 18 x 13. Jo Ann and Julian Ganz, Jr., Los Angeles, California.

whose works had been shown in an exhibition of English painting in New York in 1857. The Pre-Raphaelites' reforming zeal and uncompromising attitude toward disciplined representation also attracted the young artists.

On January 27, 1863, a group of strongly Ruskinian young men met in Farrer's studio in New York to found the Society for the Advancement of Truth in Art. The most aggressive of the group was the irascible critic Clarence Cook; the most thoughtful, the architectural historian Russell Sturgis. Also active in forming the organization was the twenty-year-old Clarence King, who became a notable explorer and writer on mountaineering. For a brief moment at the beginning, John Henry Hill was president, but by March Clarence Cook presided. The young, devoted Charles Herbert Moore became secretary. In April 1863 the group announced a journal to be called *The New Path*, and produced the first issue in May. Wrote the editor:

Aaron Draper Shattuck, *The Cascades, Pinkham Notch, Mt. Washington*, 1859, oil on canvas, 15¼ x 19. Private collection, New York.

We believe that all nature being the perfected work of the Creator should be treated with the reverence due to its Author, and by nature they do not mean only the great mountains and wonderful land effects, but also every dear weed that daily gives forth its life unheeded, to the skies; every blade of grass that waves and shivers in the wind; every beautiful pebble that rolls and rattles on the sea sand.

The *New Path* group admired the poetry of Emerson, Lowell, Whittier, Holmes, Longfellow, and Bryant, but declared that none of the older schools of painters approached the truth of observation expressed in their poems. "It is the business of our artists," said one article, "to go out into the woods and fields and paint all the beautiful things there, one by one, and that with

121

David Johnson, *Brook Study at Warwick*, 1873, oil on canvas, 25⅞ x 39⅞. Munson-Williams-Proctor Institute, Utica, New York.

such accuracy that we can feel assured, after seeing one or two, that their report is worthy of credit." The group did not condemn the practice of earlier artists insofar as they studied out of doors, but they accused them of arbitrarily assembling their too hastily gained information, inserting their own conventions and interpretations between the natural object and the viewer. "The younger men paint always on the spot," they boasted, "each tree trunk and mossy rock having its portrait painted from a certain point of view, without change or disguise." The morality of the representation was as much a product of the self-abnegation and industrious application of the artist as it was the voice of nature. To be true, art must show sacrifice. Farrer's comment, published in *The New Path* in 1863, reads like a religious testimonial: "Oh, I wish I could express in words, and make you feel how much happier I have been since I have been working rightly, doing the truth, and what a glorious consciousness it is, after a summer of earnest effort, to know that however faulty your work may be, and whatever its shortcomings, yet, it is absolutely right, that you sought God's truth, and sat down and did it." It was rare that these critics praised an entire painting. Only nature was perfect and thus parts or studies were likely to be more acceptable than the whole. As with the *Lukasbund* in Rome fifty years earlier, it was the effort that counted.

Aaron Draper Shattuck, *The Pool*, 1857, oil on paper, 13½ x 21¼. John B. Stewart, Stratford, Connecticut.

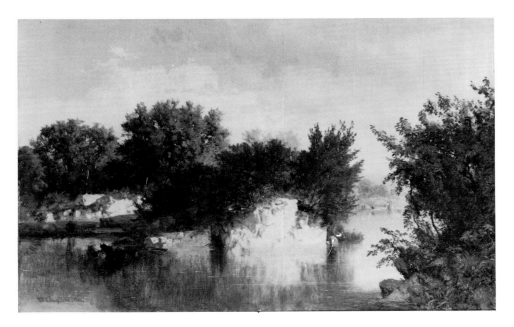

William Trost Richards, *Trees along Stream in Fall*, 1861, oil on canvas, 12⅝ x 20. National Collection of Fine Arts; Museum purchase.

The Society for the Advancement of Truth in Art was not destined to dominate the course of American painting, although the attitude it represented, variously formulated, had a marked impact on the formation of a generation of painters and affected as well the taste of patrons who came to believe that there was something immoral about a painting that was not highly finished. For one thing, the delight in viewing and recording the precise appearance of a single clump of plants or a few striated rocks was

Fidelia Bridges, Untitled, 1876, watercolor on paper, 14 x 10. National Collection of Fine Arts; Given in memory of Charles Downing Lay and Laura Gill Lay by their children.

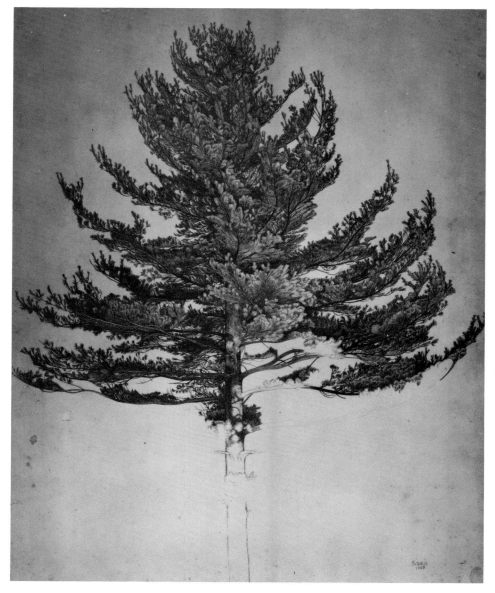

Charles Herbert Moore, *Pine Tree*, 1868, pen and ink on paper, 25 1/16 x 29. The Art Museum, Princeton University, New Jersey.

overshadowed by the inviting panoramas of the recently opened West, in which the spiritual impact of nature was on a grander and more traditionally acceptable scale. While Charles Herbert Moore might be content to find spiritual satisfaction in drawing the local fields with a hard, sharpened pencil, a painter such as Albert Bierstadt, who had returned from study in Germany and Italy just in time to profit from western exploration, preferred the soaring peaks and vast reaches of the Rockies that better symbolized the expansive aspirations of the American public. Ironically, his vast canvas *The Rocky Mountains* was shown in New York in 1863, the very year the Society for the Advancement of Truth in Art was founded. Many painters

124

Charles Herbert Moore, *Saw-mill at West Boxford*, 1874, watercolor on paper, 11⅞ x 18. The Art Museum, Princeton University, New Jersey.

Albert Bierstadt, *Yosemite Valley*, after 1860, oil on canvas, 27¾ x 39½, Columbus Gallery of Fine Arts, Ohio; Bequest of Rutherford H. Platt.

William Keith, *Evening Glow*, 1879, oil on canvas, 36 x 60. The Butler Institute of American Art, Youngstown, Ohio.

followed his lead. A few years later, Thomas Moran, with the ecstatic words of Ruskin in his head and the image of Turner before his eyes, sought his exaltation in the great sweep of the Yellowstone and the mysterious canyons of the Colorado.

These bold expressions of the West were not simply the landscape of the Hudson expanded; they represented a whole new phase in America's identification with nature. There was something about these gargantuan landscapes that could make even the city-bound inhabitant proud in incorporating the unmatched western image into his visual definition of America. Finally, America had the mountains that could be claimed to match her men.

There was another factor that worked against the ideology of the *New Path* critics. Possibly as a result of the nagging insistence that all inclinations to structure or simplification be subjugated to the minute representation of nature—the reduction of the artist to a pious imitator rather than an imaginative creator—a strong reaction began to be evident in the late 1860s and 1870s. Like the expansive western painting, it was not because of any doubt in the spiritual value of nature, but because of a suspicion that somewhere in the artistic process the spirit was being crowded out. This was certainly the case with George Inness who, like some others, moved in the 1850s from a tight painting of each detail—although not very specifically observed—to a kind of painting based on a more general and unified vision. At the very time the *New Path* brethren were arguing that truth to nature meant the selfless representation of each thing, some artists began to consider truth to be a matter of vision, of perception, rather than of things. It was evident to such a painter as Inness that in looking at nature one did not at once see everything in the same degree of explicitness. At any one

Thomas Moran, *Mist in Kanab Canyon, Utah,*
1892, oil on canvas, 43¾ x 37¾. National Collection of
Fine Arts; Bequest of Mrs. Bessie B. Croffut.

moment there was a necessary and natural subordination of one part to another, depending on focus and attention. It could be maintained that a *New Path* presentation of a scene from nature was, in its simultaneous depiction of everything in detail, a representation of nature as it never could be seen. Only in a feverish vision would the mind fail to subordinate some visible facts.

To see all at one time, then, became a new mark of truth—true to seeing, true to the human experience. Unlike the earlier generalized painting that tended to follow established formulas, these somewhat simplified views were no less based on direct observation than were the Ruskinian studies. They were postulated on the artist's being in direct contact with the landscape.

With Inness, the direct relationship between artist and landscape gradually produced still another awareness. As he concentrated more and more on the total impression of the scene, he became conscious of the impact that the total impression had on his state of mind. A man much concerned with spiritual values—he was fascinated by the teaching of Swedenborg—Inness was moved to equate the process of seeing nature with an emotional process that had reassuringly spiritual implications. Spirituality was derived, then, not from ideality or drama of form, nor from an awareness of specific natural growths, but from the interplay of light and shade and color as they presented themselves to the mind while one contemplated nature. Especially from the 1870s on, Inness's paintings offer the viewer ever less detail, even though they clearly represent specific places. Instead of being conscious of particularities of things existing in front of us, we are thrown back upon our emotional responses, set free to wander not only in the undefined washes of color in the landscape, but also pleasurably in the reaches of the mind. Seeing, for Inness, became a way for feeling, and he was enough of a mystic to believe that the intuitive responses to his visual world were a means for contact with God.

In his serene landscapes from the last fifteen years or so of his life, objects appear and disappear in the spring or autumnal haze like punctuation in a continuous poetic reverie. The fields and rugged trees of the American countryside are translated into luminous subjects of contemplation. Even that early pride of America, Niagara Falls, becomes sublime in a new way—not by force but by persuasion. Its mists dissolve the solidity of things to allow them to become the elements of thought.

This softness and evocativeness of color and form associated with the vision of nature appealed to several artists, beginning in the 1870s. Sometimes, in their overzealous efforts for organization, historians have linked this vision with that of the independent painters in Paris whose exhibition was dubbed "impressionist" in 1874. In the case of Inness and Ralph Blakelock, for example, the association is meaningless. Their motivation arose from a belief in the emotive power of art and its mysterious association with a religious feeling. They borrowed some aspects of their technique from the

George Inness, *Early Autumn, Montclair*, 1891, oil on canvas, 30 x 40. Delaware Art Museum, Wilmington.

George Inness, *Niagara*, 1889, oil on canvas, 30 x 45. National Collection of Fine Arts; Gift of William T. Evans.

Ralph Albert Blakelock, *Sunset, Navarro Ridge, California Coast*, oil on canvas, 35 x 57. National Collection of Fine Arts; Gift of William T. Evans.

Barbizon painters, but their background was that of the long tradition that found nature, especially American nature, holy. Their perception was so linked to a sense of mystery in nature that to speak of it as to any degree objective would be to falsify its character. It was a very rare American painter who, before the turn of the century, could simply look dispassionately at nature. Even when colors begin to move away from the traditional pigments to approximate the elements of light, the overtone of feeling and awe remained. No matter how it was to be defined, landscape had a special place in the psyche of America that was not easily displaced by artistic modes.

As an afterthought it is worth noting that with the Yellowstone Act of 1872 the grandeur of the American wilderness was given governmental recognition, and out of this the extensive national park service would grow. This was a moral, not a practical commitment, and the works of artists played not a little part in bringing about the consciousness that made it seem essential to the nation. In a way, it was the government's first major alliance with art.

Homer Dodge Martin, *New-port Landscape*, 1882, oil on canvas, 18 x 30. The Butler Institute of American Art, Youngstown, Ohio.

The Frontier and the Native American

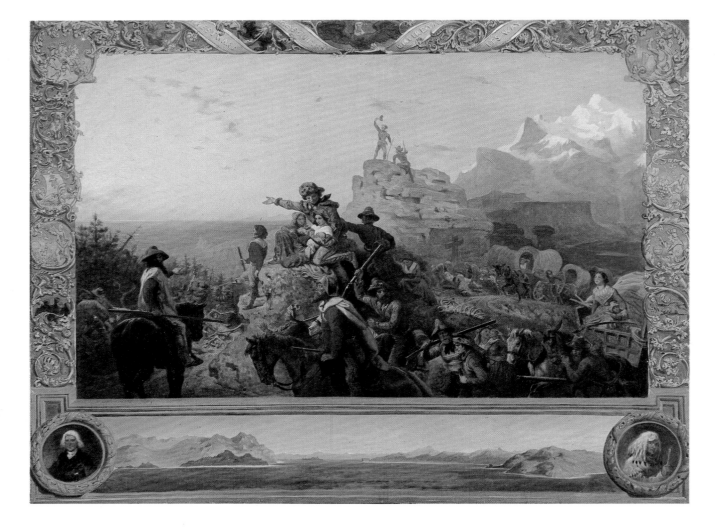

Emanuel Leutze, *Westward the Course of Empire Takes Its Way*, circa 1861, oil on canvas, 33⅜ x 43⅜. National Collection of Fine Arts; Bequest of Miss Sarah Carr Upton.

The Frontier and the Native American

When Frederick Jackson Turner delivered his famous paper on "The Significance of the Frontier in American History" in 1893, Americans hardly needed to be told that the frontier had been an important aspect of their culture. America had begun as a frontier settlement and throughout the first 300 years of the country's history the frontier had drawn many Americans to migrate across the continent and many more to live imaginatively and vicariously the life of excitement and adventure that seemed to be associated with the shifting boundaries of civilization. Turner's great contribution was not the discovery of the influence of the frontier, but a particularly complex and compelling interpretation of that influence. For Turner, the frontier was the wellspring of American democracy. He believed that long-settled communities had a tendency to become stratified through the accumulation of wealth and power in ever fewer hands. Democratic values were, he thought, threatened by this process. The special fortune of American democracy was the existence of cheap land to the west. This "safety valve" of land available to the urban poor had served to revitalize democracy by turning a potential proletariat into independent small property holders. It also helped keep the eastern cities more democratic by maintaining a high price for labor. Each generation of pioneers recreated democracy on the frontier and spread its patterns and values back toward the East. What would happen to American society after the frontier came to an end concerned Turner for the rest of his career. Indeed, the occasion for his 1893 address was the announcement by the superintendent of the census in 1890 that America no longer possessed a continuous frontier.

For Turner, this census announcement marked "the closing of a great historic movement." In later essays he called attention to the need to develop new social dynamics in modern urban America that would take the place of the frontier in its democratizing and revitalizing role. Turner's sense of the great importance of the frontier experience has been often echoed in the rhetoric of the twentieth century. With its call for a new

frontier and its program for the conquest of the "frontiers of space," the Kennedy administration made the image of the frontier a keynote of its political rhetoric. Frontiersmanship became the game of the hour and the effectiveness of this appeal caused politicians of every sort to call on their fellow citizens in terms of this symbol. It was clear that, as the 200th anniversary of the American Revolution approached, Americans were as imaginatively involved with the concept of the frontier as they had ever been, even though it was some eighty years since there had been anything resembling an actual frontier on the North American continent.

The work of more recent historians has raised some serious questions about several aspects of Turner's explanation of the significance of the frontier. While there are numerous instances of poor and disadvantaged people who left the cities of the East to seek new opportunities on the frontier, recent studies suggest that this may not be as typical as Turner assumed it was. On the contrary, the majority of those who moved West were not the disadvantaged poor, but well-established members of the middle class. Considering the investment necessary to put together an outfit sufficient to travel west, and once there to stock and equip a reasonably successful farm or ranch, it is not surprising to find that most of those who became permanent settlers of the West came from families of some means. The same conclusion emerges when we look at the westward movement of immigrant populations. To a considerable extent, the ethnic groups who played a major role in the settlement of the West were of northern European extraction and represented classes who had been substantial property holders in the old country; individuals from, for example, German or Scandinavian backgrounds brought with them the resources, the experiences, and the kinds of institutions that enabled them to successfully operate farms on the frontier, while the truly poor and dispossessed peasantry of eastern and southern European background tended to settle in the cities and become part of the growing industrial labor pool. If those who settled the West were, on the whole, from families who had already established themselves in the East, Turner's vision of the frontier as a safety valve guaranteeing equality of opportunity for the poor and thereby insuring the regeneration of democracy certainly has to be qualified, if not rejected.

Another important element of the frontier thesis is the dramatic contrast that Turner drew between eastern cities as a source of antidemocratic social forces and values and the frontier as the perennial seedbed of democracy. Studies like Arthur M. Schlesinger, Jr.'s, *The Age of Jackson*, however, have argued that many of our most important democratic institutions and values have been created in eastern cities. Other historians, like Richard Wade, have shown that the Turnerian image of frontier settlement as a reversion to simple forms of social organization and spontaneous democratic individualism is much too simple a picture.

Finally, the frontier thesis treated the frontier as, in effect, culturally empty prior to the incursion of American settlement from the East. There

was, perhaps, a grisly appropriateness to this view since a substantial portion of the settlers totally failed to perceive the long-established Native American and Spanish cultures that had occupied the land before the coming of the pioneers. An Indian spokesman once put it most effectively: "There was no wilderness until the Whites arrived"—a statement that has many layers of meaning, perhaps the most important symbolizing the pioneer attitude that the land was not significantly occupied by the Indians and was therefore rightly taken over by American settlers for their own purposes. Throughout the process of settlement, the western frontier was deemed, as Henry Nash Smith has shown us, a "virgin land" on which a new civilization could be fathered. The frontier thesis with its central definition of the West as "free land" reflected this image of America as empty wilderness. But of course the land was not really free, except perhaps in the sense that it did not appear to cost very much in money to purchase or seize it from the native inhabitants. In actuality the price was high and terrible, not only in lives lost by both Indians and whites, but in the destruction of cultures, in the creation of institutions and attitudes that we are only beginning to regret, and in a legacy of bitterness that Americans will be paying off for years to come.

It appears that the frontier thesis requires substantial revision. The postulation that the frontier experience was unique and that it had a basically positive influence on the development of democracy in America has been strongly qualified by many contemporary historians and simply abandoned by others. That the thesis failed to take into consideration the complex moral and cultural implications of the destruction of Native American cultures is another basic problem that has been analyzed by both Native American spokesmen and white historians in recent years.[2] Yet, though we find it increasingly difficult to specify just what has been the social and economic significance of the frontier in American life, there is no doubt about the enormous role of the West and the Indian in the American imagination. When we enter the realm of image through works of art and literature about the West, or through the mythical patterns that are reflected in all manners of American utterance and attitude, it becomes immediately clear that the frontier and the Native American have always been and remain today one of the central imaginative preoccupations of our culture, and that to explore the many different images which Americans have woven around them since the beginning of American history is to encounter some of the deepest and most complex ambiguities and conflicts of value in our culture.

2. A problem of terminology symbolizes the difficult heritage of the frontier and has led many writers to abandon the term "Indian" for new constructions like "Native American." There is excellent reason for this. One of the most unfortunate habits of Europeans and Americans has been to lump all the diversity of Native American cultures under the single term "Indians." At the same time it seems clumsy and misleading in other ways to keep talking of Native Americans and Americans. With a sense of considerable discomfort, I will use the traditional term "Indians" and distinguish between Indian and white Americans in this essay, except in cases where the terms seem wholly inappropriate.

Actually, imaginings about the West go back before the beginning of American history and were an important part of the cultural baggage that the earliest settlers brought with them. In different ways, the European classical and Christian traditions both contained important myths of a New World. For Christians, this was a world more in time than in space—the promised Millennium, the new heaven and earth hinted at in some of Christ's enigmatic promises about the future and further developed in the tradition of Christian apocalypse. From the point of view of later visions of a new world in the West, the most important and influential theme of the Christian myth of the Millennium was its vision of a time of moral and spiritual regeneration when man's sinful nature would be purged and human society transformed into God's kingdom. Of course, not every Christian saw the Millennium in the same way. Some felt there would be no regeneration on earth, and that only after a cataclysm of destruction would men rise in spiritual form and be judged. But, however defined, the idea of Christ's Second Coming and the Millennium as some form of moral and spiritual transformation and purgation of human society was a central theme in the Christian heritage.

If the coming of a new heaven and earth was the promised Christian end of history, there was in the Hebraic-Christian myth of Genesis another vision of the human estate that has also played a profound role in American imaginings about the West. According to this myth, man was created in the Garden of Eden, an ideal paradise of simplicity, innocence, and harmony with nature from which he fell, through primal sin, into the turbulent conflicts and sufferings of history. Certainly one way of imagining the Millennium was as a restoration of man to this primal state of innocence and harmony. As Henry Nash Smith, R. W. B. Lewis, and Leo Marx have shown in their studies of American mythology, the metaphor of America as the garden of the world and of the American as a new Adam is one of the dominant images of American literature. For example, Crèvecoeur's well-known description of the New American clearly sees the crucial characteristic of American society as the reestablishment of a moral state of simplicity and harmony based on the cultivation of a beneficent nature and free from the artificial social forces of Europe:

> *He is arrived on a new continent; a modern society offers itself to his contemplation, different from what he had hitherto seen. It is not composed, as in Europe, of great lords who possess everything, and of a herd of people who have nothing. Here are no aristocratical families, no courts, no kings, no bishops, no ecclesiastical dominion, no invisible power giving to a few a very visible one; no great manufacturers employing thousands, no great refinements of luxury. . . . Some few towns excepted, we are all tillers of the earth, from Nova Scotia to West Florida.*

138

There is much in common between Crèvecoeur's contrast of America and

Europe and Turner's comparison of the frontier and the settled East. The vision of America as a new Eden still lies beneath the sophisticated social and economic ideas in terms of which the frontier thesis is commonly presented.

The classical myth of a great kingdom to the west was rather different. First of all, this mythical world was located in space rather than in time. Secondly, it usually represented a land of greater magnificence and splendor, where men were happier in an earthly way than in any known society. Though this land was commonly thought of as a place of justice for all, particularly when it found its way into the musings of a philosopher like Plato, connotations of worldly power and human happiness and pleasure were more important than visions of spiritual regeneration. The Homeric poems are our first recorded versions of this myth, which is embodied in Odysseus' visit to the extraordinary kingdom of Phaeakia. In his account of a brilliant and happy land of surpassing loveliness, located somewhere to the west, Homer gave the myth a twist it would often have in succeeding centuries. After many exploits and the loss of all his crew, Odysseus is cast ashore in a magnificent land where men are rich and happy. There he encounters a beautiful princess, who offers him her hand. But Odysseus is determined to return to his own kingdom and family and when he departs, the god Poseidon, angry that the Phaeakians have aided Odysseus, casts a mist about the land so that men can never come into contact with it again. This theme of the magnificent kingdom that can never be found again echoes down through the centuries in Plato's myth of Atlantis, which disappeared beneath the waves; in Marco Polo's Cathay, which also had its beautiful princess and to which Columbus was trying to find a sea route when he bumped into the Western Hemisphere; and in many other legends of mythical kingdoms current in the Middle Ages. Many American legends also reflect different aspects of this basic mythical pattern, indicating the degree to which imaginings about the New World were influenced by the mythical heritage that explorers and settlers brought with them. The legendary seven cities of Cibola, El Dorado, and the recurrent stories about lost mines that are still told in the American West echo the story of the great and wealthy kingdom discovered and then lost forever. The story of the fountain of youth was also a variation on the theme of a source of human happiness and pleasure that someone had stumbled across and nobody else could find. The delightful tale of John Smith saved by the beautiful Indian princess Pocahontas clearly taps the same imaginative roots as Homer's account of Odysseus and Nausicaä. There are even scholars who feel that the great kingdom of Atlantis was not a mere myth but an actual place located somewhere in the present United States and destroyed by some geophysical cataclysm in the distant past.

The Christian vision of a millennium on earth, the myth of Edenic simplicity and harmony from which man had fallen, and the long-standing European fascination with lost kingdoms where men had achieved splendor

and happiness for all through incalculable riches were images well established in the minds of Europeans before the Age of Discovery, and it appears that their force was intensified as the news of the discovery of a continent to the west swept across Europe. Since actual knowledge of the American continent was minimal, the decision to emigrate and risk one's all on the very edge of civilization must have been strongly colored by these images. Indeed, if we look at the two earliest permanent settlements in what later became the United States—the Pilgrim-Puritan colonies in the Massachusetts Bay area and the Virginia settlement at Jamestown—in terms of what we know about the motivation of the settlers, it seems evident that the northern effort was strongly shaped by the aspiration to create a purified, godly community, echoing the Christian vision of the New World, while, for most of the Virginia colonists, the underlying dream was the discovery of a land of riches and pleasure. If this is so, neither group found anything like its aspirations and expectations. The Puritans did not find that once free from the rotten ecclesiastical institutions and ungodly powers of Europe they could create a permanently regenerated community in the New World. Instead, they found themselves confronting not only the rigors of the New England climate but also fighting what seemed to the orthodox an endless and losing battle against schism and the decay of piety. This did not mean that the dream of a regenerated community died out; on the contrary, as we shall see, it became one of the recurrent themes in the imagery of the American frontier. The early Virginia colonists, dreaming of gold and jewels, found disease and starvation and were nearly wiped out before they reorganized themselves and found a different and more realistic way of expressing their aspiration toward a mythical kingdom of splendid riches and pleasure: not by finding gold and jewels but by exploiting the possibilities of tobacco, cotton, and slaves.

We have dwelt on this first American frontier because in many ways it presents a paradigm of the imaginative role of the frontier in American history. Two basic patterns stand out. First, under the initial impact of the Christian and classical myths of a new era or a new kingdom, the frontier was perennially envisioned by Americans in terms of discontinuity with what had gone before. Archibald Hanna effectively defines two aspects of this discontinuity when he says:

> The ideal West has never been crystallized into a final form, but has varied from individual to individual. Two features, which are basic to the idea of the West and very closely related to each other, are "otherness" and "remoteness." Much of the charisma of the West has been bound up in the concept of a region which was qualitatively, not just quantitatively, different.

The idea of the frontier, then, expresses a kind of boundary between what is known and what is sufficiently distant to be imagined as significantly different, a new human or natural potentiality on either the social or indi-

vidual level. So long as the West remains a place apart, it is possible to imagine almost anything about it, such as a new moral era or a chance at great riches. But man's visions have always been qualified by the fact that when he arrives somewhere and settles in, he finds himself. This, as Turner's critics have pointed out, was generally as true of the western experience as it has been of most human history. Human cultures evolve and undergo significant change very slowly. Even revolutions usually turn out to have been much less of a departure than they appeared to be at the time. So Americans moved west into an aura of aspiration and desire for a departure from the past. But when they arrived they found mostly what they had left behind, and the dream of discontinuity had to be pushed forward onto another frontier. Yet the tension between the vision of something new across the frontier and the developing realization of continuity with the past has been a driving and creative force in American life and was surely one of the cultural forces which, for better or worse, led Americans to migrate across the continent with remarkable rapidity.

The second basic pattern is illustrated by the different aspirations that characterized the Massachusetts Bay and Virginia colonists. Because the frontier was imagined as a line between the known and the unknown, it was common for very different and even conflicting versions of the West to arise. Even today it is obvious that the West means many different things to different people, sometimes to the same person. Take, for example, three images current today: the West as "God's country," the last surviving bastion of morality, decency, and democracy in a rapidly degenerating urban society; the West as Las Vegas, the wide-open town where anything goes and one can do with impunity things that would be considered both illegal and sinful back home; and the West as the heroic concept that forms the staple of western films, paperback novels, and television series: a landscape of epic struggle between large forces—pioneers and savages, townspeople and outlaws, cattlemen and sheepherders—dramatically resolved through a heroic act of regenerative violence by a legendary cowboy or gunfighter. The implications of these images are profoundly different, yet each has become a major symbol of the West, and the inspiration for many different kinds of artistic expression. And there are, as well, many other images with equally various connotations that have developed to give some shape to the hazy otherness of the frontier. Just as the conflict between myth and the pressure of actuality has played a crucial role in the development of imaginings about the frontier and the Native American, so the tension between alternative and conflicting myths of the West has been one of the dominant characteristics of the history of the American imagination.

We come at last to the artist and the writer, those individuals whose special talents for expression in different media lead them to take on the vital cultural function of embodying in visual images or words the images and myths that float through the culture. The process by which artistic expression interacts with the images of a culture is a terribly complex one, for,

once expressed in artistic form an image becomes a material reality that can in turn generate new images in the mind, which lead to further artistic expressions. There are entire traditions of art—the popular western novel being one example—that spring as much from a succession of past images and art works as from a renewed imaginative encounter with the world outside of the particular mythical tradition. Most westerns can probably be said to be more directly inspired by earlier films or novels than by direct experience of the setting and society they describe. Many of the most important popular westerns have been created by men who hardly knew the frontier they described. Zane Grey, the most popular western novelist of all time, had hardly seen the West when he began the series of novels that would make him famous, and he never saw the frontier world he commonly wrote of. Frederick Faust, who created hundreds of western novels and short stories under a variety of pseudonyms (including Max Brand), spent his most prolific writing years in a villa in Italy. Once his publisher suggested he visit a ranch in Texas to actually experience the scenes he had so often depicted in fiction. It is said that he fled as soon as possible, finding the dust and the lack of amenities more than he could put up with. Both Grey and Brand derived their images of the West more from earlier literary and artistic traditions than from direct encounter, yet this does not invalidate their work, for it is the function of a certain kind of artist—the sort often classified as a "popular" writer or artist—to elaborate on existing images rather than to create new ones. But there is another kind of creator—probably more important in the long run—whose task is to set conflicting mythical traditions into creative tension with his vision of the real world. These writers and artists tend to last longer because we recognize in their work a depth and complexity that transcends the more limited images of particular mythical traditions. Yet, we clearly need both kinds of expression, and the history of American culture's attempts to come to grips with the meaning of the West has been the product of a complex interplay between cultural myths, popular artistic traditions based upon these myths, and the work of unique artists who somehow found the ability to link a vision based on a fresh encounter with experience to the mythical traditions of their culture.

To gain some perspective on this complex history, let us first attempt to sort out some of the prevailing American cultural images of the West. I have already suggested that one central characteristic of the role of the West in the American imagination was its capacity, as a place of otherness and discontinuity, to generate a great variety of images. Thus, any attempt to reduce this proliferation of images to a limited number of primary patterns runs the risk of oversimplification. The following discussion, then, should be viewed as one possible framework of classification rather than a definitive structural analysis, with the understanding that it is in the nature of such systems of mythical classification for there to be some overlapping between the categories. Indeed, it is from the tension between conflicting myths that much artistic expression arises. Yet, in spite of these analytical

difficulties, it is useful to delineate four major traditions of cultural mythology about the West and the Indian.

1. One major tradition views the West as an empty and dangerous wilderness to be conquered and civilized by pioneering. This was the West of manifest destiny and of the epics of the pioneers and the railroad. In this tradition, the otherness of the West was represented primarily as emptiness and wildness or primitiveness, viewed as obstacles to be overcome through heroic endeavor. This vision of the West was closely linked with another central American myth, the ideal of progress. Faith in America as a country of perpetual improvement freed from the static and constraining institutions of the European past became, during the nineteenth century, a kind of public religion, a statement of the transcendent purpose of the American nation. Though the ideal of progress was perhaps most obviously symbolized in the acceleration of technological innovation and change and the extremely rapid development of America as an industrial giant, it was also progress that the pioneers were imagined to be bringing to the West. Thus, for a time it was possible to see the industrial development of great cities and the pioneering efforts of farmers on the frontier as part of the same grand cultural development. In the later nineteenth century it became a favorite rhetorical device to refer to the financial magnates and aggressive entrepreneurs who were transforming America as "industrial pioneers," thereby casting around them the mantle of heroic sacrifice and endurance (which fit perhaps more closely around those who actually braved the great trek across half a continent).

In this scheme of things there was no place for the Indian except as an antagonist and an obstacle, because the Indian in his native culture represented an earlier stage of society, doomed to be wiped out by the march of progress. In the myth of the West as empty wilderness, when the Indian was recognized at all—and many Americans expressed the view that Indians were no different from other kinds of wild life, such as the bison—he was confronted with a Hobson's choice: assimilate (i.e., reject his culture totally) or die. As Roy Harvey Pearce has shown, the concept of the Indian as savage arose and flourished because it provided a kind of philosophical and historical justification for the destruction of the native cultures. According to this view, the Indian was irremediably bound to a primitive stage of life much earlier on the evolutionary scale than the culture represented by the pioneers. Therefore, it was not only an inescapable "fact" of history that the Indian cultures should give way to the advance of white civilization but—in one of those perversions of moral reasoning of which history is so full—it could be argued that the expropriation of the Indian was for his own good. In conjunction with other myths of the West, as we shall see, quite different attitudes toward the Indian grew up that were, if not less mythical, at least more ambiguous or even sympathetic. However, it was this primary myth of the Indian as obstacle to civilization that to such a tragic extent prevailed.

The myth of the pioneers and the empty wilderness played a very im-

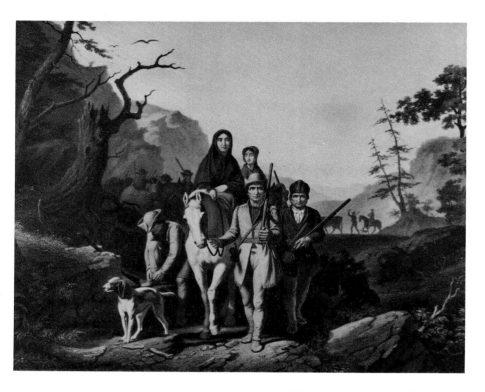

Claude Regnier after George
Caleb Bingham, *The Emigra-
tion of Daniel Boone*, 1852,
lithograph, 18¼ x 23¾.
Missouri Historical Society,
Saint Louis.

portant role in nineteenth-century art and literature. One of its grander
artistic manifestations was George Caleb Bingham's epic painting of Daniel
Boone leading the pioneers across the Cumberland Gap. In this painting we
see in the foreground a rocky cleft in the mountains littered with gnarled
and broken dead trees. The foreground is dark and ominous except for the
patch of light that spotlights a group of pioneers moving toward us through
the cleft. In the background of the painting there is more light and the sug-
gestion of green and cultivated hills, which the pioneers are leaving behind
in their heroic determination to bring life to a dead and empty wilderness.
The symbolism of the pioneer group bears out this vision. These are family
groups. One of the central figures is a Madonna-like woman on a white
horse led by a highly romanticized figure of Daniel Boone. Their composi-
tion evokes the traditional artistic symbolism of the Holy Family on the
Flight into Egypt. This central group is followed by men and women, bear-
ing axes and driving stock. Boone, a pivotal figure in many versions of the
western myth, here appears as a highly civilized man, dressed in a costume
that has buckskin fringes but otherwise is in the height of gentlemanly
fashion, a far cry from the rough and gnarled Boone figure of the wilderness
hunter garbed in rough animal skins that appears on many other canvases
reflecting different visions of the West. In Bingham's painting the symbols
of Christianity, civilized cultivation, technology, and even a strong flavor
of gentility come together to characterize the march of the pioneers into a
landscape that is nothing but broken rocks and sticks before their arrival.

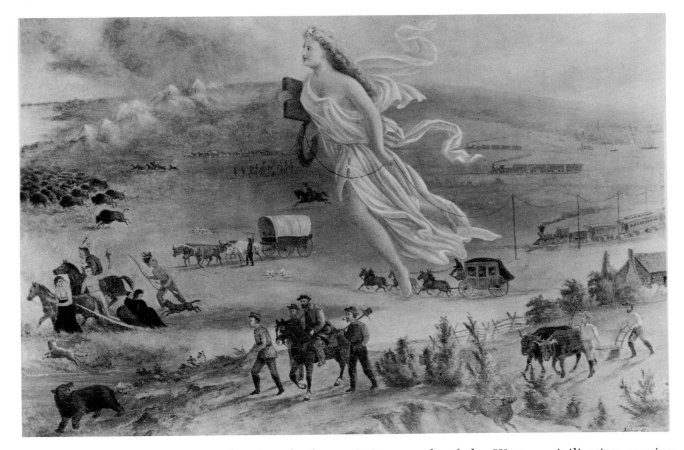

John Gast, *Westward-ho (Manifest Destiny)*, 1872, oil on board, 12⅛ x 16⅛. Harry T. Peters, Jr., Orange, Virginia.

Another, far less artistic example of the West as civilization moving into the wilderness is an 1872 painting, *Westward-ho,* attributed to John Gast, whose iconography is reflected in many places, including a popular Currier and Ives print. In this painting a motley group of Indians, a bear, and a herd of bison are being rapidly pushed out of the lefthand edge of the painting by successive groups moving in from the right and representing first a covered wagon, a small group of prospectors, and the pony express, and then a stagecoach, several trains, and a farmer plowing a field with oxen. Overhead flies a gigantic young female figure—in the mode of allegorical eroticism so favored by the Victorian era—clad in loosely flowing and chastely revealing draperies. In one hand she carries a large book bearing the title "school book" and with the other she is laying a telegraph wire across a string of poles leading toward the right (the East). Basically this is a much cruder and more obvious expression of the same symbolism portrayed more subtly and majestically in Bingham's painting. Christianity, domesticity, and femininity preside over a great movement of civilization into a wilderness peopled only by Indians and wild animals doomed rightly to extinction. This movement is progressive and brings with it all the blessings of technology and settled life in an orderly and rapid passage across space and time. It is a grand and majestic progress and everybody is happy

with it except that snarling bear and those wretched Indians in the lower lefthand corner.

The myth of the West as progressive pioneers cultivating a desolate wilderness and thereby accomplishing the manifest destiny of the American people was very likely the most widely accepted public vision of the frontier in the nineteenth century because it seemed to correspond with the actuality of the westward movement and with the central moral ideologies of Christianity and progress. Yet, the fact that several other mythical versions of the West grew and flourished in the American imagination during the same period suggests that the vision of the frontier as pioneering was somehow not fully satisfying to the American imagination; perhaps the idea of settling the West in order to make it an extension of the East was simply not up to those two great visions, the heavenly kingdom on Earth and the new Atlantis, that Americans had brought with them out of their mythical heritage. In any case, other visions of the frontier reflected an imagined transformation far more dramatic than anything dreamed of in the myth of the pioneer and the wilderness.

2. In a second primary image of the West, it was seen as the locus of a morally redeemed community purified from the errors and sins of the past. This image was a direct extension of the Christian vision of a new heaven and a new earth and found its first major American expression in the Puritan dream of a city on a hill, a godly commonwealth. The Puritan dream was itself soon shaken by the emergence of movements such as that led by Roger Williams, who sought to build an even more purified and godly community by withdrawing into the wilderness. By the nineteenth century the utopian thrust had become endemic to American culture and a vital part of the movement to the frontier. Though not every American attempt at a religious or social utopia involved a movement to the frontier, the more intense a group's dream of escape and transcendence, the more likely its members were to cast the dust of the East from their feet and seek a haven in the wilderness. Obviously, there is some connection between the image of the West as pioneering and the vision of a redeemed community on the frontier, but there is also a great difference. Pioneering envisioned the bringing of the East into the West, but the dream of a morally purified community implied the severing of links with the East and the generation of something new. In the image of the pioneer, the otherness of the West was empty wilderness that was to be transformed into the model of eastern, Christian civilization. As the caravans of covered wagons pushed across the continent, they drew behind them the lines of the telegraph and the railroad, thereby establishing ever more close and continuous contact with the East. But for the myth of the redeemed community, the otherness of the West lay primarily in the new and purified society that would be possible through an escape from eastern corruption to the open possibilities of the frontier.

While the westward movement in the nineteenth century was replete with utopian visions ranging from the religiously oriented Amana communi-

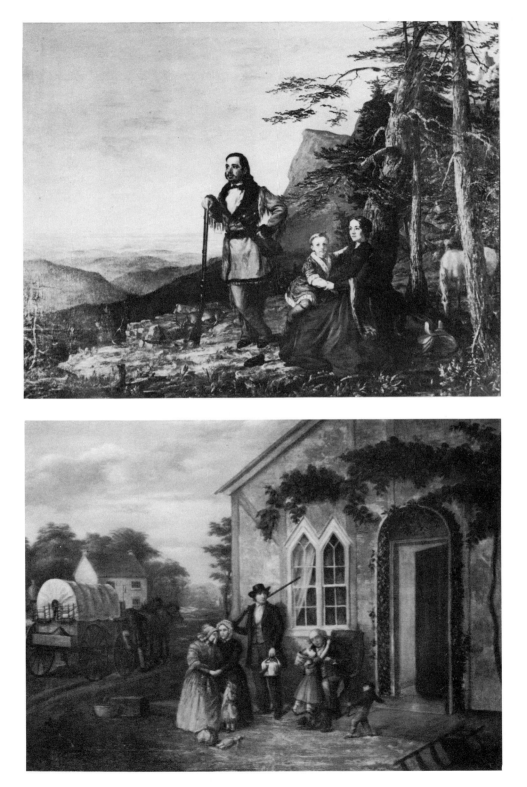

William S. Jewett, *Promised Land*, 1850, oil on canvas, 61½ x 76. Private collection.

James F. Wilkins, *Leaving the Old Homestead*, circa 1854, oil on canvas, 28⅛ x 36½. Missouri Historical Society, Saint Louis.

147

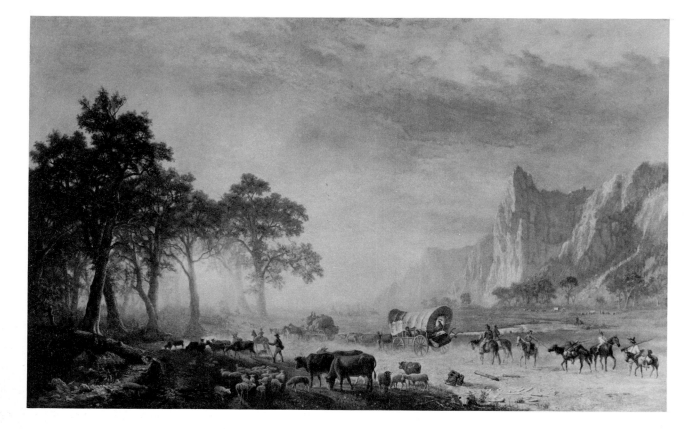

Albert Bierstadt, *The Oregon Trail*, 1869, oil on canvas, 31 x 49. The Butler Institute of American Art, Youngstown, Ohio.

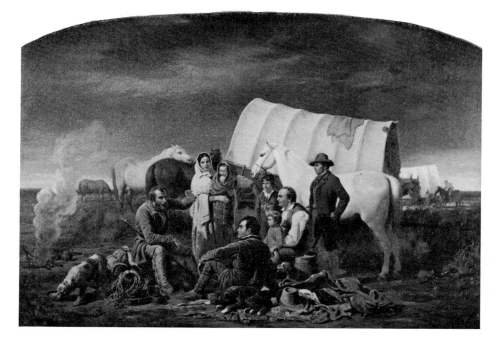

William T. Ranney, *Advice on the Prairie*, 1853, oil on canvas, 40 x 54. Mr. and Mrs. J. Maxwell Moran, Paoli, Pennsylvania.

148

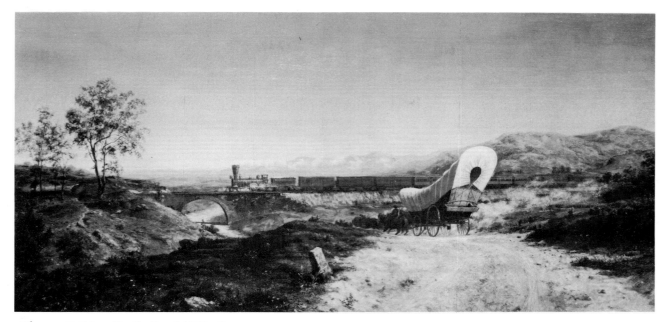

Thomas P. Otter, *On the Road*, 1860, oil on canvas, 22⅛ x 45⅜. William Rockhill Nelson Gallery and Atkins Museum of Fine Arts, Kansas City, Missouri; Nelson Fund.

Andrew W. Melrose, *Westward the Star of Empire Takes Its Way—Near Council Bluffs, Iowa*, circa 1865, oil on canvas, 25 x 46. Post Road Antiques, Larchmont, New York.

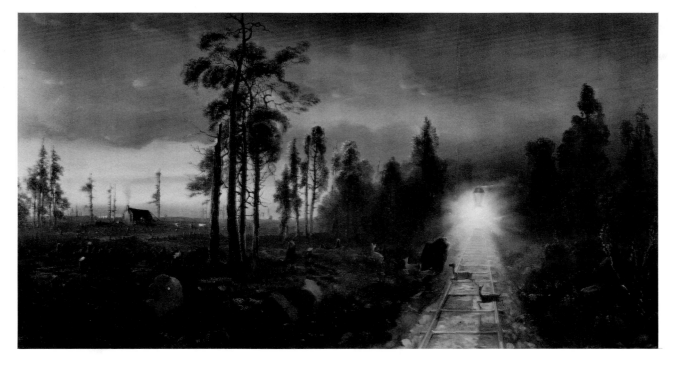

ties in Iowa to socialistic utopias like Robert Owens's New Harmony, the most spectacular of all was the great Mormon trek to the wilderness of Utah. The Mormons, a religious sect based on the prophetic revelations received by Joseph Smith, had attempted to establish their dream of a new Zion in various midwestern states by founding communities in Ohio, Missouri, and Illinois. However, the Mormons' form of theocratic government, their unique, semicommunistic economy, and certain of their religious beliefs and practices, including polygamy, brought them into constant conflict with their "gentile" neighbors. In Missouri and Illinois this hostility broke into open warfare. After being harried out of Missouri, the Mormons founded the settlement of Nauvoo in a relatively undeveloped part of Illinois, but after a remarkable period of growth in that area, the increasing hostility of the gentiles—exacerbated by certain internal conflicts that had broken out within the Mormon community—led to the killing of Joseph Smith and his brother by a gentile mob. Brigham Young, Smith's successor, determined that the only way to create the Mormon Zion was to move into the wilderness far beyond the laws and the settlements of the gentiles. On February 4, 1846, the great exodus from Nauvoo began. The first substantial party of Mormons arrived on July 24, 1847, in the Salt Lake Valley, where they would begin to build anew. In ensuing years, thousands of Mormons crossed the Great Plains in one of the most effectively organized mass migrations of modern times, drawn on by the dream of a new Zion in the mountains.

The Mormon vision of a morally purified community ultimately placed an ineffaceable stamp on large areas of the West, for even though the separatism of the Mormon state was ended after the Civil War and polygamy was outlawed by a series of measures in the 1860s and 1870s, the Mormon church continued to flourish. In the twentieth century its vision of a purified separatist community within the modern state has been spread throughout the nation and the world through zealous proselytizing. The image of the West as God's country, so dramatically symbolized by the Mormon migration, continues to be an important component of the West's sense of itself far beyond the boundaries of the Mormon faith. Indeed, there are manifestations of the dream in forms that would horrify a good Mormon, such as the many communal establishments of young people in California and other western states. The hippie commune may seem a far cry from the austere piety of a Mormon family, but images affect different people in different ways. The expression may be different, but the dream of redemption through a purified community in the West underlies a great variety of specific manifestations.

In this particular version of the western myth, the Indian tends to be imagined in very different terms than the savage obstacle that must be bypassed or eliminated. In fact, the record of utopian communities in dealing with their local Indians is sometimes better than that of most pioneers. Among the Mormons, for example, although the settlement of Zion would

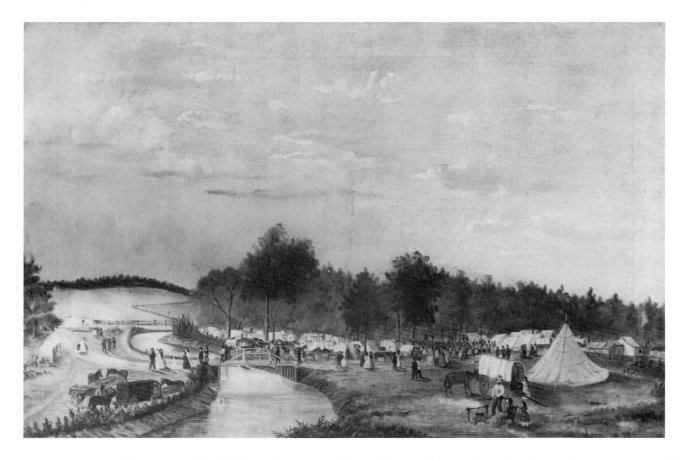

George N. Simons, *Mormon Camp Meeting, Council Bluffs*, oil on canvas, 17¼ x 26. Joslyn Art Museum, Omaha, Nebraska.

hardly have been possible without taking Indian land and there was a good deal of fighting with Indians who resented this intrusion, the general policy was an attempt at conciliation and conversion. Brigham Young is supposed to have said, "If a white man steals, shoot him. If an Indian steals, teach him better." But there was also a darker side to the image of the Indian sometimes evoked in connection with the vision of the purified community. For the Indian could also be seen as the ultimate moral antagonist, the agent of the devil symbolizing an unrestrained license and eroticism that posed a desperate threat to the religious community. In his recent study *Regeneration through Violence,* Richard Slotkin has suggested that the Puritans tended to project onto the Indians their own ambiguous feelings about the social, sexual, and religious restraints of the Puritan community. By making the Indians a symbol of diabolical temptation, Slotkin argues, the Puritans created a mythology centering around the figure of the Indian captive who was tempted to turn away from the religious community by nefarious enticements. The image of the Indian as erotic threat has been a central theme of western imaginings from the Puritan captivity narratives down to the "fate worse than death" so often threatened in more recent western novels and movies, though in fact sexual depredations by white men against Indian

women certainly far exceeded the instances of rape by Indian men against white women. In the Puritan mythology, as Slotkin points out, the moral threat represented by Indians was often so strongly felt that it had to lead to exorcism through violence, thus becoming an even stronger emotional and religious justification for the destruction of the Indian cultures.

This ambiguous fascination with the Indian as a symbol of erotic license also probably relates to the obsession with Indian rituals of torture and self-mutilation that was so often a central element in popular as well as scholarly literature about the West. While such practices did form an important part of some Indian systems of belief, images of the Indian as fiendish torturer and participant in orgiastic sexual ceremonies were far enough from actuality to suggest that the striking emphasis in popular story and painting on this aspect of Indian life was some form of psychosexual projection for the public. But just as the Indian could be construed as a diabolical fiend and a scapegoat to exorcize impulses that Americans preferred not to confront in themselves, so also could he be idealized into a figure of noble heroism, as he frequently was in conjunction with other mythical images of the frontier.

3. From a literary and artistic point of view, one of the most important and vital images of the West was as a place where one might escape from the artificial and corrupting boundaries of society into a spontaneous and open relationship with nature. Though this image was in some ways even less tied to actuality than the visions of pioneering and the purified community on the frontier, and was also quite antithetical to these other western myths, the vision of the West as escape into nature has maintained an extraordinarily potent hold over the American imagination from the seventeenth century to the present day. Even the austere Puritan community could generate its mythical antithesis in the fascinating figure of Thomas Morton of Merrymount, who moved out of the Bay Colony into the wilderness not to find God but to enter upon a harmonious and spontaneous life in nature and with the Indians. Though his own experimental settlement was quickly suppressed by the Puritans, Morton's rebellion against the constraints of civilization has had innumerable echoes in the images of writers and artists since his time. One need only mention such creations as Cooper's Leatherstocking hero, Thoreau's *Walden*, Twain's Huckleberry Finn and his final departure for the "territory," or A. B. Guthrie's lone trapper in *Big Sky* to realize how basic this image has been to American literature and thought.

In contrast to most of the other western mythologies, the image of the West as escape from society has usually had an extremely important and even highly sympathetic role for the Indian. In this myth the Indian became the positive symbol for whatever natural virtues were being projected onto the frontier. The American Indian as noble savage crops up with considerable frequency in Europe and America throughout the eighteenth century, but it was certainly the Leatherstocking tales of James Fenimore Cooper that established the noble image of the American Indian for the nineteenth and twentieth centuries. In his characterizations of Uncas and Chingach-

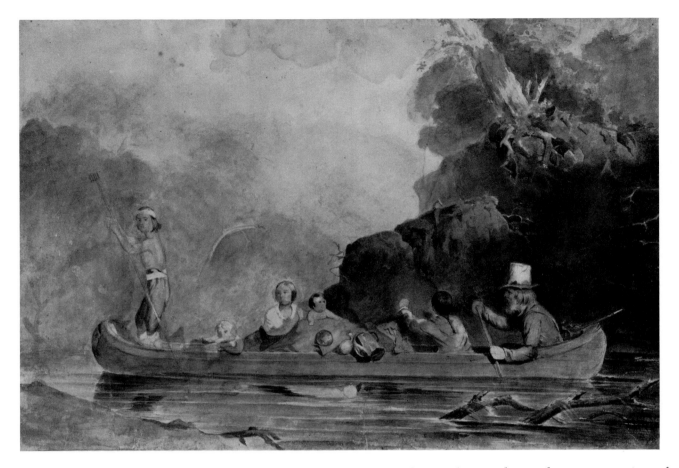

Charles Deas, *The Trapper and His Family*, watercolor on paper, 13⅜ x 19½. Museum of Fine Arts, Boston, Massachusetts; M. and M. Karolik Collection.

gook, the last of the Mohicans, and in such episodes as the tragic oration of Tamenund, the king of the Delawares, Cooper gave an unforgettable embodiment to the portrait of the noble Indian as last of his race, lamenting in splendid mournful periods the Vanishing American, yet accepting it all in good spirit with stoical resignation to the will of the Great Spirit. It was not difficult to feel the greatest sympathy and respect for this mythical figure, and throughout the last century his effigy looked out from numerous novels, paintings, and sculpture. The Vanishing American at the end of the last trail has always been a favorite theme for sculpture in bronze, but the image of the final lament of the last of his race has also played its role in history as well. Many statements and petitions were made by Indians to the American government and the public throughout the nineteenth century, and very few were heard, just as very little effective public sympathy was aroused for Indian rights. But the one form of Indian expression that seemed invariably to be greeted by the public with great interest and an enormous outpouring of sympathy was that which embodied the mythical image we have just depicted of the noble Vanishing American philosophically accepting his fate. From Chief Logan's eighteenth-century elegy for a dying people to

Unidentified Artist, *Louden and Company's Indian Expectorant* [patent medicine label], 1848, engraving. Library of Congress, Washington, D.C.

Chief Joseph's surrender speech at the end of the Nez Percé war, such statements were widely reprinted, became favorite set speeches, and brought tears to the eyes of the conquerors. Even today, the legend of Chief Joseph, the philosopher who became a warrior and fought the American government to a standstill and then surrendered in the immortal words "from where the sun now stands I will fight no more forever," is a frequent subject of novels, films, and television programs, and may very well be on the way to replacing Custer's Last Stand as the episode of the long white-Indian conflict most magnetic for the American imagination. All this is not to say that Chief Joseph was not a great man in a completely nonmythical way but that the public perception of his greatness was deeply shaped by the long-lived mythical image of the Indian as primitive philosopher and noble savage.

Another highly positive image of the Indian exploited his capacity to stand for a special relationship with nature as a popular advertising symbol. Innumerable nineteenth-century patent medicines, food products, and other items in which the qualities of purity, potency, and naturalness were deemed important made use of the figure of the Indian warrior, medicine

Edward Mendel, *Bennett Pieters and Company's Red Jacket Stomach Bitters* [patent medicine label], 1864, lithograph. Library of Congress, Washington, D.C.

man, and maiden as a primary image for the purposes of advertising. Tonics, flours, tobaccos, soaps, and many other products were sold with such appeals. It may be that in this use of the Indian as advertising image we find a transformation into positive terms of the myth of the Indian as figure of incredible erotic potency and diabolical temptation, but whatever the psychological sources of the pervasive image of the Indian as guarantor of purity and potency for foods and medicines, it remains a puzzle for the ironist to ponder that Americans could imagine the Indian as supreme expression of an ideal state of natural health, vigor, and purity, while accepting the inevitable rightness of his expropriation and destruction. Indeed, it is not unfair to say that one of the burdens white Americans have continued to lay upon the Indian is that of mythical idealization, a tendency we ought surely to watch out for even in ourselves.

The image of the noble savage pervades much early-American art about the Indian. It is not really until the second quarter of the century that a style for the portrayal of Indians based more closely on the gradually accumulating record of visual documentation and direct experience began to develop.

George Catlin, who set out in the 1830s to study each of the Indian cultures, was in his life and art one of the great mid-nineteenth-century American uniques. Like Walt Whitman, he was in many ways a self-taught artist, and the creator through personal choice of his own artistic tradition. Thus, he was able to establish, in the Emersonian phrase, an "original relationship with the universe" to a greater extent than most of his contemporaries. Such an artist could understand and represent the American Indian in a new manner. This does not mean that Catlin was completely uninfluenced by the artistic conventions and cultural attitudes of his day. He was far from immune to the fashionable contemporary romanticism with its myth of the noble savage. One of Catlin's most striking and memorable portrayals, his double portrait of the Assiniboin, *Pigeon's Egg Head (The Light) going to and returning from Washington,* shows the deep bitterness the artist felt at the degradation of the Indian's magnificent natural nobility resulting from his corrupting encounter with the white man.

While the painting represents in its contrasting images the destruction of the Native American cultures, it also suggests how important the idealized symbol of the natural man in his barbaric splendor was to the American imagination, and how that overly romanticized response could easily turn to an excessive feeling of disgust and anger when, after encountering the complexities and temptations of white civilization, the Indian failed to live up to his heroic image. Ironically, Americans apparently preferred to see their imagined Indians go down to heroic defeat with splendid sentiments on their lips, than for them to have to deal with the anguish and the dilemmas of surviving and accommodating. While it would be deeply unfair to Catlin to say that his profound dedication to and love for the Indian reflected any such ambiguities, the popular image of the noble savage as it

George Catlin, *Great Chief*, 1831, oil on canvas
mounted on aluminum, 21⅛ x 16 7/16. Smithsonian
Institution.

George Catlin, *One Sitting in the Clouds, a boy*, 1831,
oil on canvas mounted on aluminum, 21⅛ x 16 7/16.
Smithsonian Institution.

George Catlin, *Bread, the chief*, 1831, oil on canvas
mounted on aluminum, 21½ x 16¾. Smithsonian
Institution.

George Catlin, *Woman Who Lives in the Bear's Den,
her hair cut off in mourning,* 1832, oil on canvas
mounted on aluminum, 29 x 24. Smithsonian
Institution.

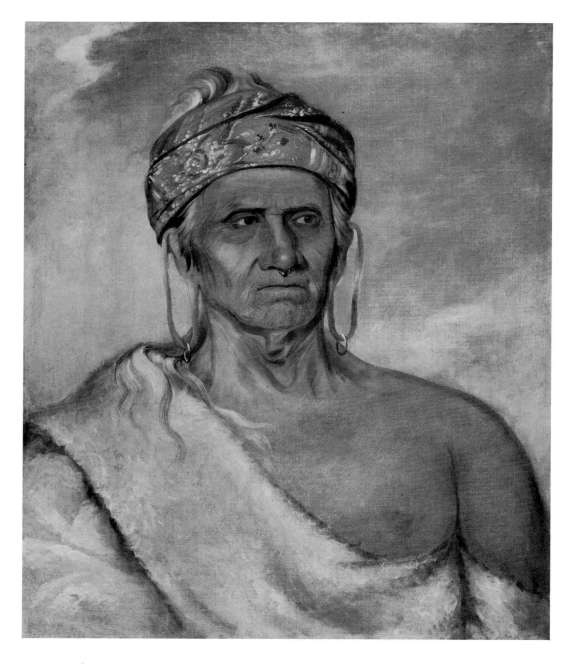

George Catlin, *Goes Up the River, an aged chief*, 1830,
oil on canvas mounted on aluminum, 29 x 24.
Smithsonian Institution.

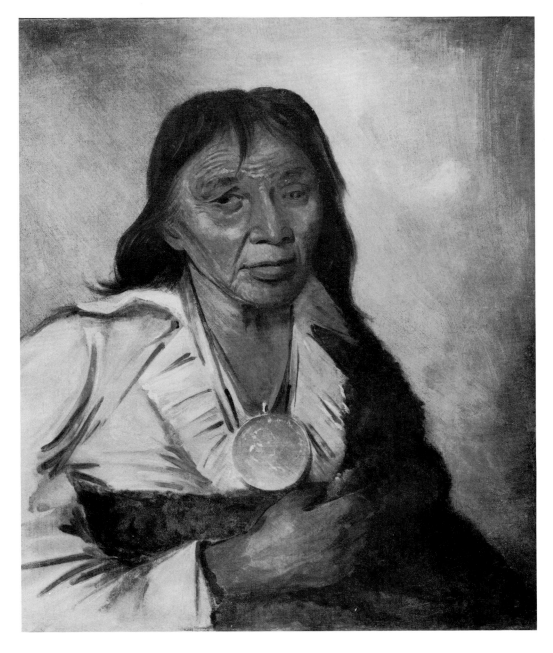

George Catlin, *Big Sail, a chief*, 1836, oil on canvas
mounted on aluminum, 29 x 24. Smithsonian
Institution.

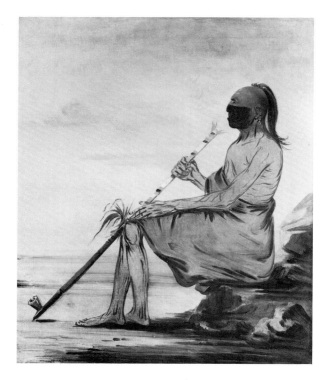

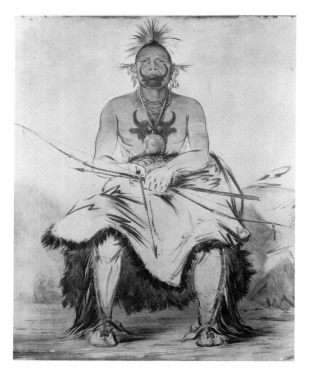

George Catlin; top: *The Owl, an old chief*, left, 1836; *Buffalo Bull, a Grand Pawnee*, right, 1834; bottom: *Two Comanche girls*, 1834; oil on canvas mounted on aluminum, 29 x 24. Smithsonian Institution.

OPPOSITE:
George Catlin; top: *Wáh-chee-te, wife of Clermont, and child*, left, 1834; *Jú-ah-kís-gaw, woman with child in cradle*, right, 1835; bottom: *Strutting Pigeon, wife of White Cloud*, left, 1844; *Chée-ah-ká-tchée, wife of Nót-to-way, a chief*, right, 1835-36; oil on canvas mounted on aluminum, 29 x 24. Smithsonian Institution.

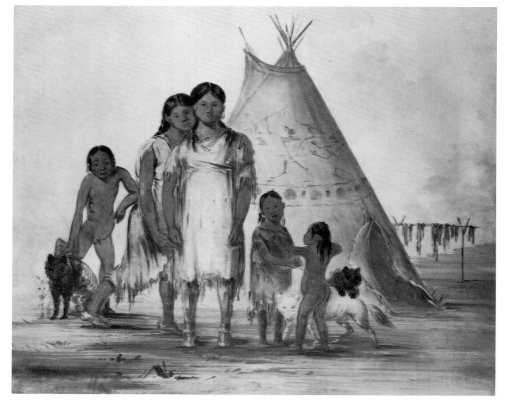

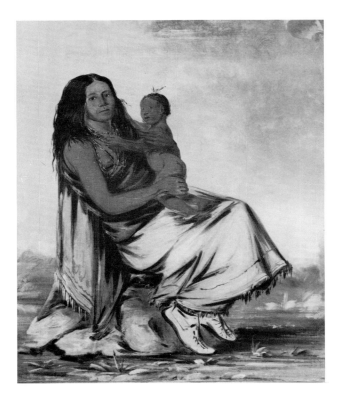

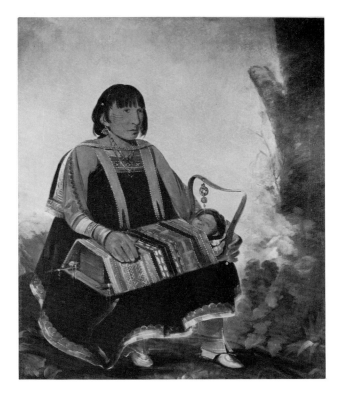

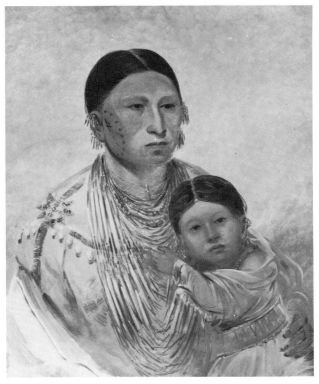

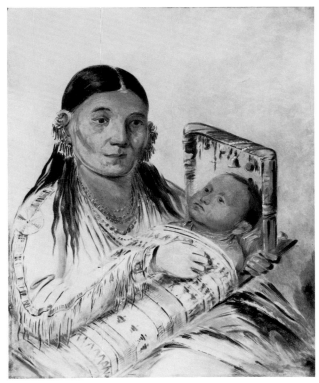

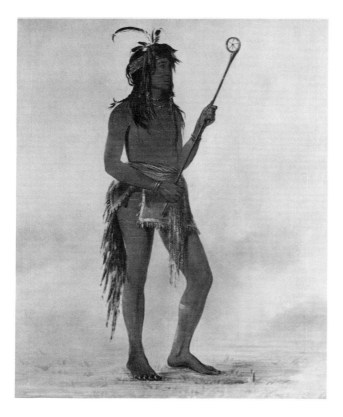 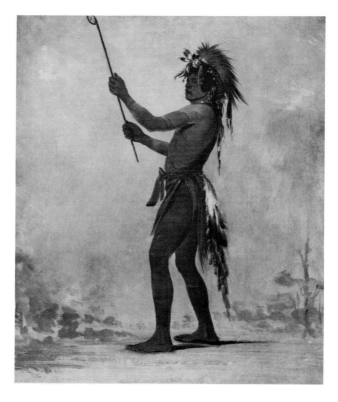

George Catlin; left, *He Who Stands on Both Sides, a distinguished ball player;* right, *Red Man, a distinguished ball player;* oil on canvas mounted on aluminum, 29 x 24. Smithsonian Institution.

OPPOSITE:
George Catlin; top: *Ball play of the Choctaw—ball up,* 1834; bottom: *Ball play of the women, Prairie du Chien,* 1835; oil on canvas mounted on aluminum, 19½ x 27⅝. Smithsonian Institution.

164

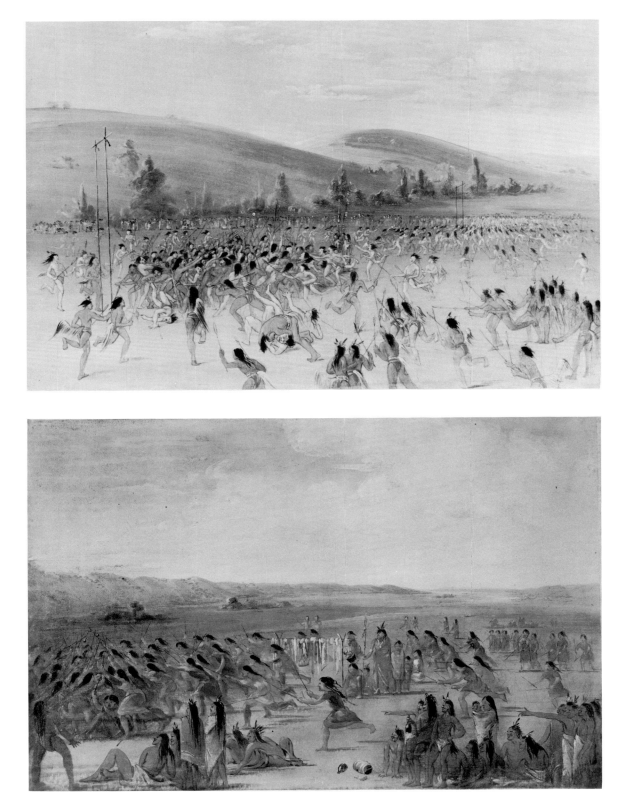

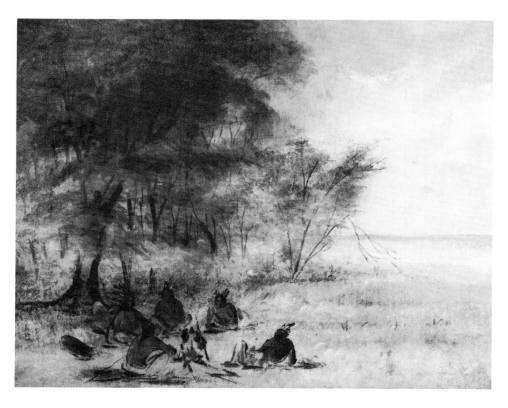

George Catlin; top: *Sioux Indian Council*, 1835-37; bottom: *Wild Horses at play, Texas*, 1834; oil on canvas mounted on aluminum, 19½ x 27⅝. Smithsonian Institution.

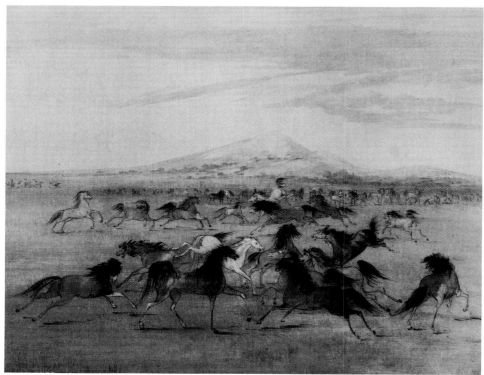

166

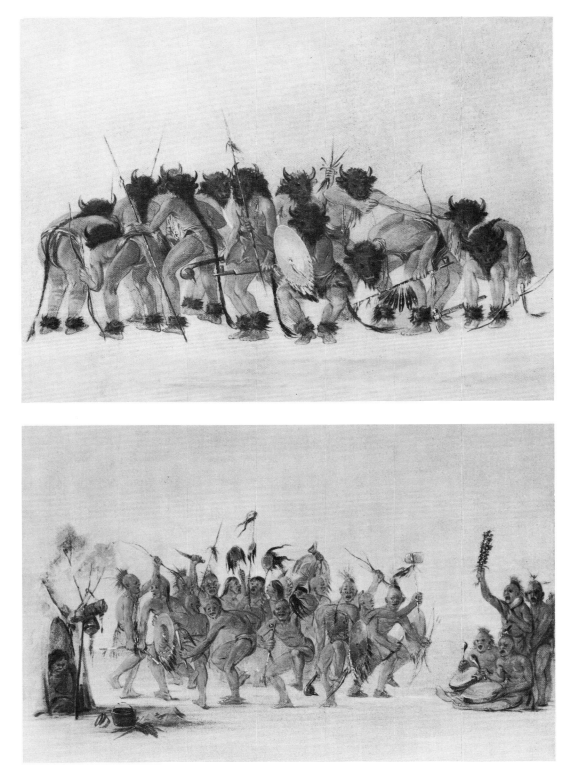

George Catlin; top: *Mandan buffalo dance,* 1835-37; bottom: *Dance to the medicine bag of the brave,* 1835-37; oil on canvas mounted on aluminum, 19½ x 27⅝. Smithsonian Institution.

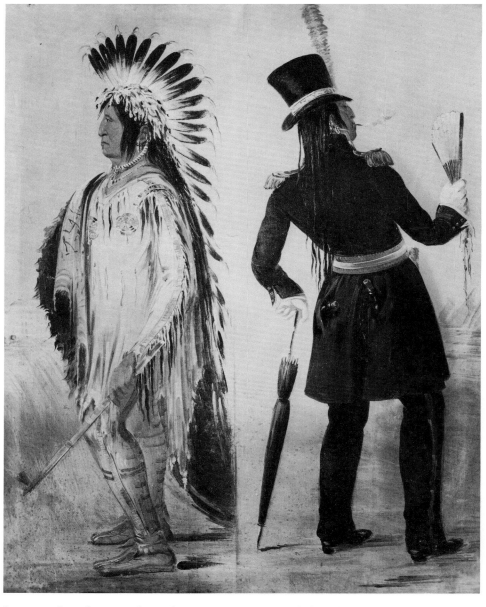

George Catlin, *Pigeon's Egg Head (The Light) going to and returning from Washington*, 1831-32, oil on canvas, 29¼ x 24¼. Smithsonian Institution.

has so often been reflected in song, story, and film has made it easier for Americans to ignore present conflicts by nostalgically focusing their emotional attention on the irretrievably lost glories and attractions of the Vanishing American.

As Ralph and Natasha Frier have pointed out, the popular visual and cinematic image of the Indian is almost totally identified with the nomadic horse and buffalo cultures of the plains. More than any other Native Americans, the Plains Indians have come to exemplify for Americans that sense of mystery and otherness on a heroic scale that is so important to our imaginings about the frontier. With their nomadic way of life, their appar-

ent closeness to nature, their mystical religious practices, and their dramatically splendid sense of dress, the Plains cultures have come to stand for the Native American. Though anthropologists tell us that Indians did not even live in this way on the plains until the introduction of the horse in the seventeenth and eighteenth centuries, and thus, that many characteristic patterns of Plains culture are no more than two or three hundred years old, the Sioux, the Cheyenne, the Comanche, the Kiowa, and the Apache have become well established in the American popular mind as the immemorial Indian. Aside from the drama, the color, and the ineffable excitement of the Plains life—those qualities that have drawn generations of American boys to fantasize about becoming Indians—several other factors have been involved in this selection of the Plains Indian as the ultimate heroic representative of the Vanishing American.

First of all, unlike the more settled eastern and southern woodland tribes, whose basic patterns of life were not that different from those of the white settlers, the nomadic patterns of the Plains tribes seemed dramatically antithetical to everything that white civilization represented. Therefore, it was imaginatively easier to treat them as noble enemy or as inescapably doomed savage. It was at least dubious, if not overtly mendacious, to insist that the settled agricultural eastern tribes were not making as effective a use of the land as the white pioneers, while it could be assumed easily, if not correctly, that the Plains Indians were using millions of acres of prime agricultural land to support a few roving bands of hunters and that this land could be put to far better use for all by white pioneers. Historical circumstances also conspired to thrust the role of exemplary symbolic Indian on this particular small group of the Native American population. The plains were the last major area to be approached by the pioneers, and it was there that the final battles between Indians and whites were fought in a period when transcontinental communications enabled persons in every part of the country to follow the course of the battles in their daily newspapers almost as they happened. Finally, there were such striking episodes as Custer's battle at the Little Bighorn and the Nez Percé war, which had aspects that coincided with already established mythical patterns about the frontier. In the end, it has been the heroic saga of the defeat of the Plains Indians that has eclipsed all other aspects of the complex history of white-Indian relations in the popular imagination, and in this mythical drama, the image of the Indian as doomed, noble warrior and natural man has played a crucial role.

Symbolizing heroic natural man doomed to extinction by the onrush of civilization, the Indian in this version of the western myth expressed a romantic nostalgia for a closeness to nature and for virtues and potencies seemingly lost in the complexities of modern civilization. A similar role was played by the cowboy in many later versions of the western; when Owen Wister wrote in the preface to his novel *The Virginian* of the passing of the cowboy as "the last romantic figure upon our soil," he took comfort from

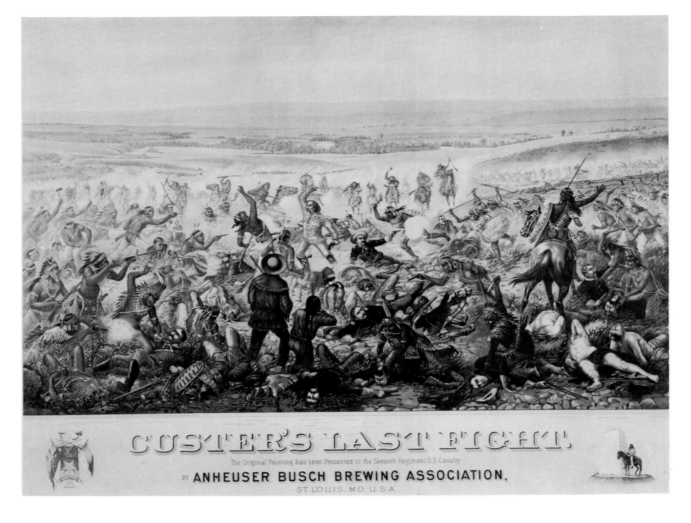

CUSTER'S LAST FIGHT
The Original Painting has been Presented to the Seventh Regiment U.S. Cavalry
BY ANHEUSER BUSCH BREWING ASSOCIATION,
ST. LOUIS, MO. U.S.A.

Unidentified Artist, *Custer's Last Fight*, 1896, chromolithograph, 24 x 38. National Museum of History and Technology, Smithsonian Institution; Henry T. Peters "America on Stone" Lithography Collection.

the thought that the cowboy represented qualities that are still present in men, because they are a basic part of human nature: "his wild kind had been among us always, since the beginning: a young man with his temptations, a hero without wings." Such a fascination with wildness and openness has been a crucial part of the imaginative meaning of the frontier throughout much of the nineteenth and twentieth centuries. Just as the vision of the West as locus of a purified and redeemed religious community tended to portray the actual inhabitants of the West as diabolical agencies that had to be feared for their tempting potency and exorcized and purged with violence, the dream of the West as escape into nature generated an antithetical vision of the Indian or cowboy as ideal liberated man. Of course, the inevitable passing of the noble savage and the heroic cowboy made it finally unnecessary to confront the conflict of values involved in this version of the frontier myth. By reinvoking in literature, in painting, or in films the spirit of the Indian and the cowboy along with the whole aura of the Wild

F. O. C. Darley, *Wyoming, First of a Series of National Engravings*, 1852, chromolithograph, 19¼ x 25⅝. National Museum of History and Technology, Smithsonian Institution; Henry T. Peters "America on Stone" Lithography Collection.

West, one could imagine that the positive aspects of this spirit might be kept alive in an urban industrial world without having to accept the continual warfare and killings that had actually accompanied the white encounter with the Indians. After the final defeat of the Plains tribes in the 1870s and 1880s, a number of men in different artistic fields made an ineffaceable mark on American culture by giving literary, artistic, and dramatic form to the image of the Wild West. Among the most important of them were the novelist Owen Wister, the showman-entrepreneur William F. Cody ("Buffalo Bill"), and the artists Frederic Remington and Charles M. Russell. These creators, along with many contemporaries who also responded to the cultural need for an image of the West as a place of epic action, heroic individualism, and liberated wildness, created the artistic forms which, through the later development of the western film in the twentieth century, would come to embody a vision of the American West as a special landscape of the imagination for people around the world.

It is simple enough to demolish the historical veracity of the imaginative vision of the Wild West by showing, as many careful historians have done, that it was not like that at all; that western society in the later nineteenth century was, on the whole, more concerned with creating cities, industries, and large agricultural enterprises than it was with chasing Indians and outlaws and shooting it out on the main street at high noon; that there was probably far less violence and wildness in the West than in the slums of New York City; that there was only a fraction of the number of vigilante

Charles M. Russell, *A Desperate Stand*, 1898, oil on canvas, 24⅛ x 36⅛. Amon Carter Museum, Fort Worth, Texas.

episodes and lynchings in Wyoming and Montana that there was during the same period in Alabama and Mississippi; that most of the Wild West's favorite heroes had feet of clay; and that the heroic episodes that have been the staple features of novels, paintings, and films either did not take place at all, or were quite unlike the standard portrayals, or were largely tangential to the historical and cultural development of the Far West. Yet such considerations of fact have never muted the appeal of the call to high adventure. As it used to be put in the introduction to the adventures of the Lone Ranger, "Come back with us now to those thrilling days of yesteryear, when out of the past came the thundering hoofbeats of the great horse Silver."

The image of the Wild West created by late nineteenth-century artists, writers, and showmen was in many ways a more elaborate and sophisticated version of the West of the dime novel, which had in turn evolved from Cooper's great series of western adventures, the Leatherstocking tales. But there was an important difference. Cooper's novels centered around a small band of people pursuing or being pursued by Indians through the pathless forest. His stories required such a landscape because his main thematic concern was the complex dialectic between civilization and nature conceived as

Charles M. Russell, *Breaking Camp*, circa 1885, oil on canvas, 18½ x 36¼. Amon Carter Museum, Fort Worth, Texas.

a spiritual force. Nature was for Cooper a primary locus of action, for it was there that man confronted the ultimate truths. In the modern image of the Wild West, nature is background and vitally important as such—it is hard to imagine a western novel or film without some extensive representation of deserts, plains, or mountains. Yet, the heart of the action takes place in a particular kind of human society, a society that lies balanced between the conditions of lawlessness and anarchy and those of settled civilization. We can see this particular social background developing in the later dime novels and in the western writings of men like Mark Twain and Bret Harte. For example, the following description from an 1878 novel entitled *Deadwood Dick on Deck* represents the basic Wild West town that recurs throughout the novels, paintings, and films of the tradition:

> For a mile and a half along the only accessible shore of
> Canyon Creek, were strewn frame shanties and canvas tents
> almost without number, and the one street of the town was
> always full to overflowing with excited humanity. The monoto-
> nous grinding and crushing of ore-breakers, the ring of picks
> and hammers, the reports of heavy blasts in the rugged mountain-side,
> the shouts of rival stage-drivers, the sounds of music and
> tipsy revelry from dance-houses and saloons; the boisterous
> shouts of the out-door Cheap John, dealer in "biled shirts"
> and miners' furnishing goods, the occasional reports of revolver-
> shots, may be heard in the streets of Whoop-Up, no matter,
> dear reader if it be during the day or during the night, when
> you pay your visit.

173

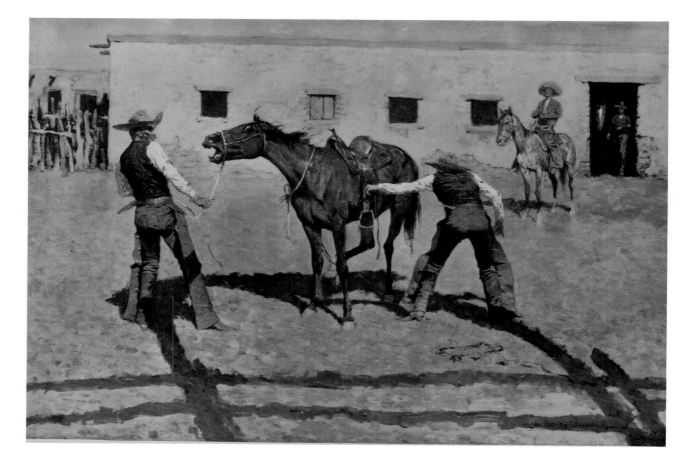

Frederic Remington, *His First Lesson*, 1908, oil on canvas, 27⅛ x 40⅛. Amon Carter Museum, Fort Worth, Texas.

The fascination of the frontier town depends, in part, on its very absence of order; it represents liberation from the normal rules of civilization, a place where the action is, where adventures can and do happen at all hours of the night and day. It is, in another favorite American phrase, a "wide-open" town and such contemporary western cities as Las Vegas and Reno have been consciously developed to elaborate this mythical vision of a town where the action never stops. One of Charles Russell's most delightful paintings, *In without Knocking*, is a wonderfully hyperbolic representation of this image of the frontier town. It shows a group of cowboys wildly riding their horses right off the dusty street and into the town's one major building, a hotel and saloon, while shooting off their six-guns. Not only the theme of the painting but also the wild and chaotic action the painting's composition conveys are expressive of the exuberant disorder, vitality, and naturalness of these men on horseback.

But while exciting adventure in a society where law and order have not yet laid down their repressive hand is a central theme of the Wild West, particularly in its more popular versions, there are other components to the image that created a richer and more compelling vision of liberation from

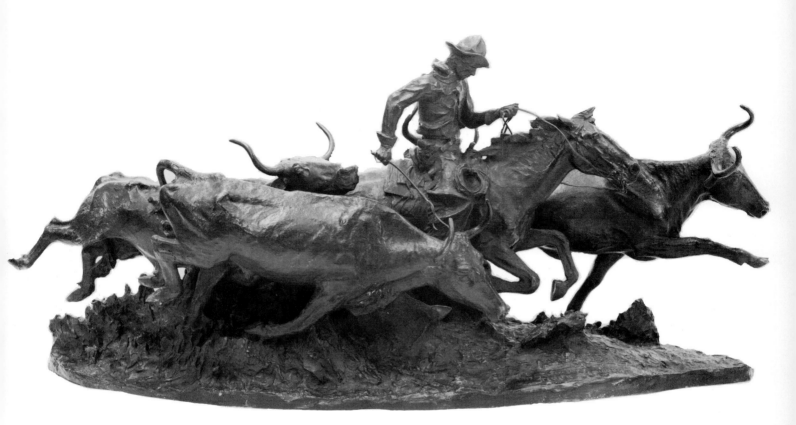

Frederic Remington, *The Stampede*, 1910, bronze, 22⅝ x 44⅝ x 14¾. Amon Carter Museum, Fort Worth, Texas.

the restrictions of modern civilization. The frontier town is a rickety, temporary, almost fragile collection of wooden frame buildings set against a natural background that evokes both danger and sublimity. Its shabbiness and lawlessness combine with the transcendent regenerative quality of the surrounding wilderness to evoke a new breed of men. Walter Prescott Webb, the great Texas historian, has left us a brilliant summary of this image of the Wild West in his description of the cattle kingdom, ineffably mingling mythical vision with historical knowledge to the point that it becomes impossible to separate them. Like Turner, Webb sees something absolutely unique in the frontier environment, but where Turner stresses political and social implications, Webb is drawn to an epic and heroic sense of the significance of the frontier:

> *Where population is sparse, where the supports of conventions*
> *and laws are withdrawn and men are thrown upon their own resources,*
> *courage becomes a fundamental and essential*
> *attribute in the individual. The Western man of the old*
> *days had little choice but to be courageous. The germ of courage*

175

had to be in him; but this germ being given, the
life that he led developed it at a high degree. Where men
are isolated and in constant danger or even potential
danger, they will not tolerate the coward. They cannot
tolerate him because one coward endangers the whole group.

Webb presents this heroic society of courageous men who, in the absence of traditional social institutions, made their own laws as a unique and lost moment in history:

The cattle kingdom was a world within itself, with a culture
all its own, which, though of brief duration was complete and
self-satisfying. The cattle kingdom worked out its own means and
methods of utilization; it formulated its own law, called the
code of the West and did it largely upon extra-legal grounds.
The existence of the cattle kingdom for a generation is the best
single bit of evidence that here in the West were the basis and
the promise of a new civilization unlike anything previously
known to the Anglo-European-American experience. . . . Since the
destruction of the Plains Indians and the buffalo civilization,
the cattle kingdom is the most logical thing that has happened
in the Great Plains.

Logical may not be exactly the right word, but this vision of a unique Wild West culture, based on courage and cattle, on horses and six-guns, on heroic individuals and their self-made law and order, has been a compelling image for Americans ever since the late nineteenth century.

Implicit in the vision of the frontier as Wild West were a number of different senses of liberation, some of which have become elaborated into images of their own. One of the most important might be labeled the Las Vegas syndrome. This is the image of the West as wide-open town mentioned earlier. Though its most massive and calculated representation is the contemporary city of Las Vegas, it has a long history, going back to Thomas Morton's Merrymount. The central idea of the wide-open town is that of a place on the edge of civilization where activities not permitted in settled communities—such as gambling and prostitution—can be carried on without legal penalty either because they are not against the law or because the agencies of order are too weak to enforce their prohibition. The existence of such towns permits the ordinarily well-regulated citizen, who would probably be the first to oppose the introduction of "immoral" activities such as these into his own community, to fantasize his own indulgence or even to go to such places for a temporary spree, without having to confront the consequences that would follow from permitting such liberation in his hometown. I shall never forget a plane trip I once took from Chicago to Las Vegas. Most of the passengers were obviously members of the upper middle class, well dressed and genteel in their behavior. However, as the

plane approached Las Vegas an air of boisterousness and excitement began to arise and as soon as the plane had landed, there was a stampede of well-dressed matrons rushing for the slot machines so conveniently placed in the arrival lounge. These were obviously pillars of society, yet they yearned for a brief period of legitimated participation in the fantasy of wide-openness as a respite from the respectable responsibilities of most of their days.

This image of the wide-open town was a favorite throughout the later nineteenth century. A large number of the early photographs of the West focus on the wildness of the frontier towns and their liberated revelers—the gamblers, outlaws, and dance hall girls who personified escape from the restraints of civilization. In stories like those of Bret Harte, and in popular journalistic accounts in magazines and newspapers, the image of "hell on wheels"—the railroad construction town or the wide-open mining town or cowtown—fascinated easterners and played an imaginative role in the lives of many people, the great majority of whom would never go near such a place. Of course, there was some reality behind the images; good myths are usually intensifications and dramatizations rather than total falsifications; yet at the same time there was certainly as much gambling, prostitution, and violence in almost any large nineteenth-century city as in a dozen mining camps or cowtowns. The special appeal of the frontier town was, as we have suggested before, its otherness. Since "hell on wheels" was removed from the experience of most Americans, it was easier to build fantasies around it that were not threatening to the average city dweller in the way that urban gambling and red-light districts were. In addition, because it was imaginatively distant, the wide-open frontier town could be envisioned as made up of a riotous bunch of happy, liberated individuals who did not have to count the social or individual cost of their untrammeled delights.

In the twentieth century, the image of the wide-open town has continued to play its role in western stories, films, and paintings, as an important part of the background of the Wild West. The image has also been organized and commercialized in wide-open cities like Las Vegas that preserve some of the original fantasy by emphasizing their difference from the rest of the country. In Las Vegas night and day are the same as one moves with increasingly leaden gaiety from one casino or burlesque show to another. In this ambiance anything seems permissible, and every effort is made to make this bastion of modern industrial capital and real estate development seem like a synthesis of the Old West with all the international glamor and exoticism that the twentieth century has added to the vision of moral liberation.

There is yet another side to the vision of the frontier as liberation that seems, at first glance, completely at odds with the image of the wide-open town. The greatest embodiment of this vision is Henry David Thoreau's masterpiece *Walden,* and though Thoreau's frontier was nothing but a small lake and a patch of woods a few miles from Concord, Massachusetts, his quest in nature for a transcendent union with reality and the self has often

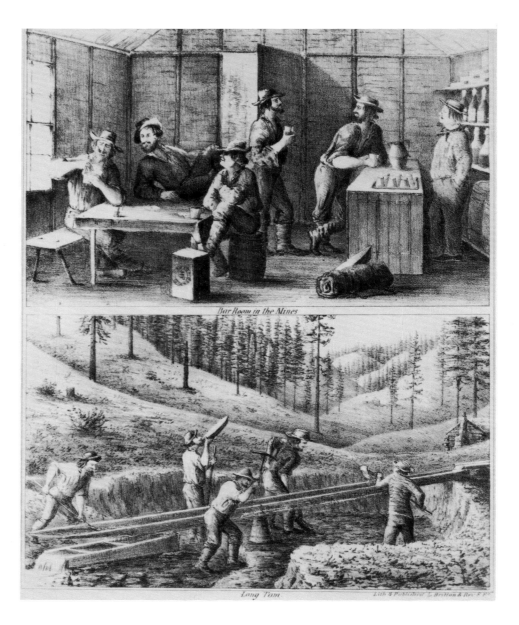

Britton and Rey, *Bar Room in the Mines* and *Long Tom*, 1852-58, lithograph, 9¾ x 7⅝. National Museum of History and Technology, Smithsonian Institution; Harry T. Peters "America on Stone" Lithography Collection.

been echoed in imaginings about the West. Thoreau himself saw the West as a symbol not of flight from civilization but as man's urge to a higher level of self-realization and discovery. The Walden impulse has been an important inspiration for many of the greatest western landscape artists and photographers.

Wilderness as transcendent union with reality in nature and wildness as escape from the constraints of civilization are visions that have some ambiguous similarities, despite their great differences. Both represent escape from the conventional and the ordinary in a quest for spontaneity and openness, and the kind of excitement and risk that is largely absent from the

settled life. Indeed, wilderness and wildness are often combined in the legends and images of the West. It is a bit difficult to imagine Thoreau playing the wheel at Caesar's Palace, but, on another level, the myth of the cowboy contains elements from both Walden and Las Vegas. The cowboy passed most of his time in communion with the wilderness and animals. His code of courage and honor, together with his love of the wide-open spaces, represented a morality of natural simplicity and innocence that transcended the artificialities of civilization. Yet the cowtown, the saloon, the gambler, and the dance-hall girl were also central to the myth. After the heroic passage of the cattle drive, the cowboy's dearest aspiration was to be the hardest-drinking and hardest-fighting and hardest-wenching man in Dodge City or Abilene, though he was somehow able to indulge in these activities without losing his natural purity and innocence. Even today this mythical pattern recurs when campers work their way from wilderness to wilderness in specially designed vehicles until, having played at Walden, they arrive in Las Vegas and the games become blackjack, roulette, and burlesque.

4. The fourth image of the frontier stressed its potential as a place of sudden wealth and power, a place where in a single stroke of luck an individual might sweep from poverty to millionairedom. Just as the image of pioneering, with its goal of a decent, progressive settlement, can be seen in terms of the Garden of Eden myth, and the vision of the morally purified community obviously grew out of millennial hopes, the imagining of the West in terms of wealth and power was an extension of the myth of Atlantis, or the great lost kingdom to the west. Dreams of great treasure to be found in the West appeared early in the exploration of the New World and gained additional currency and force after reports of the Spanish conquest of Mexico and South America, where great cities and their wealth seemed to give a solid incarnation to the wildest dreams of avarice. Though such cities and such treasure were not immediately discovered north of Mexico, legends flourished not only of great cities and hoards of gold and silver but of objects of even greater value, such as the water from the fountain of youth.

In its simplest form, the image of the frontier as wealth and power was a dream of gold to be easily taken from a hole in the ground or an unresisting Indian. For the one lucky enough to find it, the treasure would lead to a dramatic transformation in life's circumstances. Some no doubt dreamed of gold as a route to power, others as a means of sensuous indulgence; because of this, the image of the frontier as treasure was often linked very closely with the dream of escape from restraint as exemplified in the wide-open mining town. Yet, one also senses that there was perhaps an even greater representativeness in the Colorado miner who, on discovering a vein of gold, threw down his pick and shouted, "Thank God, now my wife can be a lady and my children can have an education," converting the myth of treasure back into the vision of the West as pioneering. Whatever the underlying

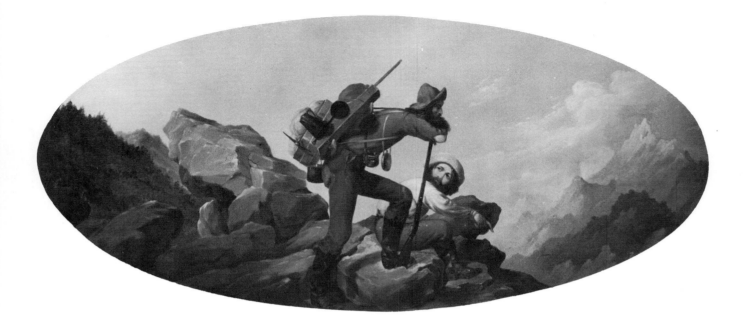

E. Hall Martin, *Mountain Jack and Wandering Miner*, 1850, oil on canvas, 39½ x 72. The Oakland Museum, California; Gift of Concours d' Antiques.

motives, the history of the West has been deeply shaped by the dream of buried treasure. The lure of Indian gold drew on the early explorers and settlers and, after the discovery of gold in California, rumored and actual strikes drew hordes of the hopeful to place after place from Arizona to Alaska. The prospector joined the cowboy as one of the archetypal western figures.

Although not quite as important a source of artistic inspiration as the image of the frontier as escape and transcendence, the dream of the West as treasure has been particularly important as a basis for comedy and satire. Perhaps because the quest for gold could be seen as so open an expression of the selfishness, folly, and greed that are not always easy to separate from the pursuit of the American dream, comic writers and artists have taken a particular delight in constructing their works around the American as gold miner. As if the miners themselves sensed the comic dimension of their frenetic activity, humor flourished in the gold camps and a number of important American writers did some of their apprenticeship in the gold fields. The two greatest were Bret Harte and Mark Twain. Another great comic treatment of the West as quest for gold was Charlie Chaplin's 1922 film *The Gold Rush,* which ironically contrasted the lunacy of men possessed by the dream of gold with the vast indifference of nature and poked delightful fun at man's willingness to undergo incredible dangers in the pursuit of his obsession. Frank Norris essayed a tragic treatment of a similar theme in his *McTeague,* where the lust for gold turns the protagonist's wife into a

miserly shrew and himself into a brutal murderer. Many artists and photographers have been fascinated by the ambiance of the mining camps, some seeing in them primarily the colorful and unrestrained exuberance of the myth of the Wild West, while others have sought to evoke in their portrayals a deeper symbolism of the ethos of American life as unrestrained pursuit of wealth.

The Indian occupies a curious place in the myth of the West as quest for gold. In some versions of this myth, as in the myth of the pioneer, the Indian is simply an obstacle to be pushed out of the way, although, since the 1930s, moviemakers have often catered to our nostalgic guilt about the past by characterizing the untrammeled lust for gold as one of the chief causes of wrongful encroachment on the Indian hunting grounds. For example, in Raoul Walsh's highly romanticized biography of Custer, *They Died with Their Boots On* (1944), Custer is portrayed as basically sympathetic to the Indians and tragically forced into action against them when aggressive hordes of gold seekers invaded the Black Hills. This, of course, comfortably projects the blame for the expropriation of the Indians onto a few nasty, greedy men caught up in the gold-rush madness. But there was another, more complex, image of the Indian that was often associated with the dream of the frontier as hidden treasure. Because the Spaniards had found great Indian civilizations with their treasures in Mexico and South America, the dream that such glories might be found on the North American continent also developed and found expression in the legends of El Dorado, the lost cities of Coronado, and later in the legends of lost mines. Since great cities were not discovered as the West was explored, many Americans came to believe that the native inhabitants of the North American continent were degenerate descendants of great past cultures and that they still possessed the secret of the location of vast treasures that were no longer meaningful to them. A favorite version of this myth identified the American Indians as descendants of the ten lost tribes of Israel, a belief which, considerably elaborated, became a central part of the revealed history recorded in the Book of Mormon. Others identified the Native Americans as degenerate descendants of other European and Classical cultures. While these imagined origins for the North American Indians had other roots, and were in fact postulated by many noted nineteenth-century scholars, in the popular mind there was an inextricable imaginative connection between the Indians as corrupted descendants of lost civilizations and the dream of hidden treasure.

The imagining of gold on the frontier was only one way in which the West was conceived in terms of a mythical drama of wealth and power. It was also easy to see in the West a new field for individual enterprise, for the sort of boosterism and go-getterism that, as historian Daniel Boorstin points out, was so central to the ethos of the western settlement. Where the myth of the pioneer stressed the transplantation to the West of a settled society of family farms and supporting small towns, the booster imagined

181

the West as a place of cities sprouting everywhere, of dramatic increases in values, and of large agricultural and extractive industries. The frontier was to be rapidly developed as a source of food and materials for the East, and this was a process in which organizations and large speculative risks would lead to sudden wealth and power for those individuals and communities fortunate enough to take advantage of the rapid surge of national growth. This image often led to the erection of a lavish hotel as one of the first permanent buildings in an aspiring western settlement as a suitable enticement for the enterprising businessmen who were sure to pour into the town and make it hum.

Finally, still another version of the frontier as new wealth and power has always captured the imagination of some Americans. This was the dream of a great American empire in which the frontier was primarily conceived as the last link in a great chain of power and wealth stretching between the oceans and ultimately bringing about a true passage to India by linking the continents under the aegis of American greatness and power. Henry Nash Smith has shown how the vision of empire, with its expansive dream of a great national destiny, played a role in shaping American policy toward the West by entering into a rather complex and ambiguous dialectic with the different myth of the Garden of the World, that vision of the continental interior as an agrarian paradise, which was one major component of the image of the pioneer. According to many proponents of the frontier as new empire, America's destiny was to use its great wealth and power to redeem the world for morality and democracy, thereby combining in a rather ambiguous way elements of the differing images of the frontier as purified community and as great empire. Unfortunately, this country in recent years was to have great trouble extricating itself from the consequences of an extension of this vision to Southeast Asia.

Thus, four complex images shaped American perceptions of the frontier and the Native American: the image of the pioneer, of the redeemed community, of the frontier as escape or transcendence, and of the quest for gold and empire. Each of these images depended on a different set of perceptions, aspirations, and values to the degree that, logically speaking, they seem to reflect four conflicting purposes, each antithetical to the others. But, as a complex collective entity, a culture does not imagine its development in terms of abstract logic. In most cultural and artistic expressions of the image of the West, we can actually discern a number of these conflicting versions of the myth of the frontier, sometimes in a state of uneasy tension, sometimes more deeply linked through a richer act of the imagination, sometimes in outright conflict that is never finally resolved. Sometimes we see expressed two very different images of the West in the work of the same man, as in George Caleb Bingham's glorification of the myth of the pioneer in his painting of Daniel Boone, and his even more compelling evocation of the image of the frontier as escape and transcendence in his brilliant painting of two Missouri riverboatmen isolated in the mystic territory of an

endless flow of water and space. The important popular genre of the western novel and film can perhaps be most clearly defined as a dramatization of the imaginative struggle between the myth of the pioneer and the fantasy of the West as escape from civilization, for, in most westerns, the central conflict is between incoming settlers or townspeople and outlaws or Indians. The townspeople represent law, order, and settled civilization, but they are weak and unable to defend themselves against the force of the outlaws or Indians, who symbolize wilderness potency and lawlessness. To resolve the conflict, a hero must emerge who is even more skillful in violence than the outlaws, but who is ultimately committed to the cause of the pioneers. Thus, the typical western plays out the fantasy of the West as escape and wildness, but in the end converts the central figure of the fantasy, the heroic cowboy or gunfighter, into a hero in the myth of pioneering. More recent western films, particularly those made since 1960, have reflected an increasing public disillusionment with the myths of pioneering and progress by placing their central emphasis on the theme of the passing of the Old West and the consequent decline of heroism and courage. A classic embodiment of this theme, Sam Peckinpah's *Ride the High Country*, presented two aging western heroes, played with aching backsides and arthritic twinges by two superannuated western actors—Joel McCrea and Randolph Scott. In the course of the film, these elderly gunfighters, now threadbare and down at the heels because their way of life has been rendered obsolete by progress, undertake one last heroic quest, culminating in a classic shootout in which the two protagonists are once again transformed into figures of epic power and courage. But this is the last time. Joel McCrea is killed in the gunfight and, while Randolph Scott survives, it is clear that he will never again become, even momentarily, a figure of heroic dimensions. The myth of the pioneer finally triumphs over the dream of the West as wildness, but the cost of the triumph seems to play an increasingly important role in our imaginative perceptions of the drama of the West.

The Image of Urban Optimism

The Image of Urban Optimism

When F. T. Marinetti began launching his manifestoes on behalf of "futurism" in 1909, exalting speed and modern technological progress and condemning all adherence to tradition, some European critics were quick to suggest that the point of view was curiously American, typifying what they assumed to be the American attitude toward culture. Certainly there was nothing occurring in American art at the time that would make such an association seem reasonable. Nonetheless, to the European the image of a bustling, iconoclastic America with skyscraper cities, production-line manufacturing efficiency, and a burgeoning automobile industry with its attendant cult was a reality, even though most Americans did not recognize it. So unlikely a person as Eugene Jolas, the expatriate publisher of *transition*, wrote in 1930:

> The mechanical surrounds us like a flood. The machine and its relations to man is doubtless one of the major problems of the age. Ever more accelerated becomes the tempo, ever more whirling are the pistons, ever more violent is the influence of this titanic instrument upon the thoughts and acts of man.
>
> It is in America and Russia that the mechanistic civilization is reaching the zenith. America is the leader, however, for on its continent the social and human structure is ineluctably permeated with the ideology of the machine. The excited interest which Europe is taking in everything American is a sign of the times. ["The Machine and Mystic America," *transition*, June 1930.]

As with the vernacular and the frontier earlier, the romance of industry and the towering city seems to have been most intense at a distance. Again America was to discover itself with the help of foreign eyes.

To be sure, Robert Henri and his youthful followers were concerned with the city, but hardly as an environment of efficiency and promise. Their spunky, pugnacious people carried on in spite of the city, bringing a robust, rustic vitality into the confines of the impersonal urban structure. The

187

John Sloan, *6th Avenue and 30th Street*, 1908, lithograph, 14¼ x 11⅛. National Collection of Fine Arts; Gift of Mr. and Mrs. Harry Baum in memory of Edith Gregor Halpert.

promise for the future was in the vulgar energy that could withstand the demands made by city living, not in the fabric of steel and cement. For most Americans who stopped to think about it, the American character was still rooted in the country, and artists looked for their subjects in rural retreats, either in the United States or abroad. The outdoor sketch class was a way of artistic life, but very few sketched the landscape of the city streets —except when in Paris.

There was every reason for Americans a century before to think of themselves as being rural. They were. In 1820 only a little over 7 percent of the people lived in cities. A century later, however, over 50 percent lived in large cities and the percentage would grow. The development of large cities had been rapid since the 1880s, when America had its first city of over a million inhabitants. The centers for manufacturing, transportation, finance, and publishing—the "nerve centers," as they were called, of the new affluent American society—the cities caught the imagination of those who were excited by a philosophy of progress and a belief in the new. Yet most Americans looked upon the city as a means for providing the affluence on which culture might thrive, rather than being a new kind of cultural expression in itself. Cities were the sites of museums of old masters, traditional concert halls, and costly dwellings filled with Louis XV furniture. As cities continued to grow in size and to take on a character of their own, the distance between art and the technological aspects of the urban environment in America seemed actually to increase. It seemed at times as if art and the artist were being used chiefly to supply an antidote to the new look of modern life.

Although the loss of the picturesque and the disappearance of the handmade were decried on both sides of the Atlantic, a youthful enthusiasm for the promise of tomorrow began to make itself felt in most countries early in the century. Marinetti's manifesto was only the most violent expression of it. The poets had already begun to sing the praises of the new monster, the excitement of crowds, and the possibility of merging the self with the otherwise impersonal city. Man, when identified with the machine, gained new power. Already in 1905 Marinetti had published his ecstatic poem "To My Pegasus," a hymn to the racing car; the automobile was not only a mechanical triumph but also a symbol for a new spiritual transport.

Nonetheless, anyone brought up in the tradition of American literature knew that cities were heartless centers of corruption and vice. In his *The Cliff Dwellers* of 1893, Henry Blake Fuller saw nothing romantic in the life that went on in the towering buildings with little relationship to the man in the street. He was not insensitive to the attraction provided by the tall buildings as symbols of commercial promise, but they also stood for ruthless competition and false human values. Instead of emphasizing the soaring height of the buildings, Fuller pointed out ominously that the higher the buildings reach, the deeper are the canyons between them. The one person with genuine artistic impulses in Fuller's novel is destroyed by his family's

Umberto Boccioni, *The City Rises*, 1910-11, oil on canvas, 78½ x 118½. The Museum of Modern Art, New York, New York; Mrs. Simon Guggenheim Fund.

mercantilism. His sensitive inclinations are associated with the shadowy mystery of the street; the fashionable but superficial architect, significantly enough, has his quarters on the eighteenth floor of a modern building where he can ignore the human consequences of the false, combative system that supports him. Yet, for all of his castigation of the city—Chicago, in this instance—Fuller's term "cliff dwellers" caught the fancy of the public and presented a daring but attractive alternative to the rural cluster of vine-covered cottages traditionally thought of as the home of the American soul. To a generation impatient with traditional restrictions and homely ties, the city's very impersonality, the fact that one could indeed lose oneself in it, was a promise and a comfort. It offered an escape into something larger than self.

In art, the cult of the city was often closely allied with tendencies that sought to avoid all sentimentality and spontaneous personal expressiveness in favor of a disciplined order and a detachment that sometimes was manifested in a studied irony. A far cry from Umberto Boccioni's compulsive physical impersonation of the forces of the city in his *The City Rises* of 1910-11, much art that was developing in Europe during the war years

C. R. W. Nevinson, *New York*, circa 1920. Unlocated.

looked toward the mechanical and geometrical, the impersonal city order, as the source of a new freedom. Once the horrors of World War I were passed, a new day did indeed seem to be dawning, and in the minds of artists and intellectuals the new cultural mentors were science and technology. The new psychology, too, in the writings of Freud and Jung, was helpful in making what had been thought private and personal quite public, breaking down the confines of the individual to allow for a consideration of man in terms of communal characteristics and the racial mind. To those who believed in it, the new impersonality meant emancipation, a term that shared popularity with the word "sophistication." It would seem that many had a strong sentimental dependence on those qualities that traditionally were the antithesis of sentiment. There was a passionate need for that which was ruthlessly impersonal, hermetic, and mocking of self. What better image could there be than the modern, mechanized American city?

Writing from Paris late in 1921 to Alfred Stieglitz in New York, the young Charles Demuth expressed astonishment at how interested the French avant-garde was in happenings in America. "Sometimes it seems impossible to come back,—we are so out of it," he wrote. "Then one sees Marcel [Duchamp] or Gleizes and they will say,—'Oh! Paris. New York is the place,—there are the modern ideas,—Europe is finished.'" The very things that Americans were escaping in going to France—mechanization, the commercial atmosphere, new buildings lacking historical overtones—were of extraordinary attraction to the Europeans. Albert Gleizes, associated with the Paris cubists, had been in New York in 1915 and had painted the city in his formal, analytical way. His attitude was much as that of C. R. W. Nevinson, the English painter who had associated himself with Marinetti and the Italian futurists, publishing a manifesto on "Vital English Art" in 1914. Exhibiting his city views in New York in 1920, he is quoted as having remarked of New York that it "might have been especially built for him, and that for the artist it is certainly the most fascinating city in the world." To Nevinson, the city's skyscrapers "were undoubtedly the most vital art works of the day." [Quoted in A. E. Gallatin, *American Magazine of Art*, April 1921.] His canvases of New York were shown there in the winter of 1920 and were viewed with pleasure and a degree of astonishment.

To Gleizes, with his concern for the complexity of vision and formal interplay, well expressed in his writings on cubism, and to Nevinson, who had taken his initial impulse from the violent modernism of Marinetti, New York was an aesthetic fulfillment. In its image an aesthetic impulse and a social reality came together. The art they represented did not actually grow out of the city—although the urban ideal was already there—but brought the city into a new sphere of meaning. Eventually the aesthetic assessment of cities, the city seen as expressive form, would actually have an influence on how cities looked.

Skyscrapers were not initially built to soar. They were built for economic advantage and, frankly, to boast of technical proficiency. They were

Hugh Ferriss, *Night in the Science Zone*, circa 1925, charcoal, crayon on paper mounted on board, 17½ x 10½. Jean Ferriss Leich, Ruston, Louisiana.

the notable products of well-organized industry and engineering. It was the artist who translated the jagged skyline and panoramic wall of jostling buildings into a dynamic symbol. Only slowly did the architects come to adopt wholeheartedly the artist's vision. But the artists did not care. They preferred to see the buildings at night or in the fog; the precise details did not much matter, and the complex was more important than the individual building. For the most part they preferred their buildings to show little evidence of an architect, as if the urban landscape were as inevitable as nature. According to Philip Johnson, who wrote a highly critical article on the skyscraper in 1931, Le Corbusier had once said, pointing to a skyscraper, "Let us listen to the advice of American engineers. But let us beware of American architects."

Only with reluctance did American architects give up their use of stylistic allusion, but historical references or no, by the mid-1920s architects were consciously making their buildings "soar," expressing what so many were now writing about the city.

The artist's image of the American city should not be thoughtlessly identified with what Le Corbusier and the architects of the *De Stijl* group were advocating in the early 1920s. Their view was only one aspect of what to be American meant. While Le Corbusier saw in American engineering the basis for a new rationality in the design of communities and living spaces, and advocated a spacious architecture of balance and calm, others looked upon the bustling, superhuman energy of the city as a kind of personal exaltation—a national feat of engineering that resulted not in calm but in exhilaration. It was, in fact, this latter attitude that was initially more acceptable in America. The difference in point of view is dramatically illustrated in a comparison between Le Corbusier's imaginative projection of the modern city, *Une ville contemporaine* of 1922, and Hugh Ferriss's speculative *The Metropolis of Tomorrow* of almost the same date. One might add also Walter Gropius's designs for the Dessau Bauhaus (1925-26). The buildings of Le Corbusier and Gropius could hardly inspire the kind of contemporary comments lavished on the American skyscraper, some of which were scornfully quoted by Philip Johnson in his article: "Above the waters stands the magic mountain of steel and stone, shining and glorious, as one of the crowns of human endeavor" (Fiske Kimball); "Its eyes gaze down from immeasurable heights on a welter of humanity and machinery. Its shining flanks are dappled with shadows of aeroplanes that 'laugh as they pass in thunder.' " (T. E. Tallmadge); "We seem to be in the presence of some titanic result of the forces of nature rather than a building by the hand of man" (Dean Edgell). This was a passionate romance with the city and its skyscrapers, an emotive belief in the promise of tomorrow, in motion and change. It is this kind of heady attitude that in a few years would make understandable and desirable the "streamlined" form of every imaginable object. Its climax was Rockefeller Center, begun in 1931, and its valedictory the Chicago fair of 1933, "The Century of Progress." It would be some years before the cool-headed rationality of Gropius, Le Corbusier, or Mies van der Rohe would dominate urban structures in America, if indeed it ever has. A belief in the dynamic promise of tomorrow, once kindled in the souls of architects and their supporters, died hard. The Olympian imagination of Norman Bel Geddes, for one, gave visual form in the theater, in product design, and in his panoramic prospectuses for future cities to the aspirations of technology that continued for a generation or more to stir the collective soul of those who awaited a technological salvation.

The city was not necessarily, then, a symbol of rationality. Although impersonal, it could hold a quality of mystery, putting man in touch with a large order. Describing the lobby of the new Daily News Building in New York by John Howells and Raymond Hood, Hugh Ferriss wrote:

Walter Gropius, Bauhaus,
Dessau, Germany, 1925-26.
Courtesy of The Museum of
Modern Art, New York,
New York.

Hugh Ferriss, *The Lure of the
City*, circa 1925, charcoal on
paper mounted on board, 15
x 22. Ann Ferriss Harris,
Mystic, Connecticut.

Le Corbusier, *Une ville
contemporaine*, 1922. From
*Le Corbusier et Pierre Jean-
neret, oeuvre complète de
1910-1929*. Published 1937.

193

Hugh Ferriss, *Crude Clay for Architects*, circa 1925, charcoal, crayon on paper mounted on board, 15½ x 18½. Jean Ferriss Leich, Ruston, Louisiana.

A circular space, 150 feet in circumference,—to be enclosed by a wall of black glass which rises, unbroken by any windows, to a black glass ceiling; in the center of a brass-inlaid floor, a cup-shaped well from which light—the sole illumination of the room—is to stream. Bathed in this light, a ten-foot terrestrial globe is to revolve—its even revolutions reflected darkly in the night-like ceiling above. . . . Is it possible that as they [those who enter] glance for an instant at a miniature revolving in a black glass room, they may experience at least passing realization of the situation of their own planet—revolving, at that very instant, in the black crystal of space. . . . Would it not be surprising if the sense of the large actualities, which is often lacking in the words of both contemporary scientists and churchmen, should be brought to us in the wordless device of an architect! [The Metropolis of Tomorrow, 1929.]

Ferriss, whose provocative renderings of imaginative future cities were much noted in the mid-1920s, was neither the first nor the last artist to find cosmic significance in urban architecture. In most depictions of the modern city there was a suggestion that more was to be found there than just the recent work of man. Sheer size was enough to make critics talk of an agelessness like that of the pyramids, and poets worshipped the aloofness and uncompromising visual silence of towering structures. If such buildings were

Hugh Ferriss, *Lobby, Daily News Building*, circa 1929, charcoal on paper mounted on board. Unlocated.

Abraham Walkowitz, *Improvisation of New York City*, circa 1916, oil on canvas, 44 x 33. Zabriskie Gallery, New York, New York.

decorated it was with signs of the zodiac, the continents, allegories of industry, or other abstractions. They formed the environment for a superlife, filled with nameless promise.

Possibly the painter who most successfully emphasized the poetic transport afforded by the city's forms, so contrary to the purist calm emphasized by Le Corbusier, was Joseph Stella. John Marin had recorded the city's bustling shuffle of buildings and Abraham Walkowitz saw the skyscrapers flock like the heavenly host, but Stella felt in the city the whole restless dynamic of modern civilization synthesized in its turbulent forms. Born in Italy and primed for the experience by the inciting prose of futurism, Stella found his greatest inspiration during the last years of World War I in the Brooklyn Bridge. As he recorded it:

> *Seen for the first time, as a weird metallic Apparition under a metallic sky, out of proportion with the winged lightness of its arch, traced for the conjunction of WORLDS, supported by the massive dark towers dominating the surrounding tumult of the surging skyscrapers with their gothic majesty scaled in the purity of their arches, the cables, like divine messages from above, transmitted to the vibrating coils, cutting and dividing into innumerable musical spaces the nude immensity of the sky, it impressed me as the shrine containing all the efforts of the new civilization of AMERICA—the eloquent meeting point of all forces arising in a superb assertion of their powers, in APOTHEOSIS.* ["The Brooklyn Bridge (A Page of My Life)," *transition* 16-17 (1929).]

Joseph Stella, *The Bridge*,
circa 1920, oil on canvas,
68 x 74. Private collection.

In studying the bridge and walking across it at night, he "felt deeply moved," he wrote, "as if on the threshold of a new religion or in the presence of a new divinity." Few artists would match Stella's unabashed exuberance in responding to the new world of engineering and mechanical wonder, but there is a bit of almost religious awe in most American artists who discovered the city in the 1920s.

When Louis Lozowick, who came to the United States from Russia in 1906 at the age of fourteen, went to Europe in 1919, he carried a strong image of the United States with him. He had studied in New York and at Ohio State University, and had visited the major commercial cities that later would serve as subjects for a series of paintings actually executed in Berlin. In Berlin, from 1920 until his return to New York in 1924, Lozowick was friendly with the group of Russian artists who were collectively known as "constructivists," actually exhibiting with them in Düsseldorf in 1922. Probably no other group was so devoted to a belief in a machine aesthetic. Their notion that the promise of the future lay in the efficient and dynamic organization of well-articulated parts, whether it was a matter of society, architecture, or urban design, was in accord with their concept of American potentiality.

In an essay entitled "The Americanization of Art" (1927), Lozowick later recalled, " 'Ah, America,' they say, 'wonderful machinery, wonderful factories, wonderful buildings.' " The constructivists found in the efficient operation of the machine, as had theorists at the end of the eighteenth century, not only an aesthetic but a morality, and considered their paintings and constructions both as symbols of a new society and as didactic models. Built from materials more usually associated with industry than with art, they provided in microcosmic form the liberating perfection of a dynamic order, freed from human sentiment and natural vagaries. The artists embraced a rationality, a materialism, that they associated with science, but embraced it with such a fervor that their faith amounted to a new religion. Although they rejected the capitalistic system that had produced the industrial America they admired, seeing it as opposed to their concept of a well-ordered state in which all parts were equal, the achievement of scientists and engineers in the United States provided a bond that gave all things American a special value. Lozowick was surprised at the success his work had in Berlin, and judged that it was in large part because of his American imagery. "All the references to my work stressed its Americanism," he later wrote.

The Russians were by no means the only ones to advocate a machine aesthetic, although they pushed its social significance rather further than others. All were aware of each other, and even though their pronouncements varied, those who believed that the future world should be organized in terms of clear, rational judgments that were manifest in a precise formal order like that of the machine were mutually supporting. Théo Van Doesburg, of the Dutch group *De Stijl*, was in contact with the newly formulated

Joseph Stella, *Gas Tanks*, 1918, oil on canvas, 40½ x 30. Roy R. Neuberger, New York, New York.

199

Vladimir Tatlin, *Model for the Monument to the Third International*, 1920. Destroyed. Courtesy of The Museum of Modern Art, New York, New York.

Bauhaus in Germany—Lozowick knew him in Berlin—and Le Corbusier, with his *L'Esprit Nouveau,* was well known to all. In 1923 the magazine *L'Esprit Nouveau* published an illustration of Lozowick's painting *Cleveland.* Obviously, Lozowick felt himself to be as much a part of the general movement as anyone and was accepted as such.

During his early years in Berlin, Lozowick produced the series of paintings based on American cities—now known only by a second series painted in the United States between 1925 and 1927—that caught the attention of the European artists. "The history of America is a history of gigantic engineering feats and colossal mechanical construction," he wrote in "The Americanization of Art." "The skyscrapers of New York, the grain elevators of Minneapolis, the steel mills of Pittsburgh, the oil wells of Oklahoma, the copper mines of Butte, the lumber yards of Seattle give the American cultural epic in its diapason." Exciting in their suggestion of immensity and superhuman austerity, these urban landscapes stop short of the personal exuberance and emotional exaltation expressed by Stella. The structures soar, but the viewer is not invited to soar with them. It is the busy, no-nonsense complex that counts, the suggestion that something important is being produced, not simply a breathless feeling of going somewhere. These paintings provide no transport to the stars. They present, instead, a finite world that above all is purposive. No building exists as decorative monument and no hesistant forms undermine the forceful thrust of clean-cut lines and planes. No human being appears in any of the paintings, in spite of the fact that they are concerned with human activity on a grand scale. In fact, a human figure would be disturbingly out of place, as if someone were thrusting his wooden shoe into the wheels of progress. These are the dreams of every man and of no man; the individual, in sensing the purposeful energy that animates the scene, can be stimulated to feel himself a part of the whole, to feel productive.

The unequaled sense of productivity as an aesthetic value may underlie also the interest of many in Lozowick's generation in the machine. Lozowick's machine drawings are not witty puns like those of Picabia or Duchamp, but elegant, exacting drawings that point up the beauty of machine parts without losing touch with their functional nature. In his essay, Lozowick stated: "A composition is most effective when its elements are used in a double function: associative, establishing contact with concrete objects of the real world and aesthetic, serving to create plastic values. The intrinsic importance of the contemporary theme may thus be immensely enhanced by the formal significance of the treatment. In this manner the flowing rhythm of modern America may be gripped and stayed and its synthesis eloquently rendered in the native idiom."

"The Americanization of Art" was written by Lozowick for a catalog of the Machine Age Exposition held in 1927 at Steinway Hall in New York. This international exhibition included machines, structural engineering, and architecture, as well as some related painting, sculpture, and architec-

Preston Dickinson, *Factory,* oil on canvas, 29⅞ x 25¼. Columbus Gallery of Fine Arts, Ohio; Ferdinand Howald Collection.

Louis Lozowick, *Seattle*, 1926-
27, oil on canvas, 30 x 22.
Hirshhorn Museum and
Sculpture Garden, Smith-
sonian Institution.

Louis Lozowick, *Chicago*,
1923, oil on canvas, 22 x
17½. Lee Lozowick,
South Orange, New Jersey.

Louis Lozowick, *New York*,
1926-27, oil on canvas, 29¾ x
21¾. Walker Art Center,
Minneapolis, Minnesota;
Gift of Hudson D. Walker,
Minneapolis.

Louis Lozowick, *Panama*,
1926-27, oil on canvas, 30 x
22⅛. Hirshhorn Museum
and Sculpture Garden,
Smithsonian Institution.

Louis Lozowick, *Oklahoma*, circa 1926-27, oil on canvas, 30 x 17. John, Norma, and Lisa Marin; Intended gift to the New Jersey State Museum, Trenton.

Louis Lozowick, *Butte*, 1926-27, oil on canvas, 30 x 22. Hirshhorn Museum and Sculpture Garden, Smithsonian Institution.

204

Louis Lozowick, *Pittsburgh*, 1922-23, oil on canvas, 30 x 17. Lee Lozowick, South Orange, New Jersey.

Louis Lozowick, *Machine Ornament #1*, 1922, pen, brush, and ink on paper, 15⅞ x 10⅞. Mrs. Louis Lozowick, South Orange, New Jersey.

Louis Lozowick, *Machine Ornament #2*, 1925-27, pen, brush, and ink on paper, 14 15/16 x 10 15/16. Mrs. Louis Lozowick, South Orange, New Jersey.

Paul Kelpe, *Abstract #2*, circa 1934, oil on canvas, 38⅛ x 26⅛. Public Works of Art Project. National Collection of Fine Arts; Transfer from Department of Labor.

Adrian Lubbers, *Exchange Alley*, 1929, lithograph, 16 9/16 x 4¾. National Collection of Fine Arts; Museum purchase.

ture, shown from an aesthetic standpoint. As Herbert Leppmann, in a review of the exhibition for *The Arts* of June 1927, wrote, "In nations of the machine age the imagination of artists is being stimulated by the abstract simplicity and innate decorative unity of mechanist design. Emotions of these individuals lead them to associate the machine with the spirit of the age." Lozowick, in his essay, was more specific:

> *The dominant trend in America of today is towards an industrialization and standardization which requires precise adjustment of structure to function which dictate an economic utilization of processes and materials and thereby foster in man a spirit of objectivity excluding all emotional aberration and accustom his vision to shapes and color not paralleled in nature . . . beneath all the apparent chaos and confusion is [a trend] towards order and organization which find their outward sign and symbol in the rigid geometry of the American city: in the verticals of the smoke stacks, in the parallels of its car tracks, the squares of its streets, the cubes of its factories, the arch of its bridges, the cylinders of its gas tanks.*

The functional geometry of the machine, then, fosters in man a new spirit of objectivity and serves as a symbol of new thought. In its reassuring clarity of form was expressed an optimistic faith in a rational future.

There is little evidence of any so grand a purpose in the cool, refined studies of industrial America by Charles Demuth. Only during his stay in Paris in 1921, it seems, did he discover that his formal taste might find a source of satisfaction in what his European friends considered most American: the utilitarian buildings and engineering feats he had heretofore ignored. Nevertheless, although he well illustrates the principle stated by Lozowick that a composition gains effectiveness by combining known objects with an organization based on plastic values, Demuth used the local scene not to enhance an awareness of "the rhythms of modern America," but to provide a vehicle for the celebration of a special taste. Demuth's pleasure in formal refinement, in paper-thin planes that sparkle in a clear revealing light, was in accord with that post-World War I insistence on a stark simplicity that characterized the purist group in France, the *Scuola Metafisica* in Italy, as well as the more architecturally inclined movements in Holland and Germany. Unlike many others, and quite in contrast to those who spoke doggedly of new societies and transcendence by way of the machine, Demuth viewed his subjects with a witty detachment, expressed at times in a whimsical formal lightness and at times by unexpected titles. One of his earliest sallies into the industrial landscape produced *Aucassin and Nicolette*, two mutually supporting towers. To a person prepared to see a soaring majesty in these witnesses to industrial America, the reference to a star-crossed pair of medieval lovers whose story had lately been revived as a part of a rather special interest in early literature, would come as something of a shock. Without a doubt the attitudes of his friend Marcel

Arnold Ronnebeck, *Brooklyn Bridge*, 1925, lithograph, 12⅝ x 6 11/16. Olin Dows, Washington, D.C.

Elsie Driggs, *Queensborough Bridge*, 1927, oil on canvas, 40 x 30. Montclair Art Museum, New Jersey; Lang Acquisition Fund, 1969.

Jan Matulka, *Cityscape*, circa 1925, charcoal on paper, 22 x 17. Robert Schoelkopf Gallery, New York, New York.

208

Duchamp had something to do with this playfulness. But there is something playful also in the handling of forms: the delicate lacework of an insecure ladder countering the largeness of the towers; the contradiction between the massive structures of the buildings and the sharp, brittle outlines that deny all sense of weight. To be sure, he used the radiating lines once associated with the futurists as lines of force, but they serve here, even more than in the contemporary works of Lionel Feininger, to divide crystalline surfaces of lighted space rather than to carry the observer into a speeding ecstasy. Possibly Forbes Watson was right when, in an article on Demuth in *The Arts* of January 1923, he remarked: "He's the Whistler of his little circle, but he doesn't talk as much about it as Whistler did. I suspect that he often smiles at the demi-intellectual sentiments of the little circle, all that stuff about this being the age of machinery and the artist, in order to realize the dynamic forces, etc., etc."

This self-conscious detachment and wit, the reluctance to admit of any whole-bodied commitment, the wariness of enthusiasm, were just as much a part of the new cult of the city as the emotional identification with urban progress. The acceptance of a totally manmade environment as a norm was bound to have its effect on the way people thought. The detachment of the "cliff dweller," decried by Henry Fuller in 1893, was hailed as a mark of sophistication in the 1920s. The penthouse, newly conceived as a roof dwelling, that abode farthest from the plane of the earth, most totally dependent on engineering contrivances and entrepreneurs, became a symbol of the emancipated. A sense of emancipation, in other words, depended on an unquestioning faith in the entire urban process. Intellectually, a similar detachment from direct contact with sources grew with the extraordinary spread of national news magazines and newspaper syndicates that allowed one to believe himself more in touch with events around the world than with his own community. And then, of course, the radio began its ascendancy at this time, a further means added to that of the phonograph for separating the primary agent of production from the public. This new reality, based upon the busy application of hundreds of kinds of intermediaries, could be looked on either as a loss of contact with the individual and a confusion in the sense of place, or as the product of a whole new sensibility in tune with a wider, more productive even though impersonal world. It was the latter view that those who courted modernity preferred, although they would rarely wish to say so in so many words. To assume the nature of the city, not to wonder at it, was the first law of sophistication. The kind of humor and polished writing established in 1925 by *The New Yorker*, which was called "the semi-official organ of sophistication" by Gilbert Seldes in 1932, represent well the careful skepticism with regard to content and the serious devotion to a sense of style that would not likely come into being outside of the urban environment. What the magazine stood for seems clearly to have been appreciated, because it was much in

Charles Demuth, *Aucassin and Nicolette*, 1921, oil on canvas, 23 9/16 x 19½. Columbus Gallery of Fine Arts, Ohio; Ferdinand Howald Collection.

Charles Sheeler, *Church Street El*, 1920, oil on canvas, 16⅛ x 19⅛. Mrs. Earle Horter, Philadelphia, Pennsylvania.

demand by would-be sophisticates throughout the country, certainly more for its "tone" than for its information about New York.

Consistent with the detached sense of refinement of the urban cult were the works of Charles Sheeler. Like Demuth, he began as a student of the Pennsylvania Academy and was early exposed to work abroad. As were many young Americans, he was much impressed with Matisse and experimented with the separation of color from literal form. By 1916 he was improvising with compositions of smooth, polished forms only remotely identifiable with nature. Well before this, however, he had been introduced to photography and his work with the camera quite changed his vision.

The camera and the city seemed well matched. The impartial passivity

212

Alfred Stieglitz, *From the Shelton, Looking West*, 1933?, photograph, 10 x 8. Doris Bry, New York, New York; With permission of Georgia O'Keeffe for the Estate of Alfred Stieglitz.

of the camera lens, analytical but cool, served not only as a means of producing suitably precise and detailed works of art but also as a model for the painter to emulate. Handled with care, the camera registered not substance but shape and interrelationships of planes in space. It had the particular fascination of rendering images that were literally true in the representation of objects, yet of aesthetic value for their subtle play of black and white shapes. Certainly Alfred Stieglitz, who had been promoting the artistic use of the camera since the beginning of the century, had a strong influence on the photograph's acceptance, but in the postwar years photography showed a merger of the photographic craft with the austere taste of the new urban vision—so different from that of Stieglitz in the early years.

213

Edward Steichen, *Sunday Night on 40th Street*, 1925, photograph, 16¾ x 13½. The Museum of Modern Art, New York, New York; Gift of the photographer.

Charles Sheeler, *Barn Abstraction*, 1917, conté crayon on paper, 14⅛ x 19½. Philadelphia Museum of Art, Pennsylvania; The Louise and Walter Arensberg Collection.

Possibly it is wrong to call Sheeler's vision urban, since one of his most interesting early series of works were of Pennsylvania barns (1915-18), rendered both by painting and drawing and by photography. The objects he was using were rough and handmade. But it is the purist taste that triumphs over the vagaries of nature and the homely structures. There is nothing sentimental or rustic in Sheeler's views. In fact, it comes as something of a shock to see the traditional seat of folksy activity reproduced with such analytical detachment. On settling in New York in 1919 he found a natural subject both for his camera and his brush in the city. In his paintings, his point of view is often that of the camera—everything seen at once, sometimes in dramatic perspective and sometimes marshaled in successive flat planes. But the simplification of parts, only suggested by the photographs, was interpreted by Sheeler as austere undifferentiated planes with the shapes of merged shadows as significant as the shapes of things. In place of Demuth's formal wit, Sheeler offers a breathless refinement. Thomas Craven, in an article published in the March 1923 issue of *Shadowland*, reported that Sheeler had told him that he wished to give his work "the absolute beauty we are accustomed to associate with objects suspended in a vacuum." It might seem odd that for Sheeler, the quintessential image of the city—an organism characterized by density of population—should consistently be rendered without people, as if in a vacuum. But again this is the point of view that assumes the existence of the city and does not presume to express its past or its future. The city was the great abstraction, sprung from the mind of man, that offered a craftsmanly beauty as reassurance that cerebral order had come into its own.

Charles Sheeler, *Delmonico Building*, 1926, lithograph,
9¾ x 7¼. National Collection of Fine Arts; Gift of Mr.
and Mrs. Harry Baum in memory of Edith Gregor
Halpert.

The Folk and the Masses

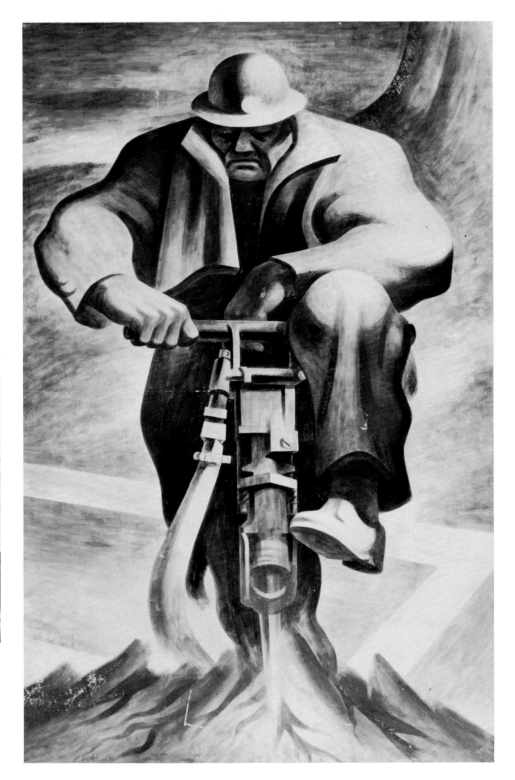

Harold Lehman, *Driller*, 1937,
tempera on fiberboard, 92¼
x 57⅛. WPA: Federal Art
Project. National Collection
of Fine Arts; Transfer from
The Newark Museum.

Thomas Hart Benton, *The
Little Fisherman*, 1967, litho-
graph, 14⅛ x 10. National
Collection of Fine Arts; Gift
of Frank McClure.

The Folk and the Masses

The optimistic view that saw the city as symbol of the triumph of rationality and of transcendent progress, and treasured a belief in science and the machine as the saviors of mankind, was sustained only with difficulty in the 1930s. Athough such ideas provided the basis for a popular mythology, maintained in part by an anxious industrial complex, artists and writers for the most part began to express disillusionment and to look elsewhere for intellectual sustenance. Some critics hailed this as a collapse of "modernism," which they had held all along to be only a passing fad. For some artists it possibly was a retrenchment; for others it was not a denying of modern awareness but of extending that awareness to wider and quite different fields.

As long as the sense of intellectual detachment based on the urban promise was supported by confidence and optimism, it was the foundation for all manner of creative imagination and delight. Once the confidence was eroded, however, the vaunted detachment could best be described as isolation and estrangement from creative roots. Complained Waldo Frank in his book *The Rediscovery of America* (1930), "We know that from the machine's need to expand has grown our ideology of persuasion, our hideous myths of progress as an external matter: that man's life is becoming more and more the pitiful rationale of the machine." Somehow, he felt, a new sense of brotherhood had to develop, a new sense of the "group"; man had either to join his fellow man or be lost. "The doubtful test is that which will decide whether such men, each overwhelmed by the mechanical and inner jungle of our life whose every power is a scattering and a marshalling against them, can join; or whether they must live alone, each one; and die alone."

The urban sophisticate did not, for the most part, like to be reminded of his small-town origins or that America had for a long while preferred to think of itself as a country of rural togetherness. Sinclair Lewis's *Main Street,* published in 1920, with its satiric attack on small-town bigotry, gave voice to the rising suspicion of complacent provincial attitudes and of the

virtues supposedly innate to traditional social organizations. Any lingering belief in the official togetherness of middle-class life in a booster community was dispelled for many by Lewis's *Babbitt* of 1922, which created a new word for a recognized American type. Yet Lewis was no kinder to those who supported their sense of cultural superiority solely by virtue of turning their backs on provincial values and local preoccupations. As he saw it, the problem was not a matter of the rural versus the city, or provincial limitations as against international awareness and breadth, but of a slipping away of all individually held moral standards under various social pressures. Even the Protestant church with its deep roots in the rural community was the target of Lewis's suspicion, and *Elmer Gantry* (1927) left nothing that could be thought of as quaint or comic in the image of the popular clergy.

The small town as a source of strength was not, however, totally discounted, even though its difficulties were realized and discussed with an air of superiority by those who followed what they held to be emancipated values. Writing as a well-traveled man who had chosen to live in a small town rather than the city, Sherwood Anderson, who did not for a minute agree that Sinclair Lewis's attacks on small town life presented the whole picture, wrote of a different kind of problem in 1932:

> *Every year the factories themselves invade new towns and the towns not yet invaded by the factories are still invaded by the machine. The factories themselves every year move deeper and deeper into the agrarian sections. On every hand the machine controls our lives. Now the players do not come to the towns. They are in Los Angeles. We see but the shadows of players. We listen to the shadows of voices. Even the politicians do not come to us now. They stay in the city and talk to us on the radio.*
>
> *There is a queer half world in which we live. There are the fields near the towns and the houses and streets of the towns. There is this actuality, the town itself.*
>
> *Then there is this other life, our imaginations fed with new food, the inside of that factory there, the lives of these people in the talkies, the voices coming to us on the radio. We feel ourselves in some strange new world, half in it, half out. We are half born men.*
> ["The Times and the Towns," *America As Americans See It*, 1932.]

Both in the city and in the small town, it was evident that many yearned for a sense of wholeness, a renewed sense of cultural integrity, quite different from that promised by the machine. Reality itself was in crisis. The threat of being "half born men" was palpable. Certainly, the Great Depression following the collapse of the stock market in 1929 had its impact on the loss of faith in a culture of optimism, but it was probably only the immediate cause. Rumbles of well-formulated doubt could be heard through out the 1920s, and it seemed only a matter of time until a modification or

James Naumburg Rosenberg, *Dies Irae (Oct 29)*, 1929, lithograph, 13 13/16 x 10½. National Collection of Fine Arts; Museum purchase.

outright denial of the superhuman abstraction based upon machine logic would have to take place. What emerged was an intensive search for cultural roots, with or without a concern for the machine. Whether focusing attention on the city or the country, the new emphasis was on the local, as distinct from the universal and cosmic, with the belief that an ultimate realization of human unity was to be built up only from locally realized experience. For this, one had to begin not with cities and skylines or theories of form but with "people," a word that had great currency in the 1930s. There were, however, various ways of defining "people." One was to look back on the traditions of America, beyond the commercial pressures of main street, to find surviving traces that might be used to extend a line of continuity from the past to the present, rooting people with a sense of national heritage. This in the United States would of necessity lead back to the farm and to the small town before the factories moved in, redefining the American once more as a fundamentally rural type. Such an effect was principally a search to discover a "folk" in America. Another definition of "people" was quite different. Looking upon the polyglot urban masses, the mixtures of races, creeds, and economic classes, some set out to define people basically in terms of social environment, class, or their aspirations for political organization. Who were not "people" in these disparate endeavors to root America? Those sophisticates of rarified aesthetic judgment and international taste, who had taken the lead in the preceding decade, were highly suspect. To escape the charge of being un-American, it behooved the independent intellectual to identify himself with one side or the other. Many, of course, were not inclined to do anything of the sort.

The fact that two such contradictory attitudes toward what America was and was about should coexist—as different as the city and the imagined countryside—is itself part of a long and unresolved tradition. Part of the tradition, too, was the fact that there should be a third force of supposedly disinterested intellectuals maintaining that their cultural detachment was the consummate expression of American freedom.

The Folk

The pursuit of an American folk sentiment took many directions. One was the study and collecting of that kind of earlier art that was produced by often anonymous craftsmen who, by virtue of not following a sophisticated tradition of style and technique, could be considered folk. Although the motives for their study might be similar, these works were not in the same category as those in the folk traditions that caught the attention of artists in Scandinavia, Russia, and Germany from the 1890s on. In such countries, modern peasant art was often identified with ancient lore and national sagas, as if the spirit of the race had been secretly perpetuated through the handicrafts of the lowly. Such an assumption was politically useful in some countries, such as Russia and Germany, in the 1920s and '30s. In most instances, except in the case of those ethnic groups that carried on a tradition brought from Europe, the origins of what was considered American folk art were not all that profoundly buried in history, although technical methods were often those that had survived over a relatively long period of time. Instead, most were the work of independent artisans who responded directly to the contemporary images around them and to the task

Horse-drawn Sulky and Driver Weathervane, circa 1875, wrought iron, copper, and wire, 61 x 39 x 9. Dr. and Mrs. Belisario R. Contreras, Washington, D.C.

222

Shaker Brethren's Rocker, maple. Mrs. Edward Deming Andrews, Pittsfield, Massachusetts.

at hand, often creating objects because no other source was available. Some of the craftsmen were amateurs, many were professional, but the fact that they had carried on their work with little reference to the flux and flow of rationalized trends in art appealed to those who had lost faith in the current state of culture.

There was another reason for appreciating some kinds of American folk art. Charles Sheeler, for example, with his eye focused on the beauty of precise and perfectly adjusted forms, began as early as 1918 to take an interest in Shaker furniture. This was an instance of a modern taste in forms being the basis for the discovery of new values in the past. There were numerous other such instances during those years, a notable one being that of the Mexican artists, such as Diego Rivera, who, trained in Paris to see form as a cubist, found new inspiration on returning to Mexico in the 1920s in pre-Columbian antiquities and popular art. Shaker furniture, with its utilitarian purpose and refined economy of means, had a very special appeal, complete with social overtones, but much other earlier art and craft was also praised for directness and simplicity of statement. The element of common sense that so effectively pervades this kind of art was a trait that many wished to regard as fundamentally American.

The first serious collecting of American folk art began during the 1920s, much of it, significantly, by artists of a modern persuasion. The Whitney Studio Club had an exhibition of folk art in 1925, but it was chiefly through the exhibition of folk painting in Newark, New Jersey, in 1930, and the exhibition sponsored by the Harvard Society for Contemporary Art in October of the same year, that the "primitive" works gained wide public acclaim. In 1931 the Newark Museum followed its initial success with a showing of folk sculpture, also arranged for by Holger Cahill, who in 1932 helped to present an exhibition of folk art at the Museum of Modern Art in New York. Dealers began to feature folk art, as distinct from simply American antiquities. Already in the 1920s there had been a tremendous upsurge of interest in collecting American antiques—fine eighteenth-century furniture, glass, and the like, as well as curiosities. But this was quite a separate tendency from that emphasizing a folk culture and was more closely related to the revival of accurately studied colonial architecture and the creation of "period" interiors. Folk art, as it came to be defined, tended to satisfy a rather different need. One of the first to build a great private collection was Mrs. John D. Rockefeller, Jr., who eventually made it available to the public as a part of Colonial Williamsburg, a project that was conceived of, significantly, in 1926. It was from her collection that the Museum of Modern Art borrowed works to lead off their monumental "Art in Our Time" exhibition of 1939, suggesting that folk art was not merely a tangential aspect of art, but a primary strain, and one of universal human significance.

As a result of this desire to return to public currency a level of artistic activity that had been buried or ignored for many years, in 1936 an extraordinary undertaking was begun under the Federal Art Project of the Works

Marian Page, *Cockerel Weathervane, 1730,* 1939, watercolor on paper, 14 x 13½. Index of American Design, National Gallery of Art, Washington, D.C.

Progress Administration (WPA). The plan was to create a comprehensive archive of American design that would serve as a reference in the future for designers, manufacturers, and, presumably, historians. It was to be published and widely circulated as a stimulation to taste, in a sense reaffirming the importance of local traditions in the continuing culture. Works were to be chosen from throughout the country, with special reference to local craft traditions (thirty-five states eventually participated) and were to be recorded in carefully executed renderings by especially trained artists. Photography was rejected as a medium because it was believed that the artist could record more truthfully the total aspect of the object, but it soon became evident that the painters, coming from a wide variety of backgrounds, would have to be prepared to follow a new, disciplined technique. All preconceptions of style were supposed to be excluded—as in the best of archeological illustration. The artist was to rely wholly on his eye. In their painstaking, anonymous style, the several hundred artists so trained made of the Index of American Design, as it was called, something of a folk-art collection in itself. The project was brought to a halt by the war and in 1943 the completed

Merrill Sumner, *Bell in Hand Shop Sign, 1795,* 1936, watercolor on paper, 12¾ x 10. Index of American Design, National Gallery of Art, Washington, D.C.

Richard Smith, *Cigar Store Indian—Squaw, 1812-60,* 1936, watercolor on paper, 24 x 10½. Index of American Design, National Gallery of Art, Washington, D.C.

225

plates, far fewer than the 50,000 that Holger Cahill, by now director of the Federal Art Project, had envisaged, were turned over to the new National Gallery of Art.

Almost from the beginning of the interest in eighteenth- and nineteenth-century folk art there grew as well a new appraisal of modern "folk" artists. There was some embarrassment over just what to call them—primitive, folk, popular, naïve—but regardless of title, by 1939 the Museum of Modern Art could include the works of Joseph Pickett (1848-1918) and John Kane (1859-1934) along with early nineteenth-century mourning pictures and fractur paintings. New folk artists were sought out, such as Horace Pippin, who was "discovered" in 1939, and some academically trained artists, William H. Johnson, for example, turned in the 1930s to a "primitive" way of painting in order to convey more directly their concern for folk themes.

In quite their own way some American painters and their supporters were moving, in the late 1920s and '30s, in a direction not unlike that of just one hundred years before. Again as a kind of reaction to cultural refinements and critical sophistication, they used their art to create an appearance of artlessness, believing that honest thought and sound communication were most likely to be found in the untutored statement. Again, the local accent became a proof of authenticity, standing now against not only the demands of international criteria of taste but the homogenizing effect of the machine and urban standardization.

William H. Johnson's case is rather special and adds another aspect to the emphasis on a native folk. A black artist, Johnson for many years in Europe painted bold, expressive paintings that drew on current artistic tendencies, quite different in goal and method from the academic procedures he had perfected in New York. In 1938 he returned to the United States and abruptly changed both his themes and pictorial form. Now drawing his subjects from humble aspects of life in the black community or from religion as expressed through Negro spirituals, he developed a direct and disarmingly simple way of painting that suggests a sober naïveté rather than a sophisticated process of taste and judgment. Unfortunately, his art was submerged in the difficulties of the depression and was eventually cut short by the failure of his health. However, interest in black culture as an appealing element in American folk tradition had already come to the fore in the 1920s and continued in the hands of others in the 1930s. Critics never failed to point out that jazz, which drew the art crowd to Harlem in the 1920s, was one of the few art forms—if not the only one—developed in the United States. Prominent black jazz musicians were hailed as folk artists, as were some white jazz musicians. The recognition by the white community of what became known as the Harlem Renaissance of the 1920s was doubtless in part based on a growing appreciation of "folk" values, even though the authors and artists involved were a sophisticated group. "Folk" meant cultural cohesiveness more than naïveté, a quality to be sought by the culturally aware.

Horace Pippin, *Cabin in the Cotton III*, 1944, oil on canvas, 23 x 29¼. Roy R. Neuberger, New York, New York.

William H. Johnson, *Woman Ironing*, circa 1944, oil on board, 29 x 24¼. National Collection of Fine Arts; Gift of Harmon Foundation.

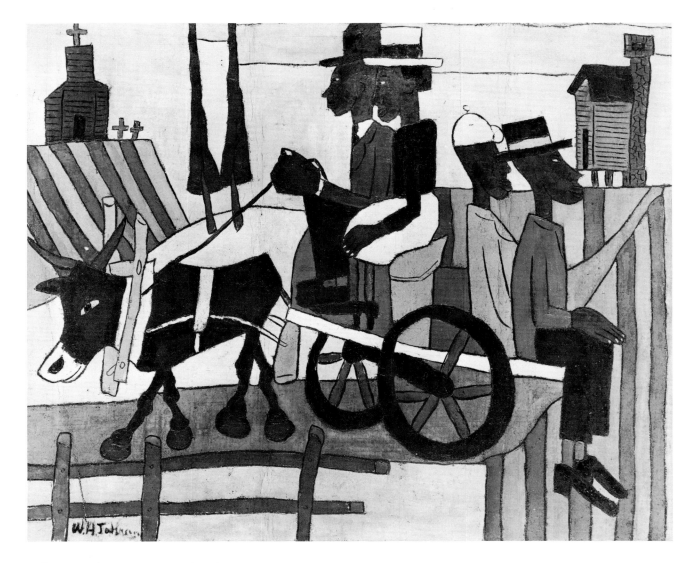

William H. Johnson, *Going to Church*, circa 1940-41,
oil on burlap, 38⅛ x 44⅛. National Collection of Fine
Arts; Gift of Harmon Foundation.

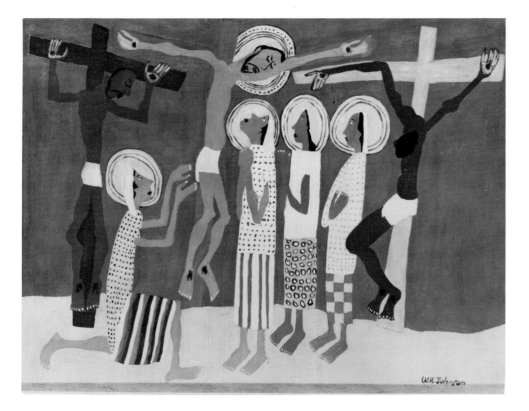

William H. Johnson, *Mt. Calvary*, circa 1939, oil on board, 27¾ x 33⅜. National Collection of Fine Arts; Gift of Harmon Foundation.

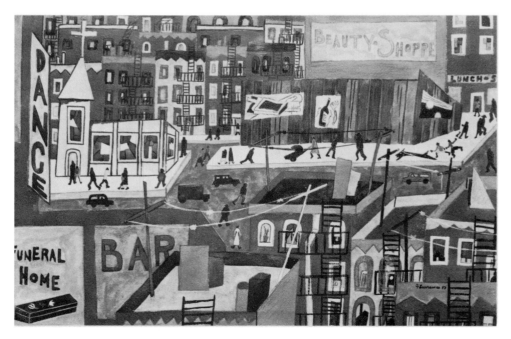

Jacob Lawrence, *Rooftops (No. 1: This is Harlem)*, 1943, gouache with pencil on paper, 15⅜ x 22 11/16. Hirshhorn Museum and Sculpture Garden, Smithsonian Institution.

228

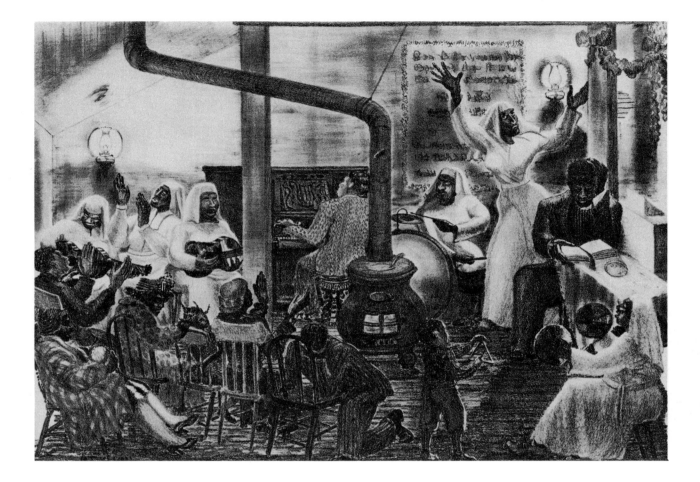

Prentiss Taylor, *Assembly Church*, 1936, lithograph, 10⅞ x 14 11/16. National Collection of Fine Arts; Gift of Irina A. Reed.

Jazz was not the only music outside the mainstream of tradition to come to prominence in the 1920s and '30s. In 1932 C. J. Sharp's extensive compilation, *English Folk Songs from the Southern Appalachians*, appeared, attesting to an interest that was to expand both in scholarship and popularity in succeeding years. Scholars spread through the hills of Tennessee, recording ballads, collating variations, and marveling at the complicated part-singing carried on by neighborly groups, the members of which were quite innocent of any capacity to read musical notation. At the same time mountain musicians were encouraged to bring their homemade instruments to town to create a novel sound for the urban sorts and broadcast their home-preserved melodies by means of the now-ubiquitous radio in such a program as the "WSM Barn Dance" (1925), which continued as the "Grand Ole Opry" (1927). Square dancing had a revival in the 1930s, and American folk dances were supplied to the young seemingly as an answer to those folkways that were imported from abroad and served alerted youths to show their sympathy with the "folk" traditions of socialist cultures.

All of this served as a significant counterpart for a new phenomenon

Fred Becker, *Birth of John Henry*, 1938, wood engraving, 6 1/16 x 4½. WPA: Federal Art Project. National Collection of Fine Arts; Transfer from D.C. Public Library.

Fred Becker, *John Henry Building a Railroad*, 1936, wood engraving, 6 1/16 x 4. WPA: Federal Art Project. National Collection of Fine Arts; Transfer from D.C. Public Library.

Fred Becker, *John Henry's Hand*, 1938, wood engraving, 6 1/16 x 4 9/16. WPA: Federal Art Project. National Collection of Fine Arts; Transfer from D.C. Public Library.

Fred Becker, *John Henry's Death*, 1937, wood engraving, 6 x 3 15/16. WPA: Federal Art Project. National Collection of Fine Arts; Transfer from D.C. Public Library.

230

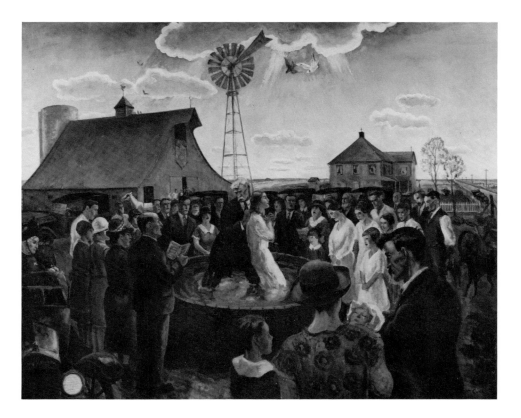

John Steuart Curry, *Baptism in Kansas,* 1928, oil on canvas, 40 x 50. Whitney Museum of American Art, New York, New York.

that was to become a cause célèbre in American painting. For example, on his return from France in 1929, John Steuart Curry, who had been born in Kansas but educated principally in Chicago and the East, decided to revert to subjects relating to his childhood. His first major effort in this direction, *Baptism in Kansas,* was shown at the Corcoran Gallery in Washington in the fall of 1928 and was duly noted for its unusual and unmistakably American subject matter. Unlike their nineteenth-century prototypes, the country people as shown by Curry are not unusual or picturesque; they might best be described as simply ordinary. Obviously, it was a serious regard for the ordinary that attracted Curry to the scene in the first place. To be sure, there is poetry in the scene, with the burst of divine sunlight and the ambiguous heavenly doves, yet neither the style of painting nor the Sunday-dressed gathering is such as to inspire a flight of fancy. Both the painter and his subjects are pursuing a traditional act with an almost defiant lack of style and self-consciousness. Curry studied hard to leave things in their place, to retain a specific, homely sense of both physical and psychological environment, almost as a rebuke to transcendent urbanism and elegant form. The painting of his mother and father sitting in their Kansas farm house, dated 1929, is a careful study in formal anticlimaxes. Any potential elegance or formal adroitness is carefully undermined to suggest the humble but unique character of the objects. Painterly facility, like official rhetoric,

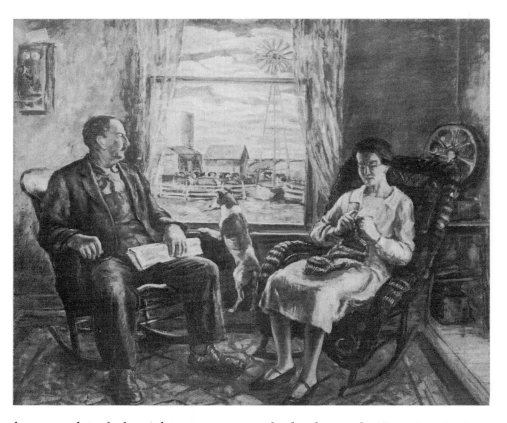

John Steuart Curry, *Father and Mother*, 1929, oil on canvas, 30 x 36. International Business Machine Corporation, New York, New York.

he seemed to feel, might cause one to doubt the truth. Curry's paintings, like a proper folk song, are sung by a carefully untrained voice.

When his paintings were shown at the Whitney Studio Club in January 1930 they were an immediate success with those critics who were looking for a fresh American spokesman. "Kansas has found her Homer," wrote Edward Alden Jewell. Many critics were looking for the great American epic in the early years of the century, and many authors were attempting to satisfy them, but Curry was not really an epic artist. He represented probably better than anyone else a strong current developing in the American art world that doubted the virtues of artistic heroism, or at least doubted the kind of boldness that would trample on the homely truth simply because the truth was lowly and formally inarticulate. Even Curry's audacious John Brown, fixed as a symbol, has an anxious texture. The self-satisfied genius had no place in the world of the common man. In an article published in 1935, Curry wrote, "Every sincere artist knows that there is no bandwagon that goes all the way; no seeming success of the moment that will atone for the thing he knows in his heart he has not accomplished or for that thing he has left undone." Humility, both of form and substance—sometimes a fierce humility—came to be seen as the only key to an ultimate security.

The same year, 1930, that Curry had his first one-man show in New York, Grant Wood, also just back from Europe, showed his *American Gothic*

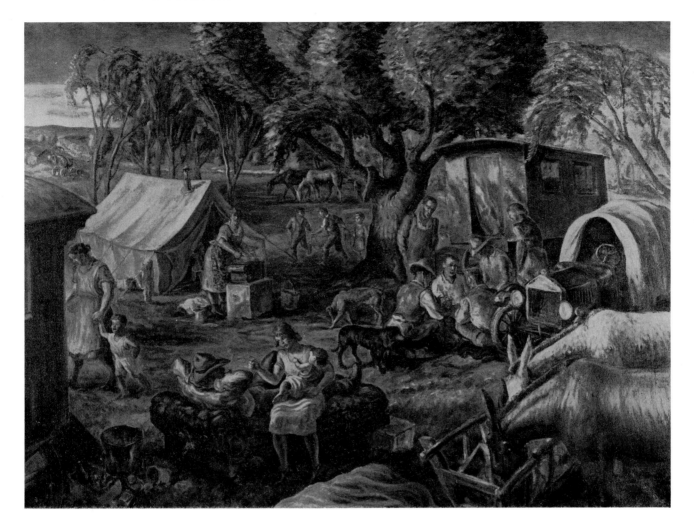

John Steuart Curry, *Road-mender's Camp*, 1929, oil on canvas, 40⅛ x 52. University of Nebraska Art Galleries, Lincoln; F. M. Hall Collection.

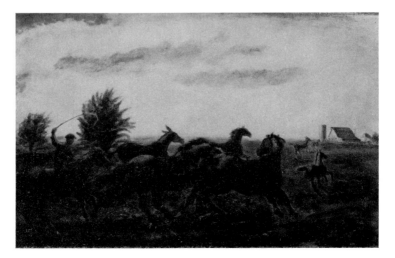

John Steuart Curry, *Early Morning Roundup*, 1934, oil on canvas, 24 x 35. Private collection.

233

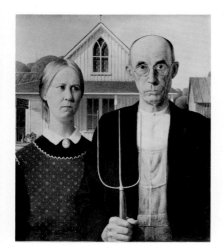

Grant Wood, *American Gothic*, 1930, oil on panel, 29⅞ x 25. Art Institute of Chicago, Illinois; Friends of American Art.

Grant Wood, *Fall Plowing*, 1931, oil on canvas, 30 x 40¼. Deere and Company, Moline, Illinois.

OPPOSITE:
Grant Wood, *Arbor Day*, 1932, oil on panel, 24 x 30. Mr. and Mrs. King Vidor, Beverly Hills, California.

Grant Wood, *Fertility*, 1939, lithograph, 9 x 11 15/16. National Collection of Fine Arts; Museum purchase.

Grant Wood, *In the Spring*, 1939, lithograph, 9 x 12. National Collection of Fine Arts; Gift of Frank McClure.

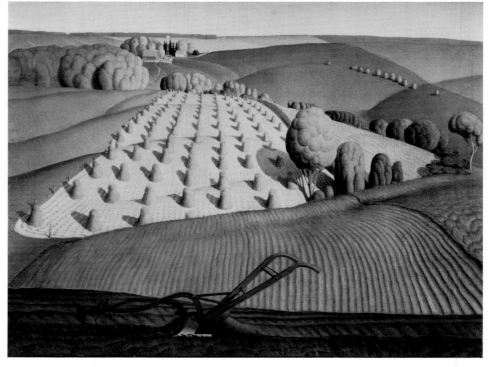

at the Art Institute of Chicago—which immediately bought it. There was some doubt about Wood's intentions, whether he was being nostalgic or satirical, but such was the time that his self-righteous, deadly serious image of two home folks seemed reassuring, even if ridiculous. There was no humility of form in Grant Wood. He liked his paintings to appear with the careful finish of a folk object, the seriousness of execution contrasting often with the implied humor. Each painting seemed created in praise of craftsmanly orderliness, the precision of the hand, not of the machine. They are prideful paintings in their way, not because they express the personal pride of the artist, but because they radiate a homely satisfaction with the well made. In this it is impossible to separate the way they are painted from how we judge the subjects; Wood's people exist in a solid and a well-made world. If Wood was to be believed, Iowa was a place in which unkindness, prejudice, and militant provincialism were minor frailties within a stable order, and Americans might do well to recognize in its homespun righteousness an image of their cultural heartland. Many Americans optimistically agreed.

The December 24, 1934, issue of *Time* magazine published a crowing article stating that the assault of incomprehensible artistic "isms" from abroad had been put to rout by a sturdy American movement beginning in the Midwest. On the cover was a self-portrait of Thomas Hart Benton, who for some years had been trumpeting the cause of an American art, as distinct from an art based on what he called "European" standards. The three personalities, Benton, Curry, and Wood, now brought together, could

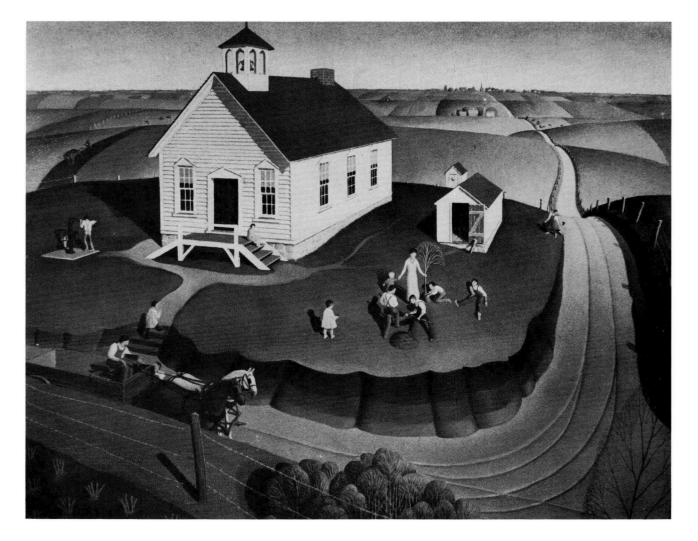

Thomas Hart Benton, *Engineer's Dream*, 1931, oil on panel, 29½ x 41¼. Brooks Memorial Art Gallery, Memphis, Tennessee; Eugenia Buxton Whitnel Fund.

hardly have been more different, but they were to be linked together in the public mind as the supporters of an art based not on personal experience but on a concept of artistic nationalism. Their works had been shown together in 1934 at the Ferargil Gallery, and in the mind of the critics a "regionalist school" was born. Together with others they became painters of the "American scene," as if the simple choice of subject matter were enough to prove their virtues or to damn their taste.

Thomas Hart Benton, who came from Missouri, had studied like the others in Paris, returning after three years to the United States in 1912. Settled in New York, he experimented with various modern tendencies and studied widely in the history of art. Through the 1920s he became increasingly interested in figurative painting and in American historical themes, and finally, in 1928, was commissioned, along with Orozco, to use his newly developed concerns in painting murals in the New School for Social Research. It was in mural painting that Benton made his mark.

Quite different from either Curry or Wood, Benton looked at America

236

Thomas Hart Benton, *Planting*, 1939, lithograph, 9⅞ x 12 11/16. National Collection of Fine Arts; Gift of Frank McClure.

Thomas Hart Benton, *Discussion*, 1969, lithograph, 9 13/16 x 12 1/16. National Collection of Fine Arts; Gift of Frank McClure.

as if he were a balladeer. He was always storytelling, and his forms have a restless, swinging rhythm that gives his subjects a generalized energy belonging more to the composition than to any one participant in his narrative. He was, in short, a painter of the fabulous, but the basis for his fabulous narratives was American life and legend. Any object in his hands took on a compulsive life of its own, whether shocks of corn or a runaway locomotive. As in a folk ballad, there is an air of earthy fantasy in his works suggesting an atmosphere in which anything might happen. His America was bumptious and assertive and filled with tall tales. Whether consciously or not, he was imitating both in his painting and in his personal manner the character of the frontiersman, popular with eastern audiences in the 1830s. Like his prototype he despised the city—after living most of his formative years in New York—and violently attacked all members of the art world who did not embrace his rugged view of America. Along with the cantankerous writer on art Thomas Craven, he so polarized the current tendencies that it appeared to many that an American art could exist only through a complete denial of the whole modern tradition, as well as through a repudiation of all art that suggested social advocacy.

What had begun as a serious reexamination of aesthetic premises and cultural roots, in the hope of discovering a saving human denominator, had degenerated by the mid-1930s into a violent and divisive polemic. Because of the foolish epithets "regionalist" or "American scene," artistic values were overlooked in favor of gross political and cultural ideologies. The serious stocktaking that many artists had felt necessary became a dangerous, chauvinistic tool in the hands of limited, bitter adversaries. Many serious artists like Curry suffered by being caught in the dispute, while some lesser artists gained a place simply by joining the favored side. Had this fight between city and country, American and European, status quo as opposed to social revolution, not developed so quickly, it would have been possible for the many different aspects of the reexamination of the local scene to have proceeded in their own way. There was Charles Burchfield fantasizing on the theme of the small town; Edward Hopper entrapped by silence in his own environment, whether on the seacoast, a small town street, or a city; Marsden Hartley painting the rugged life of the Maine coast; and many other painters sincerely drawn to their local environments in pursuit of sources for their art. Because of a tragic confusing of artistic sensibility and a grotesquely simplified list of presumed national virtues, an artist could be denied aesthetic citizenship in his own country. So warped were the issues that the vaunted "grass roots" movement could neither take root nor grow, cut off as it was from the perceptions and thoughtful principles that had deeply stirred the modern mind. "Sanity in Art," the self-righteous movement begun by Josephine Hancock Logan in Chicago in 1936, was typical of pedestrian efforts which, purporting to protect serious content in art, served only to render serious pursuits trivial. The real sanity to which the artist and serious critic looked in their conquest of the folk, lay at a level

Marsden Hartley, *Fisherman's Last Supper*, 1940-41, oil on canvas, 29⅞ x 41. Roy R. Neuberger, New York, New York.

quite beyond anything Mrs. Logan's well-bred notions of art could reach. Nor was it to be defined by chauvinistic limits or political jingoism. Under all of the bluster and name calling was hidden a genuine movement to re-identify America with art, and it merits being separated from the enthusiastic misconstruction of its motives that was formulated at the time. In their own ways, the collectors of folk art and the believers in the naïve, and the painters who sought to identify themselves with the local scene, were responding to a similar need in a not dissimilar fashion, even though they seemed to be expressing themselves in different languages. They were all following the promise that in the unselfconscious culture of America, art still had a chance to formulate a reassuring word.

The Masses

The search for "people" among the masses met with as many difficulties as the search for meaning in the American folk. Here, too, there was—and has been since—a not always helpful mixture of art criticism and political theory. Yet the impulse was more than that explainable by schemes of social change and class consciousness. Basically, it was an effort to reestablish a sense of human value founded not on genteel assumptions or remote idealities, but on what to the candid urban observer seemed to be the actual condition of man.

If the optimists of the 1920s persisted in looking up at skyscrapers and regarding buildings as soaring, those urban dwellers less sanguine about the promise of a mechanized future insisted with equal deliberateness on concentrating their regard on the street. The term "realist" was constantly evoked to describe their vision, and authors and artists alike felt the need to regard themselves as "social realists." There was nothing in the application of the term to suggest that society in its present state was good. On the contrary, the long tradition attached to the word "realism" usually dwelt on the less optimistic aspects of life—there was little reality in laughter, unless ironic laughter—and when joined with social concern, "realism" concentrated chiefly on the difficulties encountered by the individual as a result of his life in a given society. The reality of the 1930s was not to be found in the image of tall buildings and larger motor cars, adequate symbols for many in the previous decade, but in the life of the streets, the labor gangs, and the desolation of urban waste. For those of a political inclination, it lay in the evident failure of the capitalist system. In whatever way it was rationalized, however, the "realist" urge was a desire to touch base, to be sure of contact with an actual, shared existence, even if the proof had to be found in pain, despair, and a frustrating awareness of social inequalities. The city dweller, no less than his country cousin, was threatened by the specter summoned up by Sherwood Anderson of being "half men." A deliberate concentration on the sweating, striving human being in his domestic habitat was defense against the other reality of talking shadows, steel and glass towers, and industrial structures whose powers seemed as great as those of God and, to the average man, no more comprehensible. Personal confidence and self-determination seemed like foolish vanities in this reality of the urban complex, in which one strove simply to keep alive his sense of being. Urban reality was a muchness—it was made up of many people, many diverse stimulants to the senses, mountains of complex machines and buildings, much painful labor, and much frustration and grief. There was little place for reticence or subtlety; to pause was to cease to breathe.

The multifaceted stimulation of city living was in itself a sufficient

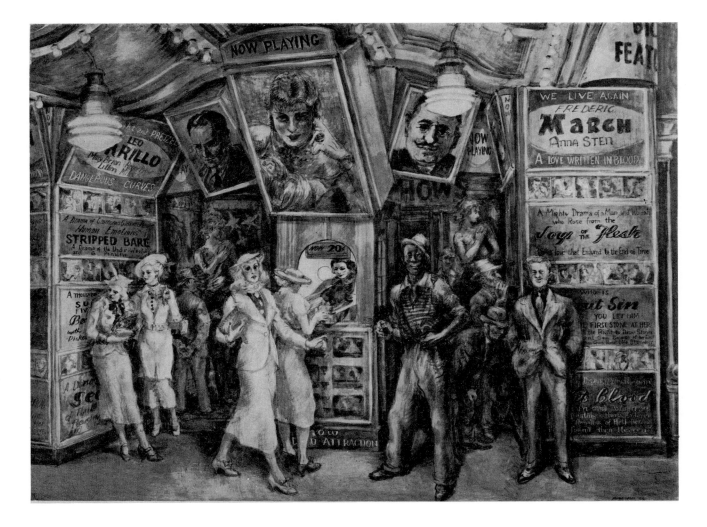

Reginald Marsh, *Twenty-Cent Movie*, 1936, egg tempera on composition board, 30 x 40. Whitney Museum of American Art, New York, New York.

proof to some artists that they existed in a human community. Reginald Marsh, for one, ignored the pretensions of urban designers to concentrate on how life went on in the environment. His people are never alone. They lurk in gangs at street corners, pile up in a sweaty mass during a day at the beach, and move in droves through the fun houses of Coney Island. The crowded compositions and restless surfaces of his paintings seem a part of the social texture he depicts, in which there are no leading roles nor any single point from which to judge the rest. People, signs, well-used buildings are all a part of the visual turbulence that provokes sympathy for its vitality without allowing one to dwell on an individual or wax nostalgic about an atmosphere. Yet there was no questioning the physical existence of his people—each one with his evident background and the equally specific environment in which he lived. Like the city itself, Marsh's paintings are impersonal complexes made up of highly personal parts.

When the great battle waxed fierce in the mid-1930s about the nation-

241

Paul Cadmus, *Main Street,*
1937, oil on tempera, 31¾ x
73⅜. Midtown Galleries,
New York, New York.

ality of painting, Marsh was often listed among the painters of "the Ameri-can scene." There is no doubting the source of his subject matter or its pertinence to thinking in America, but Marsh was basically an observer of people wherever they might come from and showed little interest in em-phasizing that the scene was peculiar to America. The earthy vulgarity of private life lived in public was proof to him of an animal persistence that was in its own way reassuring, making the acceptance of the commerce-ridden city with its crowded masses an understandable point of view. City vitality as seen in the 1930s knew no distinction in class. When the com-petitive, acquisitive city dweller moved to the suburbs, if Paul Cadmus's works of the 1930s are to be believed, he took his aggressive vitality along. No matter how much space may be around them, there seems always an excess of people. Vulgar as they are, they fill what many considered an aesthetic vacuum, rudely crowding out utopian plans and artistic niceties.

But the visually perceived texture of the city itself has a character of its own, constituted almost wholly of unknown people and man-made—and man-abused—objects. So many minds and so much chance have been in-volved in its creation that it has some of the anonymity of authorship that other than transcendental types attribute to nature. But the city environ-ment is not nature—in the way one might speak of the Iowa hills—because the seed of its growth is to be found only in the entangled lives of the people who live, and have lived, within its confines. To paint a city street is to paint a society, so intimately are the individual lives and the places they are lived related. It is this inseparable, seemingly inevitable relationship be-tween the person and the urban texture from which he emerges that is so evident in Marsh, and possibly even more so in Isabel Bishop. Her somber young women, preoccupied with their own thoughts, live in a curiously im-measurable space that one assumes is filled with people, even when they

Paul Cadmus, *Aspects of Suburban Life: Polo,* circa 1938, oil on tempera on fiberboard, 31¾ x 52⅝. WPA: Federal Art Project. Art in the Embassies Program, Department of State, Washington, D.C.

Paul Cadmus, *Aspects of Suburban Life: Public Dock,* circa 1938, oil on tempera on fiberboard, 31¾ x 52⅝. WPA: Federal Art Project. Art in the Embassies Program, Department of State, Washington, D.C.

Paul Cadmus, *Aspects of Suburban Life: Golf,* circa 1938, oil on tempera on fiberboard, 31¾ x 52⅝. WPA: Federal Art Project. Art in the Embassies Program, Department of State, Washington, D.C.

Charles Surendorf, *Five and Ten*, circa 1939, wood engraving, 8½ x 11 13/16. WPA: Federal Art Project. National Collection of Fine Arts; Transfer from D.C. Public Library.

cannot be clearly distinguished. For all the activity that seems to be taking place, there is a subtly evoked monotony that suggests an uneventful continuity in the lives of the people picked out in the crowd. Small happenings —a dash of fresh color, a slight flirtatious glance—become important moments in a span of time that seems to have no particular beginning and no specified goal. If Marsh's determined young women cope with their collective lives in a state of almost bestial intensity, it might be said that Isabel Bishop's, no less physically implanted in the urban scene, take the opposite route, mutely harboring their feminine dreams as they go about their routine of living in the city. Often there seems to lie beneath the surface that satisfying but anonymous familiarity that exists among habitual riders of the same subway system. There is an aspect in which the city becomes the family.

Accepting the city as a place lived in provided the artist with a variety of material with which to establish a communal bond. To discover visual pleasures in environments not suspected of artistic leanings is a contribution not to be ignored, and throughout the 1930s many artists translated the urban scene into a game for seeing, without being false to the mundane stuff with which they worked. Ilya Bolotowsky's *In the Barber Shop* (1934) has the atmosphere of the neighborhood gathering place, not yet a nostalgic relic, but it also provides a lively play of color and the formal play of the endless, slightly canted reflections in the mirror. Similarly, Millard Sheets's 1934 painting *Tenement Flats* is a noncommittal portrayal of life in a California tenement, but, at least as important, is also an ingenious and sprightly

Isabel Bishop, *On the Street*,
circa 1932, oil on canvas,
14½ x 26. Mr. and Mrs.
Paul Wachs.

Theodore C. Polos, *At Night*,
1939, lithograph, 14½ x 10¾.
WPA: Federal Art Project.
National Collection of Fine
Arts; Transfer from D.C.
Public Library.

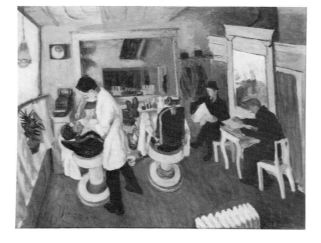

Ilya Bolotowsky, *In the Barber Shop*, 1934, oil on canvas, 23⅞ x 30⅛. Public Works of Art Project. National Collection of Fine Arts; Transfer from Department of Labor.

Millard Sheets, *Tenement Flats*, 1934, oil on canvas, 40¼ x 50¼. Public Works of Art Project. National Collection of Fine Arts; Transfer from National Park Service.

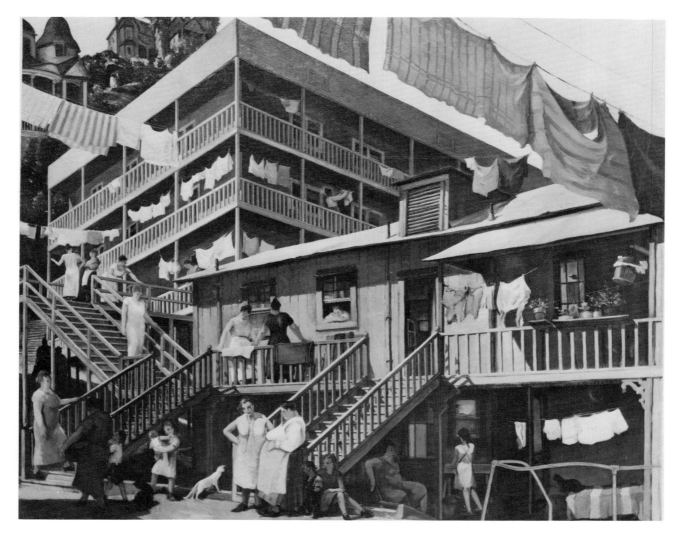

Stuart Davis, *Abstract Landscape*, oil on canvas, 22⅝ x 29¾. WPA: Federal Art Project. National Collection of Fine Arts; Transfer from General Services Administration.

composition that takes the eye on an unending series of adventures. The local scene is animated by artistic structure. The man who most successfully presented the city as a visually provocative place, giving it an emphatic human content without even representing a human being, was Stuart Davis. Beginning in the 1920s he made it clear that he was not intimidated by the city, its impersonal signs and machine-made appurtenances, and proceeded to turn even the most ordinary objects into animated acquaintances. His lively canvases could serve as amiable lessons from which city dwellers could learn to see themselves as participating in an endlessly stimulating environment. His efforts were not always appreciated as doing precisely that. Davis felt the need to work out his social concerns in other ways.

For the most part the city was seen as the center of work, and the seriousness of the working masses became a dominant concern for many urban artists. The primary image was of the heroic stature of labor and the uncompromising seriousness of the working class. Artists had already become fascinated with factories and the urban laborer in the late nine-

248

James E. Allen, *The Builders*, 1933, etching, 9⅞ x 11 15/16. National Collection of Fine Arts; Gift of the Family of James E. Allen.

Spencer D. Crockwell, *Paper Workers*, 1934, oil on canvas, 48¼ x 36¼. Public Works of Art Project. National Collection of Fine Arts; Transfer from Department of Labor.

teenth century, but conditions had changed over the past forty years. Harold Lehman's worker with the pneumatic drill looms like Thor with a modern thunderbolt, not just a man working but the image of labor as a great, impersonal force. Whether this is translated into terms of a Marxian proletariat or the growing power of American labor organizations, it represents a unifying state of mind. Cities and factories could no longer stand as abstract dreams; they were built and maintained by men who were refusing to be ignored. In the purposiveness of the workers' efforts, artists found an answer to the seeming arbitrariness of their aesthetic choices. Their identity was not with machines functioning but with men working. In their desire to belong, to establish a firmly rooted human contact in art, it was easy to merge, possibly to confuse, an aesthetic principle and a social outlook. Like his rural counterpart, whom for the most part he despised, the urban artist, thus persuaded, lived the part of a laborer, thought in terms of craft and workmanship, and began himself to think in terms of unions and cooperative organization. In part, this was a product of the depressed economic situation of the depression, but it also was in response to an artistic crisis. It was the desire for a kind of folk anonymity within the sophisticated urban structure, a pursuit of human roots in a society threatened by inhuman bigness.

Socialist thinkers saw the matter differently. They saw the crisis in

249

William Gropper, Study for mural, *Construction of a Dam* [Department of the Interior, Washington, D.C.], circa 1937, oil on canvas, three panels: overall size, 27⅛ x 87¼ [side panels, 27⅛ x 22⅝; center panel, 27⅛ x 41¼]. Treasury Section of Painting and Sculpture. National Collection of Fine Arts; Transfer from National Park Service.

Bendor Mark, *Two Men and Cart*, circa 1937, oil on canvas mounted on paperboard, 16⅛ x 22. WPA: Federal Art Project. National Collection of Fine Arts; Gift of Bernard Marcus.

Bendor Mark, *Two Men Pushing Cart*, circa 1937, oil on canvas, 20⅛ x 27⅛. WPA: Federal Art Project. National Collection of Fine Arts; Gift of Bernard Marcus.

250

Jackson Pollock, *Miners*, circa 1934-38, lithograph, 11½ x 15½. National Collection of Fine Arts; Museum purchase.

artistic direction as a reflection of disillusion in a decaying but still vicious capitalism, and offered the Marxist revolution as an organizing principle for both society and art. The John Reed Club of New York was founded in 1929, an affiliate of the International Union of Revolutionary Writers and Artists, and in 1932 a national conference was held in Chicago with eleven clubs represented. The *New Masses* reported that "the conception of art and literature as an ivory tower affair is now outgrown . . . writers and artists must align themselves with the revolutionary proletariat, looking toward a classless society and toward an infinitely higher culture than capitalism offers—or they must align themselves with the capitalist enemy."

The first exhibition sponsored by the John Reed Club was held in New York early in 1933 under the title "The Social Viewpoint in Art." Just about anyone who painted contemporary life with an other than optimistic view was included, much to the annoyance of the more militant social revolutionaries. Although some were content with an art that simply showed the unfortunate condition of man in the present society, others insisted that art must actively help provoke social change by whatever means possible. The debate over art and propaganda was heated, with those artists who did not obviously take an advocatory stance being called "reactionaries," no matter their choice of subject matter. Simply to record was to identify one's self with the status quo. Thomas Craven objected to the views of international Communism not so much on political grounds as for the fact that it substituted an international concept of class for the regional ties of the artist. For

251

O. Louis Guglielmi, *Relief Blues*, circa 1939-40, tempera on fiberboard, 23⅞ x 29⅞. WPA: Federal Art Project. National Collection of Fine Arts; Transfer from The Museum of Modern Art.

O. Louis Guglielmi, *Connecticut Autumn*, circa 1935-37, tempera on fiberboard, 23⅞ x 29⅞. WPA: Federal Art Project. National Collection of Fine Arts; Transfer from The Museum of Modern Art.

252

Joseph Vavak, *Women of Flint*, 1937, oil on canvas, 25¼ x 36¼. WPA: Federal Art Project. National Collection of Fine Arts; Transfer from The Museum of Modern Art.

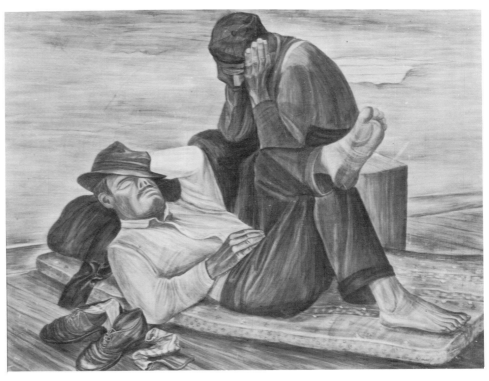

Edward Millman, *Flop House*, 1937, tempera on fiberboard, 23 x 29⅞. WPA: Federal Art Project. National Collection of Fine Arts; Transfer from The Museum of Modern Art.

Joseph Hirsch, *Hero*, circa
1939-40, oil on canvas, 41 x
30⅛. WPA: Federal Art
Project. National Collection
of Fine Arts; Transfer from
The Museum of Modern Art.

William Gropper, *I Cash
Clothes*, circa 1935, brush
and ink on paper, 15⅝ x
11½. National Collection of
Fine Arts; Gift of the artist
and his wife.

Ben Shahn, *Scott's Run, West
Virginia*, 1937, tempera on
cardboard, 22¼ x 27⅞. Whit-
ney Museum of American
Art, New York, New York.

254

Jack Levine, *The Feast of Pure Reason*, 1937, oil on
canvas, 42 x 48. The Museum of Modern Art, New
York, New York; Extended loan from the United States
WPA Art Program, 1938.

Ben Shahn, *Willis Avenue Bridge*, 1940, tempera on board, 23 x 31⅜. The Museum of Modern Art, New York, New York; Gift of Lincoln Kirstein.

Philip Evergood, *American Tragedy*, 1937, oil on canvas, 29½ x 39½. Private collection.

Theodore C. Polos, *Street Fight*, circa 1939, lithograph, 12 x 14⅞. WPA: Federal Art Project. National Collection of Fine Arts; Transfer from D.C. Public Library.

Ida Abelman, *My Father Reminisces*, 1937, lithograph, 15 x 18¼. WPA: Federal Art Project. National Collection of Fine Arts; Transfer from D.C. Public Library.

257

him and others who spoke of "regionalism," the artist could create meaning-fully only within his own environment. This was the principle of the rural "folk." Diego Rivera, who was much cited and very active on the American scene, had much more quality and significance, according to Craven, when painting in Mexico than when painting in Detroit and New York. The ideological difference was fundamental; between a concept of roots depend-ing upon regional and national associations, or on membership in an inter-national proletariat.

So far as the larger group of artists was concerned, the style of painting had little to do with political ideology, once it was agreed that art should be drawn from and communicate with the common man. What was com-municated, however, was another matter. The social revolutionaries believed that an art which made man feel more a part of his particular environment, either out of human sympathy or aesthetic pleasure, was counter to the aims of the revolution; others saw the demands of organized social advocacy as destroying all creative revelation in art. But there was no doubt on either side that art and the artist belonged somehow to the population at large; art wanted very much to be considered as belonging.

Given the economic situation in the early 1930s in America, there seemed to be some question about whether art could survive long enough to belong to anyone. Much of the patronage upon which artists had tradition-ally depended had dried up, and many artists, like others, were hard pressed simply to maintain themselves. Late in 1933, after some struggle of both an artistic and a political nature, an unprecedented program called the Public Works of Art Project was launched by the government, payed for out of relief funds. Prompted by the painter George Biddle and organized under the Treasury Department by Edward Bruce, the PWAP got off to an abrupt and stormy start in its efforts to commission unemployed artists across the coun-try. Most commented on were the murals painted in public buildings, which often alarmed the public but gave the artists their chance to feel closely allied with the people and the public welfare. Over 500 of the smaller works created by artists with government support were shown at the Corcoran Gallery in Washington in April and May 1934. The tone of the exhibition was serious. Paintings related to industry and the working man predomi-nated. The artists employed as workmen made clear their desire to be iden-tified with the laboring class.

Out of this brief beginning grew the Treasury Department's program for art in federal buildings, administered by a new Section of Painting and Sculpture (later part of the Treasury Section of Fine Arts). In this program commissions were usually awarded on the basis of competitions rather than on financial need, with due emphasis placed on quality. Economic relief was necessary, however, and in both the Treasury Relief Art Project and the Federal Art Project (part of the WPA) emphasis was placed on artists who were unemployed.

The Federal Art Project, from its beginnings in 1935, reached artists

Joe Jones, *Street Scene*, 1933, oil on canvas, 25⅛ x 36⅛. National Collection of Fine Arts; Transfer from Department of Labor.

Elizabeth Olds, *Scrap Iron*, circa 1935-39, lithograph, 11⅞ x 16⅝. WPA: Federal Art Project. National Collection of Fine Arts; Gift of Audrey McMahon.

Leonard Pytlak, *New For Old*, circa 1935-39, color lithograph, 11¼ x 13¾. WPA: Federal Art Project. National Collection of Fine Arts; Transfer from D.C. Public Library.

Moses Soyer, *Artists on WPA*, 1935-36, oil on canvas, 36⅜ x 42⅛. WPA: Federal Art Project. National Collection of Fine Arts; Gift of Mr. and Mrs. Soyer.

throughout the country by way of state administrators and offered sustenance in all branches of the arts. It was under the WPA that many of the works in this section were created. So far as the Federal Art Project was concerned, no kind of art was proscribed, but some local administrators were notably hostile to whatever they considered "modernism." For the most part, however, this was not a major problem since most artists, now working directly with a large public, were not tempted to go much beyond that public's capacity to understand. More scandalous than style was overt political content. Once the artist joined society at large he wanted his say, and it sometimes came as a shock to those who preferred to consider the gentility of art that many artists no longer felt bound by the patronage

Jenne Magafan, Study for mural, *Western Town* [Littleton, Colorado, Post Office], circa 1939-43, oil on fiberboard, 14⅛ x 39½. Treasury Section of Fine Arts. National Collection of Fine Arts.

Kenneth Evett, Study for mural, *Extractive Industry*, 1941, tempera on fiberboard, 12 x 24½. Treasury Section of Fine Arts. National Collection of Fine Arts.

261

traditions of the recent past. For all of its bureaucratic meddling, the government proved for many to be an agreeably neutral sponsor, affording the artist the blissful freedom to work continuously at his art as he saw fit. In a way that he had not expected, the artist became rooted to his environment and gained a new confidence in his place in society. He belonged in the American scene, whether he painted it or not. And at no time earlier had the public at large been so conscious of art and the artist, surrounded as it was with murals, neighborhood art centers, print and craft projects, to say nothing of the projects in music, theater, and literature. The way was open for a whole new meaning of art as a phenomenon germane to America.

A Center of Art

Clyfford Still, *1946-H*, oil on canvas, 78 x 68½. Vincent Melzac, Washington, D.C.

A Center of Art

Critics and art historians will never cease to debate the causes and nature of the extraordinary flowering in the late 1940s of an art in America so vigorous and moving that, for the first time in history, the United States was looked to as a source of vital artistic expression, as an artistic avant-garde. America finally had its place in art not because of its wilderness, its engineers, or its promising skylines, but because of the creations of its artists.

Significantly, the art that in the early 1950s began to be recognized as American paid little heed to what had previously been considered American traits or the local scene. But then, artistic imagery everywhere by the 1940s had little to do with national schools. With more than a quarter of a century of explosive experiment and intensive self-awareness as an inheritance, artists were far more conscious of fundamentally human concerns than they were of devisive schemes that supported some form or other of local definition. Furthermore, with the increased migration of artists during the 1930s, national origin became of far less significance than the working environment, the artistic contacts and exchange of ideas that made possible a new kind of citizenship in art. Nonetheless, for whatever reasons, what took shape in New York in the 1940s and '50s was an art distinct from that produced in any other center. Although an art of extraordinary diversity in every usual category of description, it seemed to have some underlying current of impulse and purpose that gave it an identifiable unity in the eyes of the discerning public both here and abroad.

The impact of the new art was far reaching. It dominated the vision of young artists for more than a decade and quite changed well-established patterns of thinking about art. Critics had to scurry to find new words to deal with the new perceptions. Yet, although it has been called a "school" and a "movement" and has been honored with a variety of terms and definitions, the art associated with New York in those few incredibly productive years probably had less of an ideological program or stylistic unity than any preceding identifiable modern tendency. Possibly the enigma posed

by its spiritual unity but stylistic diversity was one of its most significant offerings to the world of art.

Why should such art develop in America at that time? Reams of prose have been offered in support of one theory or another, some analyzing the works in terms of combined "isms," others providing social explanations or tracing it all to the presence of displaced European artists in New York. All of these histories are doubtless true; creative history must be recognized in modern times as a part of creative art. In fact, what later happened to the various aspects of the general movement was in part dependent on the different views of history the younger artists embraced. But to try to deal with isolated "influences" is to miss the character—possibly the peculiar character—of the modern artist in America. Significantly, few American artists have ever properly fit the historical categories dear to the hearts of historymakers. It has often been lamented that Alfred Maurer was not properly fauve or cubist, that Max Weber was not fully cubist or futurist, or, to go further back, that the American "impressionists" never really approximated the visual detachment of Monet. Although the modern historian, taking full advantage of hindsight, can distill the essences of schools and movements and judge the participants on the basis of how clearly they matched their historical role, the active artist lives in no such well-analyzed environment. His goal is not, usually, the articulation of history, but the creation of works that are to him at that point meaningful and necessary. It is blessedly not essential that he know the sources of his means and his impulses.

The range of experiences available to an artist growing up in New York in the 1930s was very broad. Although "modern art" was still a matter for disparagement, already the revolutions of the past twenty years were demonstrated to be inevitable historical fact. At the very time battles were raging over regional art, socially conscious art, and pure aesthetic standards, the Museum of Modern Art was displaying analytical exhibitions of "Fantastic Art, Dada and Surrealism" and "Cubism and Abstract Art." That all of this should have existed at the same moment is important because it meant that even if an artist chose to throw his lot with one militant group or another, he could not avoid being affected by the various other artistic pressures of the complex environment. Nor was it simply a matter of conservatives and rebels; rebellion had many faces. Furthermore, in large part because of the federal art projects, artists of all kinds worked together. Probably for the first time in America, art had its own broadly constituted community of fellows, not determined by where they had studied or by membership in an honorific organization, but simply by the fact of their being artists. By the end of the 1930s the warring factions that had carried on so vehemently early in the decade had lost their clarity of position. It is not that one artistic direction had finally conquered; the kinds of distinction once considered so important simply did not mean much any more. Artists had their environment in which to work and, although quite conscious of

society as a whole, they felt themselves to have a broader franchise to be artists on their own terms than ever before. They did not have to seek roots either in the country or the city masses, but found their sustenance in the serious reaches of art itself.

By the time the Museum of Modern Art in New York opened its new building in 1939, a surprisingly wide public was ready to accept the fact that the foundations of art had shifted and the possibilities in art were many-leveled and unpredictable. It is important to note, moreover, that neither the public nor the artists of this generation had acquired the new vision by passing through a gradual historical process, moving from fauvism, to cubism, to abstraction, and so forth. Although intellectually the interested public might understand the progressive chronological scheme that was put forth in one apologia after another, perceptually all of the tendencies were there to be grasped at the same time. Of particular importance, too, is the fact that all of the previous formal revolutions were accepted at a moment in which most artists and writers were concerned with psychological processes. Already the language of psychology textbooks was supplanting that of philosophy in criticism. By the later 1930s Freud was a folk hero on university campuses, sharing top honors only with Marx. The age of formal innocence was past.

So a new art was born out of a renewed confidence in the artist as creator, from the belief that art was the product of people, not places, and that the modern inheritance belonged to everyone, no matter where he lived. Moreover, art was serious and all encompassing, not simply a social decoration. Art did not reflect but encouraged life.

If a common denominator were to be found, it would probably be masquerading behind the word—too popular in the 1950s and '60s—"participation." In one way or another, all art requires a participation on the part of the viewer, whether simply that of memory, a kind of visual scansion, or some more profound involvement. But two important aspects characterize participation in works of the New York painters: at no time is sensuous involvement separable from a state or activity of mind—there can be no separation of the sensuous form and the content it implies; and the experience engendered seems to begin with the painting and remain there, satisfying but unresolved.

Usually, when we speak of participation we mean to participate physically in an act, as distinct from being a spectator, and it is significant that one of the terms attached to this painting in 1952 was "action painting." Unless the full nature of the action, from the point of view of both the artist and observer, is carefully considered, as Harold Rosenberg (who first used the term) pointed out, the term can be disastrously misleading. The simple fact that a painting serves as a bond between the action of the artist and the sense of activity experienced by the viewer is in no way new, nor does it of necessity provide a particular artistic content. Many theories, beginning late in the previous century, discussed the persuasion of a line or

Jackson Pollock, *Mural*, 1943,
oil on canvas, 97¼ x 238.
University of Iowa Museum
of Art, Iowa City; Gift of
Peggy Guggenheim.

form to carry the viewer with it, creating a vital rhythm that seems in some mysterious way to be allied with harmonious bodily function. The psychophysical aspects of aesthetic judgment were widely discussed throughout the early years of the century. Although some of the artists took this empathetic participation as a working premise, what their action produced was not, in fact, to be compared in any simple way with earlier creations of formal persuasion.

One of the most talked-of artists, because of his unconventional methods in creating painting, was Jackson Pollock, and the growth of his distinctive painting illuminates a direction that was shared in different ways by many. Maturing in the midst of the Great Depression, he suffered the difficulties of poverty and was sympathetic to the problems of the working class. For some years a protegé of Thomas Hart Benton, he devoted himself initially to regional themes and folk imagery. But rather than socially aware subject matter, what attracted Pollock in the work of Benton, Orozco, and Siqueiros was an earthy vitality of forms that carried a serious burden of individual expressiveness. He early accepted the fact, being quite aware of Jung, that the response to such forms was deeply rooted in the unconscious mind, and consequently that the expression such forms referred to was palpable but beyond the reach of rational analysis. So out of his rhythmic entanglements of the early 1940s emerge hints and signs that conjure up a secret stratum of life, sometimes animal, sometimes human, but always goaded by violent impulse and throbbing emotion. But the signs that seem like random symbols from a lost culture began to disappear, and his impulsive mural painted for Peggy Guggenheim in 1943 takes its power almost wholly from the strength of the artist's gesture. Although it is filled with possible images, they never materialize, and the viewer is moved to join the artist in a frenzied and continuous dance. The word "dance" is appropriate because this is movement responding to an inner purpose, not simply

268

Jackson Pollock, *Number 7*, 1948, oil and enamel on
canvas, 35¾ x 130. Private collection.

rhythmic gymnastics. Although it is hard to resist the force of the artist's persuasive gesture, it does at this point remain essentially his dance, his world of experience into which we are allowed to peer. But by 1947 this effect of personal gesture was changing in Pollock. By dripping and spattering paint, instead of using brushes or palette knives, he could create equally involving complexes, multilevel patterns of action, without their being read in terms of the controlling gesture of the artist's hand. The difference was important. The viewer could no longer fall back so easily on the time-honored escape from commitment by saying "the artist felt . . ." or "the artist was trying to . . ." but faced a complicated artistic phenomenon on his own terms.

Several aspects of this new painting bothered the public. Accustomed to appraise the skillful "hand" of the artist, they found nothing in the controlled chance of Pollock's work on which to base a judgment. Said the witty Mr. Hyatt Mayor of the Metropolitan, "I suspect any picture I think I could have made myself." Then there was the matter of composition. Traditionally, composition was based on thrust and counterthrust with a keen respect for the shape and edges of the canvas. Color was skillfully repeated to create a triadic stability. Although one cannot deny their exterior poise, Pollock's paintings have no beginning or ending, and lead not to resolution but to an increasingly more absorbing involvement with newly discovered linear complexities. The size and shape of the paintings are important, too. They cannot be taken in at a glance, since by the time one has drawn close to follow the activity he has lost the edges of the canvas and his tidy definition of measurable space is swamped by his engagement in an endlessly varying process of action. Furthermore, in this moment of absorption there is continuous promise of a new discovery, of a revealing image just beyond the threshold. It is a new world that Pollock offers, in which time and space have nothing to do with clocks and maps, and the distinction between the conscious and unconscious mind becomes immaterial. It offers a kind of freedom—a delight in freedom—of a kind hardly known in painting before. For many of the very same aspects that some found difficult to accept in Pollock, the Italian critic Bruno Alfieri wrote in 1950, "Jackson Pollock is the modern painter who sits at the extreme apex of the most advanced and unprejudiced avant-garde of modern art."

The quality Alfieri emphasized was chaos, an aspect which, looking back from today at Pollock's often lyrical works, may be hard to understand. Yesterday's chaos often becomes today's accepted harmony. But by systematically destroying all preexisting props—whether technical, formal, or imagistic—and yet creating an intensive sensuous and psychological involvement that in the experience proves consistent and true, Pollock and others were opening up a whole new realm of experience to be explored and in so doing were expanding at the same time the potentialities of art. To be sure, there was much in the method that was allied to surrealist thought, and much early Pollock shows clear reference to Miró and to Picasso in his

Guernica kind of expression, but by the late 1940s the paintings of Pollock were free of interpretable references of a textbook sort. His belief in automatism was such that he did not need literary confirmation for his purely pictorial images. In an often-quoted statement of 1947-48 he said, "When I am *in* my painting, I'm not aware of what I'm doing. It is only after a sort of 'get acquainted' period that I see what I have been about. I have no fears about making changes, destroying the image, etc., because the painting has a life of its own. I try to let it come through."

In a disarming way, looking at a Jackson Pollock painting is not essentially different in process from creating it. In fact, by bowing out of his own picture—or being absorbed totally by it—Pollock allows the viewer to engage in a procedure akin to creativity. Mentally, it is creativity because Pollock, in his appealing "chaos," provides the inquiring mind with the possibility of endless discoveries, unexpected harmonies, and activities at many levels of the consciousness. Since all appears to be by chance, each discovery seems to belong as much to the viewer as to the artist. In this sense, it is true participatory art. It is less that the artist is telling people something or "expressing himself" than that he is providing a community of experience on a level that is both profound and personal. It becomes an expression for everyone.

Jackson Pollock was by no means alone in his goals and purposes, nor were his methods the only means. Each artist developed very much in his own way. Although there was much discussion among the artists in New York and a lively intellectual concern for ideas about art, none of the major figures were at all interested in following a predetermined program. In fact, much of their discussion had to do with how to escape from the classifications and aesthetic categories so precisely enunciated during these same years. "I think it is the most bourgeois idea," said Willem de Kooning to a group of his fellow artists in 1949, "to think one can make a style beforehand. To desire to make a style is an apology for one's anxiety." "Style is a fraud," he said. "I always felt that the Greeks were hiding behind their columns." What was required, many agreed, was sufficient faith in the act of painting to devote oneself to it with complete intellectual and emotional openness, avoiding by any means possible the limits of preconceived style or image. One might talk endlessly about philosophical goals and niceties of perception, but when it came to painting one painted. Said critic Harold Rosenberg in 1952, "What they think in common is represented only by what they do separately."

De Kooning, for one, has never felt it necessary to decide whether he is an abstract or figurative painter. Since he has always enjoyed being in close touch with his visual surroundings, it is natural that they might appear in his paintings just as they figure as a part of his thoughts. Yet to suppose that they constitute the subject of his painting in a specific interpretive way would be to miss the nature of the whole experience. The goal for each painting is a total expression that may or may not make use of obviously recognizable images. Although his paintings of the late 1940s may not be

identifiable in terms of objects, only a mind rasped bland by theories of abstraction could fail to respond to them as embodiments of specific sights and touch and nameless imaginings. The action called for in such paintings is not the kind that sets out to slough off all thought and reflection by moving vigorously, but is a special kind of activity that carries the whole mind along, leaving no quiet monitor to sit alone at home.

How awkwardly de Kooning fits into any historical scheme of abstraction became dramatically evident when he began to exhibit his paintings of women. Again looking backwards, it seems strange that this should have come as such a surprise, but the art world was again embarking on a scheme of categorizing and name-giving to stimulate a newly awakened American market, and the concept of the abstract was the great hurdle the art-appreciating public had finally been eased over. The grotesque, sometimes charming, more often aggressively vulgar images tended to upset the soothing prose about the purity of formal interplay. Yet the bumptuous, assertive brusqueness, whether expressed in de Kooning's women or Franz Kline's untidy beamlike lines, with little thought of "good taste" or *belle peinture*, was one of the qualities that gave American painters a firm grasp on a new expression. If no limits were to be admitted, the image must be allowed to intrude where it wished. The intrusion, however, was not into the artist's line of sight but into the activity of painting, erupting inevitably and naturally as an element of mind.

The anonymity of seeming chance, and spontaneity, form an essential premise for de Kooning and Kline as well as for Pollock, but these qualities must be understood in a special sense. De Kooning worked for two years on his large *Woman I,* making studies, scraping and repainting. The studies did not lead step by step, as with nineteenth-century history painters, to the final statement, but were, each one, explorations complete in themselves. The ultimate work—if that term could be used—was the result of continuous elimination of all that might seem posed, prethought, or in other ways distracting from the restless energy that infuses the entire painting. In other words, the effect of spontaneity that disarmingly sets the stage for a trenchant and possessive expression is itself the product of much study. Rather than a search for style, such a procedure is a contest to avoid style. When it was mentioned in a discussion that young French painters have a "touch" that gives their work a look of completeness—a beautifully made object—de Kooning agreed. "They have a particular something that makes them look like a 'finished' painting," he said. "They have a touch which I am glad not to have."

To someone inclined to formal analysis, it would be easiest to describe Kline's mature paintings in terms of bold lines that thrust and counterthrust or tie themselves in dramatic knots. One might even talk of improving them by cleaning up the rough edges and clarifying ambiguous overlaps. The power of Kline's images, however, rests precisely on their seeming to be in the process of clarifying themselves, and by the fact that we seem to encoun-

Willem de Kooning, *Woman,* 1950, oil on canvas, 64⅛ x 46. Weatherspoon Art Gallery, University of North Carolina at Greensboro; Lena Kernodle McDuffie Memorial Gift.

Franz Kline, *Painting No. 11*, 1951, oil on canvas, 61½ x 82¼. Mr. and Mrs. Richard E. Lang, Medina, Washington.

ter them at a precarious moment in which, as if by fate, the forceful strokes and masses reveal a kind of magical relationship with each other. They are in no significant way the heirs of the superbly detached symbols of cosmic balance created by Mondrian. Each shape is not an element drawing its character from the ensemble, but a character in its own right, bearing its own power to act. Often the brushstrokes are recalcitrant and do not fall smoothly into place, hinting at a hidden willfulness in their shadowy forms. We lend them our energy and yet we wonder at their strength. Even though they may make reference to construction and city architecture, Kline's paintings are very human because the shapes welcome our participation and never rigidly dictate our response. Kline, like the others, invites the spectators to share. "If you're a painter, you're not alone," he once said. "There's no way to be alone. You think and you care and you're with all the people who care, including the young people who don't know they do yet . . . you paint the way you have to in order to *give*, that's life itself. . . ."

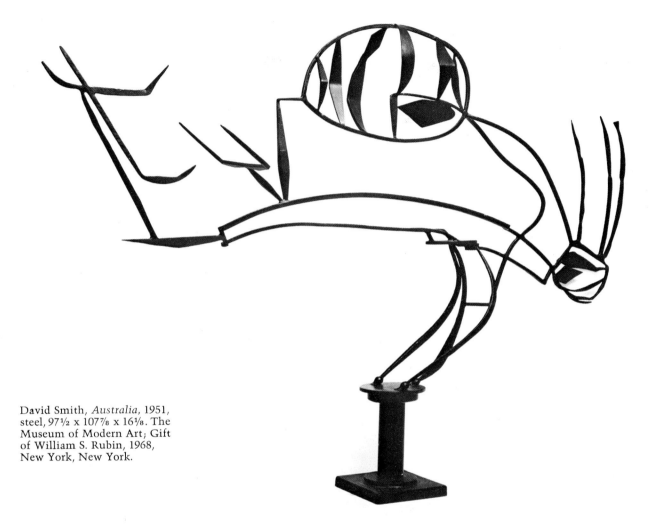

David Smith, *Australia*, 1951, steel, 97½ x 107⅞ x 16⅛. The Museum of Modern Art; Gift of William S. Rubin, 1968, New York, New York.

A somewhat similar sense of sharing marks also the contemporary sculptures of David Smith. Like Pollock and others he had been concerned with the imagery of Picasso's works of the 1930s and the idea of surrealism. Giacometti-like forms and Lipschitz structures people a recognizably strange spatial world. In the mid-1940s he began to shake off some of his intense but self-conscious symbolism to create more open landscapes for the mind. It was evidently the thought of sculpture's drawing its subject from landscape rather than from creatures that freed his thinking and allowed him to create forms that convincingly share their vitality as well as their mystery with the viewer. To say that his work became more abstract can be misleading. The forms are, indeed, simpler and often refer to inanimate objects, but whether they refer to trees or calligraphy, they have a sense of mysterious purpose and an inner life of their own.

Much of Smith's early work demands a kind of muscular empathy. The implied motions are judged by our own capacity to move. In the landscapes,

275

however, a different sense of movement prevails, responding to the fact that the space in which it takes place is both actual and imaginary. Smith creates not only a being but a world, a world in which all manner of things might happen, both grave and ebullient. In his *Australia* of 1951, there seems to be something of an argument as to whether the sculpture is going to be seen as a drawing on a plane or as lines freely moving in space. The viewer cannot help looking through as well as at. It is a useful ambiguity because in the "no-place" a great deal is going on that would be curtailed by a more specific sense of dimension. The suggestion of aboriginal drawing is exotic, but the sculpture also makes a direct appeal for our participation through the unmechanical flow of its lines and its hints at recognizable things. It has the dual habitation of a cult object, partly at home in a realm of magic and secret meanings, and yet existing very palpably in the world of the senses.

This double appeal followed through all of the works of David Smith's subsequent career, no matter his change in formal method. He was not concerned with making models of cosmic order but with creating works that were monumental in their earthly authority, yet the means for the rekindling of a sense of mystery.

Although the key to participation in the work of all of these artists is a sense of movement, of empathetic identification with what becomes spiritual form—to be sure very different in each case—this was only one of various means for the new shared experience. Physical participation was in no sense the common method of the new painting. More basic was the assumption that visual form can have consequences for the free working of the mind, and the consequences are most relevant and thus of greatest value when the form can disassociate itself from preunderstood order of any sort, whether style, likeness, or symbolic schematism. Thus the opportunity for active visual meditation could be as engaging as the possibility of sublimated physical action. However, meditative involvement engendered by the painting itself, and not by an emotional or philosophical scheme for which the painting is only the point of focus, presents its own visual problems. How are the initial conditions established so that the mind can penetrate to a new consciousness of itself? Again, the course was described as a disentanglement from styles, schemes, and ideologies to reestablish, as it often was said—only partly metaphorically—the unencumbered relationship between the individual painter and the canvas on which he worked. Clyfford Still, looking back over many years of work in 1959, spoke clearly and poetically about the process:

> To acquire such an instrument, however—one that would transcend the powers of conventional technics and symbols, yet be as an aid and instant critic of thought—demanded full resolution of the past, and present, through it. No shouting about individualism, no capering before an expanse of canvas, no manipulation of academic conceits or technical fetishes can truly liberate. These only make repetition inevitable and compound deceit.

*Thus it was necessary to reject the superficial value of material—
its qualities, its tensions, and its concomitant ethic. Especially it became
necessary not to remain trapped in the banal concepts of space
and time, nor yield to the morbidity of "the objective position"; nor to
permit one's courage to be perverted by authoritarian devices for social
control.*

*It was a journey one must make, walking straight and alone. No
respite or short-cuts were permitted. And one's will had to hold against
every challenge of triumph or failure, or the praise of Vanity Fair.
Until one had crossed the darkened and wasted valleys and come
at last into the clean air and could stand on a high and limitless plain.
Imagination, no longer fettered by the laws of fear, became as one
with Vision. And the Act, intrinsic and absolute, was its meaning, and
the bearer of its passion.* [Statement in *Paintings by Clyfford Still*,
catalog of an exhibition held at the Buffalo Fine Arts Academy and
Albright-Knox, 1959.]

The "imagination" that for Still "became as one with Vision" can be
taken almost in the sense of William Blake. He meant it not as fantasy or
the wanderings of the stimulated mind, but as the reflection of that mystic
source that is home to the soul. In fact, Still quoted Blake, noting that
although the context was different, the metaphor was apt:

The Vision of Christ that thou dost see
 Is my Vision's Greatest Enemy:
Thine is the friend of All Mankind,
 Mine speaks in parables to the Blind . . .

Obviously the sensuous appeal is necessary, but to stop with a concern
for patterns and color would be to sell Still short. Still's painting begins after
one is absorbed by the haunting shapes and unexpected spatial suggestions.
It affords a peculiar satisfaction beyond vision, a harmony that does not
necessarily delight the eye.

References to myth, to religious insights, and to universal spirit are
frequent in the comments of the New York artists through the late 1940s
and '50s, yet there was no inclination to embrace any established creed—to
establish a new Christianism as earlier in the century or to follow Theoso-
phy or a specific Oriental faith. Painters such as Mark Rothko and Barnett
Newman were thoroughly aware of the various theological persuasions that
had interested artists, as well as of anthropological studies exploring primi-
tive religious practice, but no one was moved to believe that he could
espouse someone else's religion, even though Rothko and Adolph Gottlieb
did speak out in praise of primitive art. The spiritual knowledge they were
building was based on their art, not the other way around. "Pictures must
be miraculous," said Rothko at one point, referring to the fact that in some
uncanny way they succeed in jogging the mind into an awareness not so
much of itself as of an existence beyond self. In no sense was this a matter

277

Mark Rothko, #22, 1949, oil on canvas, 117½ x 107⅛. The
Museum of Modern Art; Gift of the Artist, 1969, New York,
New York.

of the artist's projecting his specific feelings or commentary. Once a painting is completed, said Rothko, "the intimacy between the creation and the creator is ended. He is an outsider. The picture must be for him, as for anyone experiencing it later, a revelation, an unexpected and unprecedented resolution of an eternally familiar need."

This would seem to say that once the painting was created it had its own presence and was not to be seen as embodying an act of the artist, any more than a building is seen in terms of the successive steps of its design. From the late 1940s on, Rothko worked in softly edged shapes that had a kind of internal energy but no specific sense of direction. Although he said in 1947 that he thought of his pictures as dramas and the shapes as performers, the gestures and activities the forms engage in are not of a kind to stir our sense of muscular participation. On the contrary, the muted atmosphere is such that a physical gesture would seem a rude interruption. In a way to puzzle anyone looking for nice categories of definition, the shapes have a human warmth and energy, and yet are peculiarly non-creatural. This phenomenon becomes even more remarkable after 1950, when Rothko confined himself only to basically rectangular shapes. Oddly enough, in these paintings there seems to be dramatic activity without actors. What Rothko created, in a way, was an environment that did not contain action so much as it provided the action out of itself, the same forms creating place, action, and, ultimately, a state of mind. One cannot identify oneself with one form as against another, but must accept the interplay of the whole as a given unity, noting, to be sure, a continuous shifting of intensities within the subtly established equilibrium.

In order to cut all ties with material or conceptual limits, Rothko was careful to avoid anything that could be construed as design or calculated mathematical measurement. His planes have been metaphorically likened to mist, fog, layers of light, because they appear always in a state of becoming and never accept a given material limitation. For a calculating and distinctly unmagical world, the paintings provide a place for magic, an inviting, unbounded space where order prevails by nature rather than by law. This is not a place for remembering or uncovering hidden quirks of the mind, but a place in which contemplation constitutes living, and the mundane active aspects of life seem remote and not of immediate import. In a persuasive way, Rothko created a spiritual ritual for a largely ritualless society, a religious experience without the trappings of a church.

For all of these painters there was the initial assumption that their painting surface, once they faced it with creative intent, constituted an all-encompassing universe in which something important would take place. "The most important tool the artist fashions through constant practice is faith in his ability to produce miracles when they are needed," said Rothko. But he had to have faith as well in the reality of the canvas as an arena for the working out of experience. Although well informed about the past of modern art and conscious of schools and "isms," the New York painters

Barnett Newman, *Be I*, 1949, oil on canvas, 94 x 76. Anna-lee Newman, New York, New York.

tried to face their canvas each time as if it were a new—though friendly—universe, and to retain a tentativeness that would allow each painting to have the excitement of a fresh exploration.

No painter depended more on the assumption of the canvas's sensitized nature than Barnett Newman. From late in 1948 he concentrated on simple voids that are brought to electric attention by what often seem like sudden piercing streaks of light that cut across the colored space. Sometimes the streaks stand out brilliantly; sometimes they seem imbedded in the color of the atmosphere that surrounds them. But by their presence the void is animated, in a sense it becomes significant as void in a provocative and telling way. The word "void" possibly is misleading. Newman's word was "chaos" —a sensuous, intellectual field unformed. If one could take the brilliant red of his large 1949 canvas as an exciting but unformed ambiance, the brilliant fine white line that bisects the painting does appear as a ringing affirmative note. The title he gave the painting was *Be 1*, a confirmation of the sharp, assertive statement.

Newman's titles are often suggestive: *Onement, Abraham, Dionysus,* etc., and this has given impetus to seeing his canvases as the working out of a complex symbolism and possibly a mystic theology. Quite probably, however, the relationship between the paintings and mythical and religious systems existed the other way around. That is, once the paintings were done, they provoked the kind of speculation, for Newman as for others, that could find voice in theological and mythological texts. The cosmic and religious feeling, in other words, was aroused by the paintings and expanded into religious thought, the religious feeling moving from the painting to theology, but leaving the precise nature of this translation into thought or religious speculation up to the observer. To pursue "what Newman meant" by searching obscure texts is to misunderstand a subtle and powerful kind of expression. To look to speculative literature for an explanation of what the effect of Newman's paintings means to us, looking at the works, is, however, quite legitimate and a testimony to their extraordinary suggestive power. To pin them down to one theological system or another, however, would cut short exactly that freedom in the pursuit of spiritual values that Newman and others at the moment held so dear. What the titles do is confirm for the viewer that the artist also saw his creations as existing in the realm of spiritual meaning, and point to the kind of thinking they generated for him. They do not establish the limits for a "correct" interpretation of the paintings and sculpture.

The power of Newman's works depends on their extraordinary focus of attention on a single event, an isolated moment of experience from which ordinary phenomenal associations are resolutely excluded. This does not mean that the mind is held in a kind of stasis by aesthetic perfection, but rather that it is freed by the very exclusiveness of the sensuous concentration to consider itself in more cosmic terms. Yet the sensuous quality is not to be denied; Newman was not one who believed that virtue existed only

Barnett Newman, *The Promise*, 1949, oil on canvas,
57 x 70. Carter Burden, New York, New York.

in the austere disciplines of the mind. Man is a sensuous as well as a spiritual being. The refinement and concentration of sensuous perception in no way implies a negation of sense. Through niceties of proportion and variations of line and texture, Newman effected a sublimation of sense without, however, leaving the specific nature of the sensory enjoyment behind.

Most of the artists in this group were born between 1903 and 1905. Kline was born in 1910 and Pollock in 1912. They had all developed through that complex period of the 1930s in which all kinds of ideologies and styles were fiercely contended, and they all indicated their impatience with doctrinaire views and aesthetic dicta. They wanted the freedom to think and feel for themselves, and art was their means. Several of the artists found their initial encouragement in Peggy Guggenheim's gallery, Art of This Century, opened late in 1942. Pollock had a one-man show there in November 1943 and annually thereafter until the gallery closed in 1947, and also painted a mural for Miss Guggenheim. Rothko had an exhibition in 1945 and Still in 1946 in the same gallery. De Kooning had his first one-man exhibition at the Egan Gallery in 1945, and Kline had his first one-man exhibition there in 1950. During these active years, between 1943 and 1950, there was much discussion in the press about the new painting, with particular attention to Jackson Pollock because of his unconventional technique. Many of the artists got to know each other during the 1940s, although some had been friends for a longer time. In 1948 a group including Rothko, Still, Robert Motherwell, and William Baziotes organized a school called "The Subjects of the Artist"—a concept close to the heart of Newman, who felt that the crisis in art was not how to paint but what to paint. The discussions begun there were taken over shortly by "The Club," an informal group of artists who met on Friday evenings to discuss the aims and directions of art and listen occasionally to an invited speaker. They did not discuss how to paint pictures, but how to sustain their goals in art and, indeed, what those goals were.

In 1950 Arshile Gorky, Pollock, and de Kooning (represented by *Excavation*) were included with others in the United States pavillion at the Venice Biennale, and a large exhibition of Pollock's painting, mostly belonging to Peggy Guggenheim, was shown in the galleries of the Museo Correr in Venice. Many of these works were also shown in 1951 in Amsterdam, Brussels, and Zurich. In the mind of the public, Pollock clearly represented what was most audacious amongst the American painters. The Museum of Modern Art, which had tended to ignore American abstract painters during the 1930s, mounted a large and ranging exhibition called "Abstract Painting and Sculpture in America" in early 1951. The point of the exhibition was in large part to justify abstraction and to show that it already had a well-established tradition in America. In support of the exhibition a symposium on "What Abstract Art Means to Me," in which de Kooning, Motherwell, and others participated, was held at the museum in February. The emphasis was not—probably to the surprise of some—on formal matters but on ex-

pressive content. Said Motherwell, "Abstract art is an effort to close the void that modern men feel." At the end of the year an exhibition called "American Vanguard Art for Paris" was assembled at the Sidney Janis Gallery and was shown in February and March 1952 at the Galerie de France in Paris. In this exhibition instigated by the French, the abstract expressionists dominated. There was much talk at this time about the relationship between the new painting in Europe and America, and a certain amount of chauvinism developed in criticism on both sides. But by the early 1950s an image of what the young American painting was like was well established, both in America and abroad.

As a kind of climax to the attention that had been growing over the preceding fifteen years, the International Program of the Museum of Modern Art, at the behest of European museums, sent abroad an exhibition that was consciously devoted to the phenomenon which had by then become internationally known as abstract expressionism. "The New American Painting," made up of eighty-one major works, went to eight European countries, beginning in Basel in April 1958. Already works by most of the painters were known in Europe, South America, and the Orient, but this was probably the largest presentation in force. Some European critics were defensive, some appalled, but many hailed the existence of a new, audacious center of art to add to the European galaxy.

Identity from Uniformity

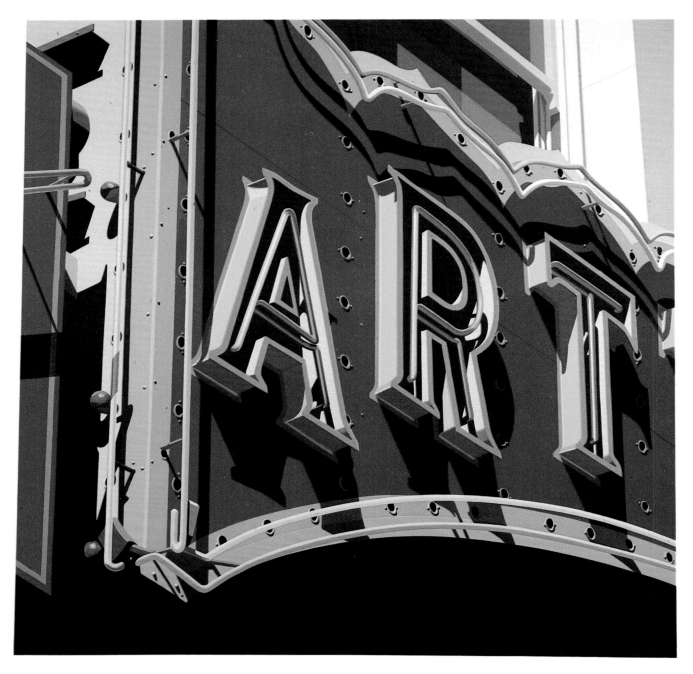

Robert Cottingham, *Art*, 1971, oil on canvas, 78 x 78. Dr. and Mrs. Ivan C. Karp, New York, New York.

Identity from Uniformity

The multiplication of uniform visual images in the modern world has quite changed our perception. It is rather hard, after all, to take one image seriously when you might expect to see it reproduced several times over in exactly the same form. And so it is, whether it is the reproduction of a painting, an advertisement, or the photograph of a person or news event. We have learned to glimpse casually because we expect to meet up with the vision again, if it has not already become a commonplace in our minds. The assumption of repetition and uniformity is a premise that we tend to accept without even being conscious of it.

Even travel provides small chance for escape. Little by little, cities all over the world have been assuming roughly the same look; most airports look so much alike that one could fly around the world without a change of the visual environment. Stores across the country display the same merchandise in exactly the same way and the products, without sampling, are simply expected to taste the same. From infancy onward, education from public sources—schools, of course, furnish only a small part of education—is devoted to "standard brands" with such excellent results that any deviation from the well advertised is likely to produce a disquieting doubt in the mind of the shopper and even a sense of guilt in the face of society, as if a trust held in common had been betrayed. A secret, unadmitted dependence on a belief in the goodness of the mass-produced has created a distrust of that which is only individual or locally made.

Consider the matter of signs, for example. No respectable store or institution would willingly make use of hand-lettered signs; legible as they might be, they would lack authority. The most elaborate mechanical devices are resorted to in order to make an individual sign appear mass-produced. Mechanical labelers can even be bought for the home, performing a function once served by the typewriter. Such things as library catalog cards, once written by hand, came to speak with the authority of the institution only when typewritten, an effect deemed worth the more cumbersome procedure.

287

In recent years, however, the ordinary typewriter, with its too-sensitive response to the fallible pressure of the human hand, has lost its authority. Now only an electrical typewriter that can make a personal letter look like the page from a book is acceptable to more and more enterprises. To come full circle, even more impressive is the individually addressed letter that we know full well is produced by a computer.

For most city dwellers, and many in rural areas too, much of what is to be seen can be accepted only if it is a part of a vast, uniform, man-made complex, or pretends to be. Uniformity and standardization are not now what man continues to impose upon a rebellious nature in order to prove his intellectual triumph, but constitute the principles, the initial assumptions, upon which his perception is based. Nature provides the variation to the norm, and even these variations have often been obviously programmed ahead of time.

Other aspects of our environment and our perception of it have been affected by the devices upon which we unthinkingly depend. The first time a filmed event appears on a television news broadcast it seems immediate and compelling. By the time it has been reproduced four times more on successive broadcasts, the film has taken on a detached life of its own, its every move and grimace becoming more real in the imagination than the event itself. The evident mechanical reproduction gives the image a kind of authority, a kind of public stamp of acceptance, that the event itself may not have provided. Little by little the mechanical device, whether photograph, film, or television, has inserted itself between the object and the perceiver to become a major factor in the experience itself. Searching back in the memory, one sometimes finds it difficult to separate the event actually witnessed from that known only from its reproduction. They have, in their way, an equal reality, with the repeated mechanical image sometimes taking precedence.

It is a rare popular singer who can face his audience, no matter how small, without a microphone in his hand. Even though he may depend on manipulating the device to promote a minor voice into a major effect, for the performer the primary function of the hand-held microphone is more psychological than technical. It is a magical transforming mechanism that tends to standardize the situation, granting a kind of impersonality to the most intimate utterances or, on occasion, creating a specious intimacy on a formal, public occasion. A performer can whisper confidentially to several thousand fans at a time, with the result that several thousand feel themselves to be alone with the performer, all together. There is safety in such diffused public intimacy—the sharing of a personal contact that does not in fact exist—but a certain bleakness, too. Like the smiling beauty in a toothpaste advertisement who sincerely makes an appeal just to you, the performance is never so far away as when it seems the closest. At that moment of remote intimacy, the extraordinary discrepancy between the mechanical, repeatable event and one's individual, nonrepeatable life can

become painfully evident. What is usually billed as the science of communication has helped to produce a philosophy of isolation.

This phenomenon is not unique to the United States, yet it often is looked upon as a characteristic of America. Possibly America has shown greater will to a kind of democratic standardization and has succeeded in creating more effective means to obtain it. Whatever the source, the environment—both inner and outer—created by this extraordinary and inescapable process has posed a critical problem for the artist, who has been taught by tradition that his art is the unique product of an individual sensibility. Only two ways would seem to be open to him: either to attempt to escape the cultural situation entirely, in effect seeking a new wilderness, or to embrace the very means and aspects of the impersonal, mechanized environment and make them his own. Like some artists at an earlier moment faced with the new industrial society, many artists of the late 1950s and '60s accepted the terms of their world at face value and proceeded in their individual ways from there.

Many different names have been used to describe the various pursuits of artists with like motivation—at one point, beginning in the late 1950s, titles of art movements were multiplying so rapidly for the benefit of the New York art market that criticism was almost reduced to being a glossary of terms—but it might be more useful to remember that all of the tendencies were, to some degree at least, a response to a given situation. And in this case the situation with which they dealt was most acutely felt in the United States.

The term "pop art" had its origin in England in the 1950s, but the heterogeneous range of works often clustered under that title are so readily associated with the "American way" that it quickly became as closely identified with the national image as the hot dog and the Coca Cola bottle. The term itself is not especially helpful, revealing more of the state of criticism than the state of art at the time. Actually, it was not so much a namable school of art as a burgeoning of individual creative achievements by artists who consciously dealt with the specific nature of the environment in which they lived. The range is great, from rather conventional aesthetic experiences produced from unlikely materials to iconoclastic images that tend to threaten all accepted standards of judgment. But the context in which all such works exist is that of the world rendered banal by repetition, automation, and mechanical reproduction.

A quality most artists who turned to commonplace objects and their images shared was a distrust of direct personal expressiveness. By the later 1950s the unbridled gesturing that had grown out of abstract expressionism seemed empty and anachronous to many younger painters. The very transcendent character of the painting, at its best, made an uncomfortable contrast with a society whose values were essentially material and whose normal imagery had little tolerance for the personal touch and refinement of sensibility. To stress the emotional involvement within a population that

was coming to think of itself as all knowing but uninvolved—no matter how urgent the circumstances—seemed to lead more to isolation than to the formation of a new contract with the world at large.

Probably the first efforts toward a new basis for art took the form of a systematic destruction of standard contexts. In various ways, familiar objects were wrenched from their usual places and isolated in the noncontinuous environment that belonged to art. In the mid-1950s Robert Rauschenberg began to combine objects with his painterly surfaces, blurring the line between the world of paint and the world of things. A seemingly accidental assortment of images—postcards, faded photographs, graffiti, and full-sized objects—mingled often with an equally unstructured smearing of paint to produce, ironically, a haunting poetry that resisted all definition but existed firmly and convincingly in the indivisible realm of mind and sense. The new context had "no respect for grammar," either formal or pragmatically functional, and made an infinite number of associations possible with no particular set probable. "It is extremely important," Rauschenberg said in 1963, "that art be unjustifiable." Once created it ceases to be a construction or an expression but becomes an undeniable fact. In the joy of discovery afforded by the liberating experience of the encounter with a new and unresolvable fact, the spectator joins the artist in an expanded sensibility that embraces with fresh intensity both the recognition of the mundane and the perpetually new.

Jasper Johns, *Light Bulb, II,* 1958, sculptmetal, 4 x 8 x 5. Collection of the artist.

Claes Oldenburg, *Pastry Case, I*, 1961-62, burlap soaked in plaster on enamel plates, in glass and metal showcase, 20¾ x 30⅛ x 14¾. The Museum of Modern Art, New York, New York; Sidney and Harriet Janis Collection.

By moving an object that by common consent lies outside the accepted circle of artistic experience into a situation in which one is prepared to lavish on it the attention traditionally reserved for art, the artist succeeds in stopping the profligate viewer cold in his thoughtless tracks. Jasper Johns's bronze flashlight, his sculptured light globe, and his obviously hand-painted bronze sculpture of two cans of Ballantine Ale are cases in point. The objects are not transformed into aesthetic delights by adroit formal modification, yet they are not construable as the original light globe or empty cans themselves. As a kind of art-life paradox they hover in the analytical mind like an unresolved question. A similar thing might be said of Claes Oldenburg's not very appetizing, gaudy models of food, in which the various levels of obvious falsity struggle against the fact that they are undeniably real. "All of the fun," said Oldenburg, "is locking horns with impossibilities."

It is much less disturbing to confront a paradox in art than in the course of daily existence. Art exists, Kant reminded us, in a world without physical consequence and thereby gains its invaluable freedom. But when the most ordinary, reliable material objects of our experience—such as those reassuringly uniform brands found in supermarkets—are torn from their context to be strewn like boulders in the placid stream of our consciousness, the definitions both of life and of art become subject to doubt. It was just such a doubt that was fostered with enthusiasm by those artists of the early 1960s, who looked upon continued puzzlement as a more vital state than the complacent assumption of unquestioned knowledge. Art provided a

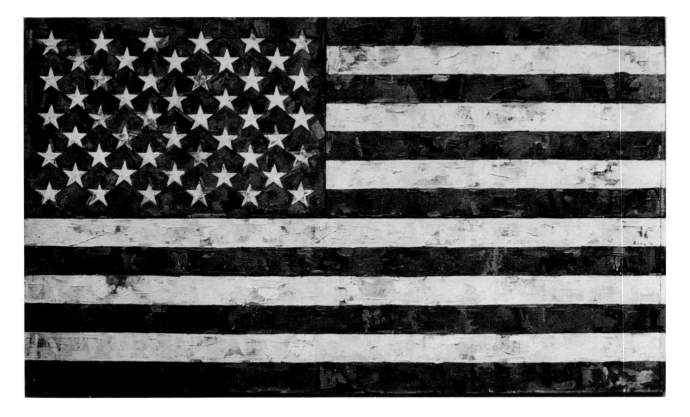

Jasper Johns, *Flag*, 1967, encaustic and collage on canvas, 33⅛ x 56. Senator and Mrs. Jacob Javits, New York, New York.

"happening," even at the expense of the art object itself. First of all an environment of surprise—of art—was necessary, and in it each object or event blazed a new role. From the sensitized environment, whether an artistic technique or an actual gallery situation, a new interest, even wonder, surrounded the objects or incidents involved. The transformation changed not the objects but the participant. What lasted was the experience, even after the ephemeral object had disappeared once more into the mundane world of things. To engage in an unstructured, surprising activity was one antidote to the exigencies of a preplanned, uniform existence.

There is a difference, however, between the object brought into the free-enterprise bailiwick of art, and that remaining in the context in which it is first perceived. When Jasper Johns, for example, painted his series based on the American flag, he took a sign that is fraught with all manner of emotional overtones, yet is visually a cliché, and developed a totally new object, infinitely subtle in its visual variations and quite detached from any prior context. What happens is all the more fascinating because of the initial unlikelihood that such an object would be the source of such an experience. Similarly, when he used standard number forms to build his shadowy, many-layered surfaces, the subtlety of the delicate, brushy tones of gray or muted color contrasts with formerly inert numbers and the routine of counting. He has artfully made a new, unique object—and a new expe-

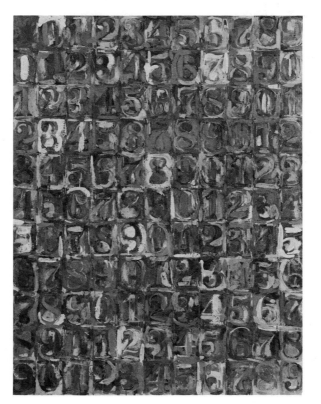

Jasper Johns, *Numbers in Color*, 1959, encaustic and newspaper on canvas, 66½ x 49½. Albright-Knox Art Gallery, Buffalo, New York; Gift of Seymour H. Knox.

rience—out of commonly held material. The object and its original context drop away in significance under the persuasiveness of the painterly treatment.

On the other hand, an image used by Andy Warhol—a newspaper photograph or an advertisement for Campbell's soup—appears in a manner no less detached and mechanical than in its original production. Obviously, Warhol preferred to associate himself with the impersonal world of commerce for his artistic satisfaction, rather than to invite the lonely object into the personal world of art.

Far from relieving the monotony of a standard image, Warhol carried it to such a degree that the monotony took on a character of its own. One might suppose that one hundred mechanical images of a can of Campbell's beef noodle soup would be that many times more banal than one, but like a common word repeated enough to lose its meaning and become an unfamiliar sound, the image takes on an abstract fascination. It comes as rather a shock to realize that a similar transformation can take place with a human image, even one that in itself speaks of great human emotion—violent death, a tense political incident, a natural disaster. And yet Warhol did not seem to be commenting on the public's capacity for callousness induced by the proliferating images around us so much as building a pleasurable unity out of the facts of modern perception.

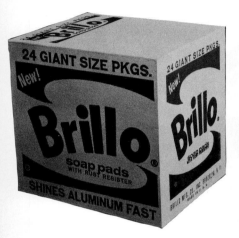

Andy Warhol, *Brillo*, 1964,
synthetic polymer on wood,
17 x 17 x 14. Leo Castelli
Gallery, New York, New
York.

Andy Warhol, *100 Cans 1962*,
oil on canvas, 72 x 52.
Albright-Knox Art Gallery,
Buffalo, New York.

Andy Warhol, *Lavender Disaster*, 1963, synthetic polymer silkscreened on canvas,
108 x 82. Mr. and Mrs. Peter
M. Brant, Greenwich,
Connecticut.

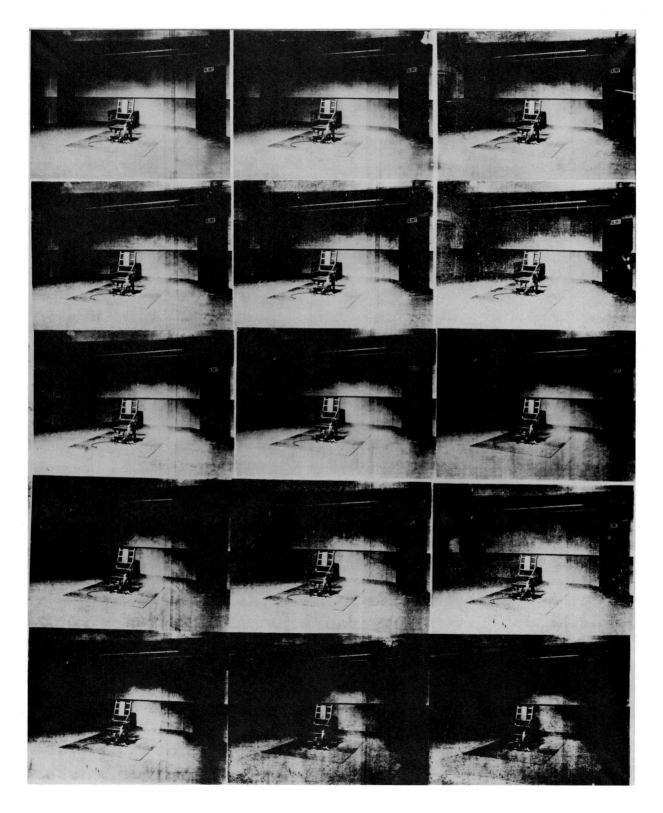

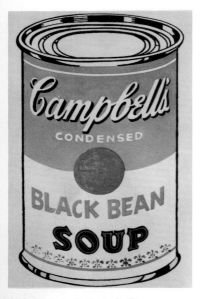

Andy Warhol, *Campbell's Soup (Black Bean)*, 1964, synthetic polymer silkscreened on canvas, 20 x 16. Mr. and Mrs. Leo Castelli.

The repetition of an image, sometimes mechanically varied, was only one means at his disposal. A simple can of Campbell's soup was sufficient provided it clearly was not to be construed as a painting by Warhol of an actual can of soup existing in reach and view of the artist, but as the rendering of a commercial picture of a soup can. In other words, the subject of the painting was not the can of soup, but the ubiquitous commercial rendering. As in dealing with the characters in a play by Pirandello, one is never quite sure when pictures cease being pictures of pictures and finally relate to the real thing. The artist has quietly stepped out of the matter, leaving no trace of evaluating touch or moral emphasis. In the case of Warhol, however, the original picture caught up in this process of multiple imitation is doubtless itself the real thing, and certainly does have its own reality in our thinking if we would face up to the fact.

Ironically, this art that deals in common, often banal, images is in truth an art of detachment. Baudelaire's famous essay in which he extolled the humanness of cosmetics is not without bearing here. It is an art that plays on a falseness that we know to be true. The advertising image—whether for soup or a movie star—is very real, even though we know that so far as the original object is concerned, it is a hyperbolic distortion. It belongs to our visual environment, where it jostles with other images of the same kind to form a separate world that has its own conventions and strict parameters. In fact, the glossy images seem to have more to do with each other, sometimes, than with the objects they represent, and it would be easy to mistake the smooth consistency of their community for the place we ought to live. From this realm of vision, already filtered through a man-made process, Warhol drew his primary material. What he did with it was not unlike what artists of the past did with objects of nature: he rang the changes on recognizable themes, isolated objects for monumental emphasis, and found a sense of order in what had been a chaos of impressions. And all of this he did without ever once casting doubts on the veracity of the world of images in which we live.

Out of the perception of the modern world of printed images and mechanized truth, Roy Lichtenstein, too, drew material for his elegant pictures. Elegant they are, although many of them from the early 1960s were based on that most despised of arts, the narrative comic strip. Taking a single frame from this continuous world of sentimental sighs, violent action, and *Blam,* he certified it as being genuinely not hand done by reproducing the dots and screening that are part of newsprint reality. At the same time, however, he showed the well-known comic image to have surprising poise and compositional beauty. What happened? Had the beauty been there all along? Lichtenstein said it was a matter of detecting a potential formal unity and making it clear. Basic to the sense of poise is the discrepancy between the sentiment and active violence portrayed, and the painstaking coolness with which the image is worked out. This discrepancy is emphasized by the gigantic enlargement of the picture, which we recognize from our reading

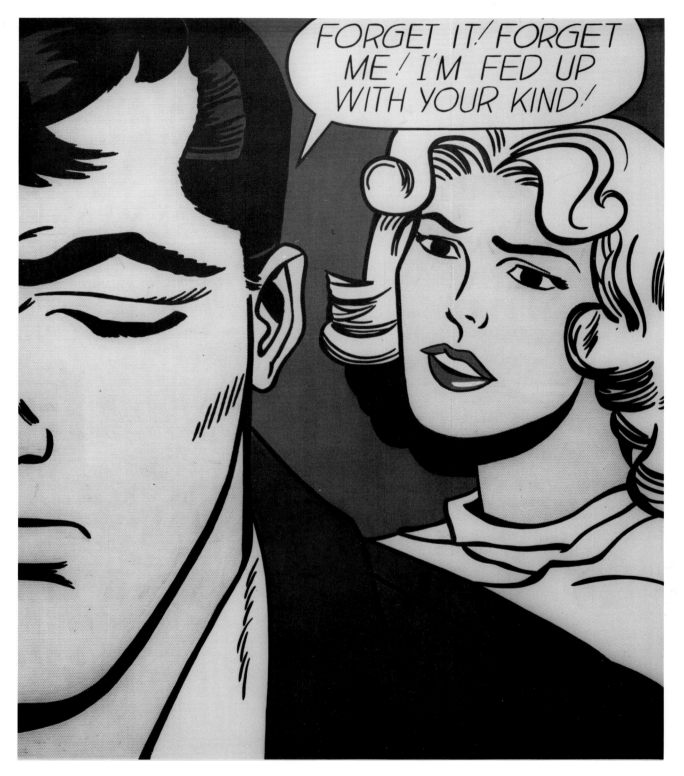

Roy Lichtenstein, *Forget It! Forget Me!*, 1962, acrylic and oil on canvas, 81⅜ x 69½. Rose
Art Museum, Brandeis University, Waltham, Massachusetts; Gervirtz-Mnuchin Purchase
Fund.

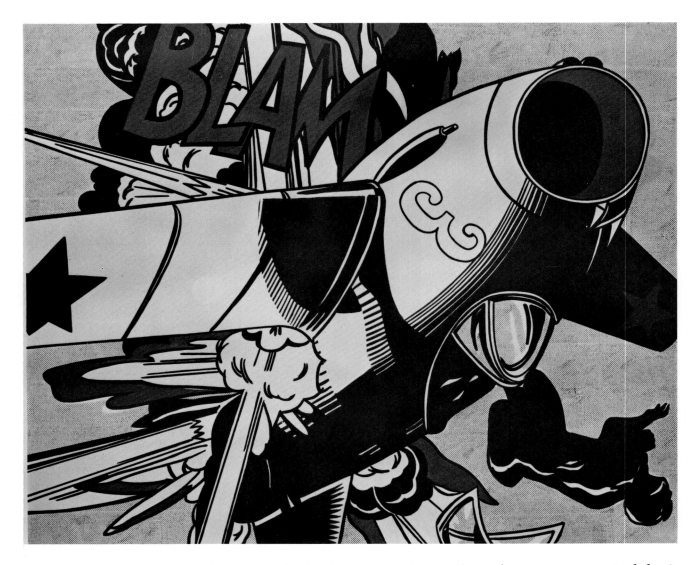

Roy Lichtenstein, *Blam*, 1962,
oil on canvas, 81⅜ x 69½.
Richard Brown Baker, New
York, New York; Courtesy
Yale University Art Gallery.

of comics as having been originally small, until every noncommittal dot is evident to the eye. So while we apprehend the violence or the sentiment as a matter of course, we are more actively engaged in noting the shapes and dots and generalized lines, which are linked in a harmony that has little to do with the image that brought them together. In a way, we are looking not at, but within, a picture. The pictorial image serves as a shelter for the experience, a shelter from, among other things, conventional judgments about art.

Lichtenstein, then, concentrates exactly on those repetitious, mechanical aspects of familiar images that we have learned to ignore in our eagerness to read images as things, and builds from them an aesthetic experience of considerable refinement. That it comes from something that has been in front of us all along, but ignored, gives the newly discovered harmony an

added element of pleasure. And what a rarefied world it is that Lichtenstein has revealed, at least twice removed from the world of things!

A totally different preoccupation with the commercial image is evident in the work of Tom Wesselman during the same years. His heroic-sized still lifes of 1962 provide no aesthetic haven. On the contrary, they enthusiastically confuse a whole range of perceptions, jumbling several kinds of illusion in a display that is buoyant yet patently false. In his *Great American Still Life #24,* an undigestible assortment of billboard-size products cluster together in a rather traditional still-life arrangement. There is no escape from seeing each object as the thing it depicts as well as the advertising image. These are not inert objects. Each one is being as enticing as possible, like a crowd of beauty contestants vying for the judge's attention. Even the travel poster glimpsed out of the window has the hyperattractiveness of an unlikely vacation. Yet in spite of the expertly contrived but transparent falseness of the images, there is an irrepressible sense of vitality and jauntiness in the bright, untroubled work. A baroque swish of curves unites a most unlikely series of objects, ranging from a half-pealed banana, to a wishbone, to a pretentious piece of drapery, and finally—or first of all—to the genuinely baroque Del Monte label on the can of asparagus. With ironic glee we can detect all of the compositional principles of a traditional painting in a supermarket pastiche. The individual persuasiveness of the huckster objects—each label speaking in its own typographical language—promotes the lively interplay, and the too-familiar images take on an unexpected animation in their artistically shrewd arrangement. Not the least of the still life's appeal is its monumental size, which allows each image to loom as an imposing presence and gives each detail an expansiveness that might otherwise be lost.

Such a work calls attention to the varied ways in which the mind takes in information. So rapidly are various spatial conventions apprehended— the three-dimensional ear of corn, the illusionistic plate of asparagus, the actual drapery, and the deep space of the travel poster—that everything seems to exist together in a unified space. The unity, of course, is only in the accepting mind, which quickly makes allowances, then goes back to audit the sources of the experience and be amused at its own vagary. This play on perception and apprehension is sometimes upsetting and at times hilarious, occasionally at the same moment.

Wesselman's *Great American Nude #43* is an eloquent example. The lounging pink nude is painted with affecting languor but unspecific detail. There is no doubt about the sex, but the bodily quality is as much a matter of acting out as of seeing. The empathetic involvement with the figure— we tend to act out her languor—tends to collapse the psychological distance necessary for visual detachment. Everything else in the painting, however, has a very specific external existence. The sharp photographic image of a Volkswagen that seems to peer into the window is shielded by an actual curtain; the half-open door creates an effect of depth that is terminated by

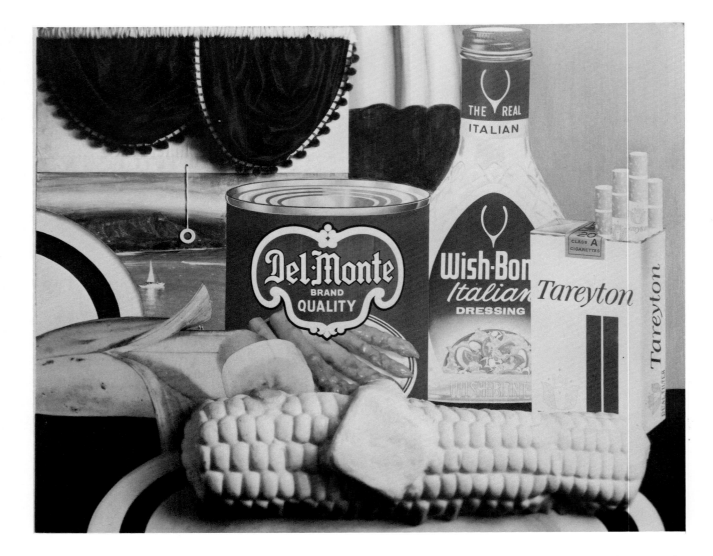

Tom Wesselman, *Great American Still Life # 24*, 1962, acrylic polymer on board, 48 x 59⅞. William Rockhill Nelson Gallery and Atkins Museum of Fine Arts, Kansas City, Missouri; Gift of the Guild of the Friends of Art.

the American flag in a multilayer version by Jasper Johns. To keep to the patriotic theme there is a bust of Abraham Lincoln at the upper right that judiciously looks away. Animating this stereotyped environment is an actual busy television set with its glossy, chattering characters ingratiating themselves to no one in particular. From this amalgam arises a provocative question about the nature of the reality we are confronting. Although the active characters moving across the television tube have all the aspects of life and are convincingly performing right now, they seem oddly remote and impersonal in contrast to the painterly streak of nude, which has none of the modeling and particularity necessary for it to be classified as "real" in the popular vocabulary. There is, moreover, something rather hilarious in the contrast between the frankly sensual and somewhat vulgar image of the nude and the prim symbols playing at life on the television set. This rela-

300

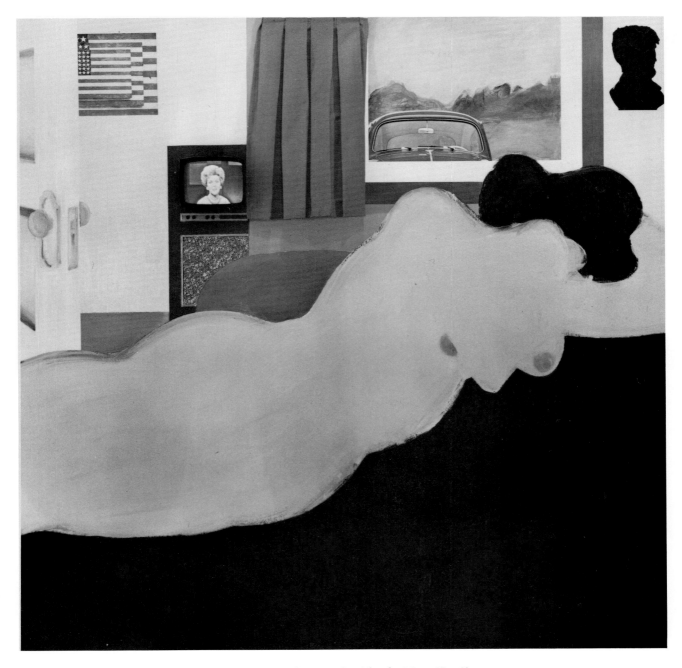

Tom Wesselman, *Great American Nude #43*, 1962, oil on wood, with television, 48 x 48.
Mrs. Robert B. Mayer, Chicago, Illinois.

tionship changes, of course, with the program; the irony of a news broadcast is different from the association with a sentimental situation comedy. But the remoteness of the television world remains. The more one watches the television, the more sensual and provocative the nude becomes. A confrontation develops between our sense of fleshly being and the world of things. But Wesselman does not philosophize about the matter. He seems content to provoke a realization of the contrast and let it stand as an unresolved fact, succinctly stated in his tightly organized pictorial universe.

There is little in Wesselman's Great American Nude series that would recall Giorgione or Titian. The paintings are not ideal or chaste. Much of the impact of their animal spirit and sensual abandon is the result of the completely standardized public images with which they are surrounded. The complementary juxtaposition of the uniform environment with the private personal world does not diminish the remoteness of the uniform product, but makes it a factor in the enjoyment of individual wit and sensibility.

For all of these artists there was a fascination in the mechanically produced image that brings us close to—yet isolates us from—the thing portrayed, a play upon the confusion that develops from an environment engulfed in images that take the place of primary facts. Wesselman in his still lifes, particularly, used the huge billboard image in a direct relationship to the thing it depicted. James Rosenquist started with billboard images and built from them a complex mosaic of visual patterns, recollections, perturbing confrontations, and lyrical imaginings. It is impossible to ignore the fact that the elements in his works are depictions of recognizable things, yet their obvious identity may or may not be pertinent to their specific use. There is little tendency to trace them back to the world of things. They exist in the imagistic world of the billboard, in the arena of the public mind. By virtue of size and the bland expertise of their depiction, even the most personal images become public and attain a uniform detachment. Such amazingly different matters as an atomic explosion, a smiling child, and a precooked spaghetti dinner can appear in close juxtaposition without provoking any great surprise. Yet out of this interweaving of images a continuity of experience develops—based at times on forms, at times on the identity of objects—that provides a special pleasure and satisfaction. The ultimate effect has sometimes been called abstract, but this is hardly true. The context remains that of the billboard world located somewhere between hard physical fact and optimistic perception, no matter how satisfying the formal problems and resolutions may be. Not infrequently an isolated image intrudes and sets up a divergent line of thought and recollection. But the noncommittal context prevails and we come back to join the harmony of the work and to pick up new clues for speculation.

Out of the mass of uniform images, then, Rosenquist provides both formal pleasures and a field for reflection. Like the billboards they began with, they are everybody's images. The hand of the artist is not in evidence to call attention to the person who provided the experience. The images

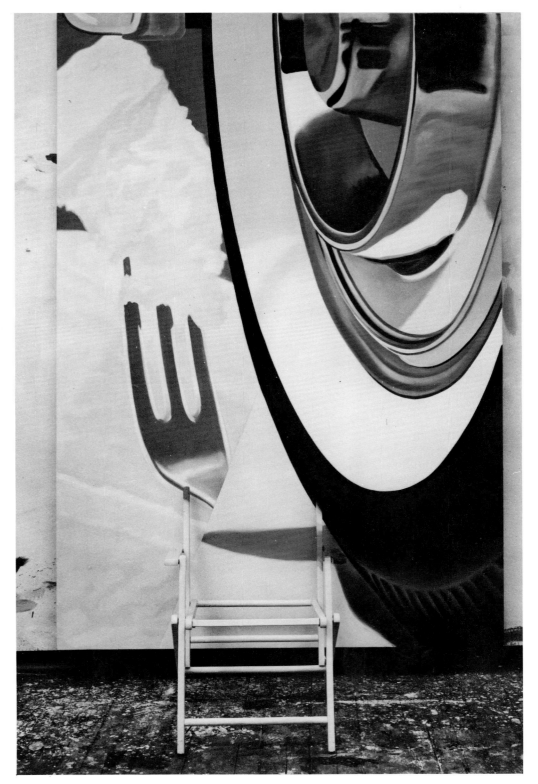

James Rosenquist, *Director*,
1964, oil on canvas, 90 x 62.
Mrs. Robert B. Mayer and the
Estate of the late Robert B.
Mayer, Chicago, Illinois.

are left in the public domain and yet are combined in such a way as to be transformed into a source for unique and personal rumination. They have become of individual significance without losing the detachment that identifies them with the modern commercial world at large.

By the later 1960s another kind of popular image began to assume a new importance in painting. This was the photograph, not as an art form in itself but as an impersonal record of the appearances of things. From its beginnings in the second quarter of the nineteenth century, the photograph had been of interest to painters for one reason or another. Some used photographs in lieu of models, some depended on them for recording information to be used in paintings, and some studied them as examples of unified vision. But the place of the photograph in more recent years has been rather different. So ubiquitous has the photographic image become that the peculiarities of the camera lens have sometimes been confused with the nature of human vision. Some young artists, however, who like most of their generation grew up with the notion that a camera was a necessary adjunct to looking, recognized in the photograph, especially in the ordinary snapshot, a quality of detachment peculiar to the lens that would prove useful to them in their art.

In the first place, a simple photograph records all at once with an impersonal eye, making no allowances for liveness, sentimental attachment, or aesthetic subordination. It presents a dazzling range of values on its flat surface that are not the product of a rationalized vision or blending by the hand, but of a mechanical and chemical process. As an object, a snapshot contains a quality of fascinating visual material peculiar to itself and its production. At the same time, it records the image of things as they might be seen if they were almost exempt from time. Although the camera may catch an action in the midst of its realization, the momentary image separates itself from the context of motion through time to remain fixed. In the hands of a skillful photographer a camera can record an action in such a way as to emphasize its continuity, but the views that have most appealed to the painters are those in which, with a seeming ingenuousness, the photographer has stopped the action and, as a result, has arrested time.

Robert Bechtle's painting '61 Pontiac expands the snapshot glimpse to monumental scale. The family, "caught" under a bleaching sun, becomes a fixed and statuesque group with the detachment of a fifteenth-century painting, even though all of the evidence places the scene on the street in front of the house. Although quite obviously painted in a surprisingly broad and simple manner, its first reference is surely to photography rather than to the scene itself or to the artist's personal touch. The familiar concentration on the camera, the viewfinder grouping, and the flattened space are all recognizable to the amateur photographer. More than that, the discontinuous light and dark, with little indication of what lurks in the blocked-out shadows, reinforces the suggestion that this is an image seen as a unit and not thought of in terms of volume and structure. Structure it does have, how-

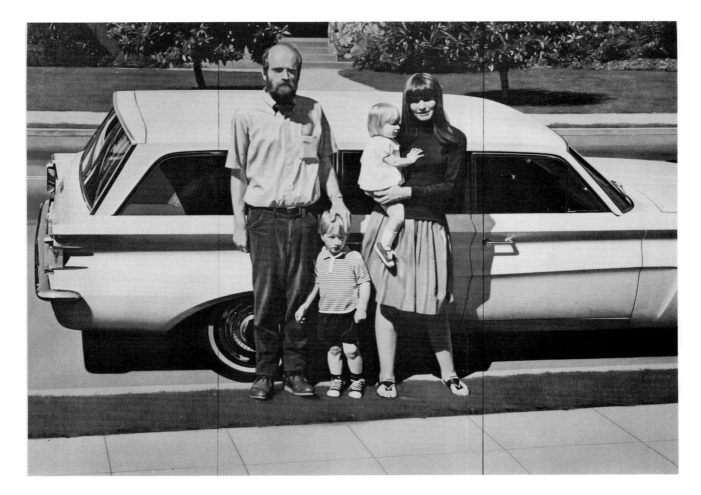

Robert Bechtle, *'61 Pontiac*, oil on canvas, 60 x 84¼. Whitney Museum of American Art, New York, New York; Richard and Dorothy Rodgers Fund.

ever, but it is a structure built out of the photographic shapes themselves rather than from physical masses or painterly brushstrokes. This is probably what creates the arresting contradiction of the painting: the sense of chance view and the effect of completely static poise. The subject—a family posed at the side of their aging car on a normal, middle-class street—supports the casual side of the dichotomy. There is nothing in the situation to mark it as out of the ordinary. But Bechtle, when he set out to create the structure of his painting, was careful to emphasize just those qualities of the snapshot that make it the record of a frozen moment out of the context of time. As a result, the family seems both very close to us and unreachably far away, the product of a casual view that can, however, find no place in the continuity of our vision. To reach the family we must go back to the camera, the hand that held it, and the moment the shutter clicked. Oddly, we do not think of the artist who painted the large picture itself. He has placed himself in much the same position as the observer, fascinated by the image but seeing it as something outside himself. The painting is, then, both intimate and remote, casual and formal, and real and aesthetically detached.

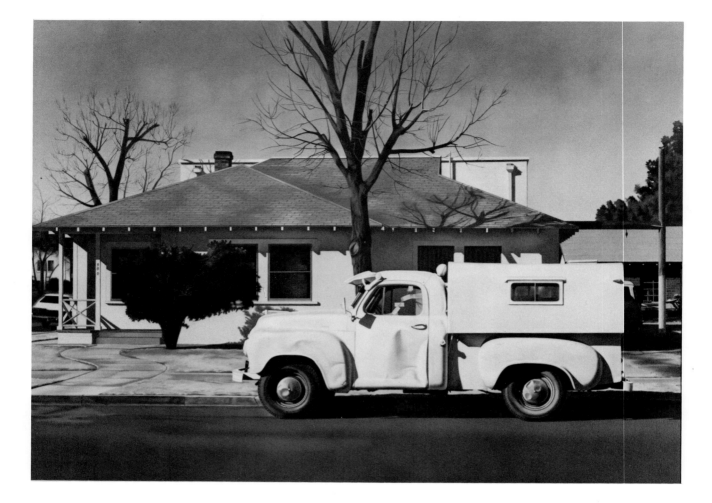

Ralph Goings, *Moby Dick*, oil on canvas, 48 x 68. Mr. and Mrs. Marvin Gerstin, Bethesda, Maryland.

The world of the photograph is usually a silent world, at least as seen by such painters as Bechtle and Ralph Goings. As translated in a painting such as Goings's view of a battered white camper of 1970, it is a silence enforced by a kind of perfection. Again the vision is such as to suggest a photograph, but the placing of each shape, contour, and color is so exacting in its scheme of interdependence that there is no room for the slightest change. There is every reason for a lover of motor cars to be disturbed by the sad condition of this well-used truck, but the battered steel is transformed by the detached photographic vision into a delicate series of subtle, rather silky, values. Nothing counts as bulk, but space is seen as a succession of flat, parallel planes that threaten to collapse into a single flat surface. Because of this, far and near shapes work themselves easily into a unified design. Far from being the record of a mundane scene, the painting becomes an elegant and peaceful ordering of phenomena in which the eye—and the mind—can find continuous pleasure without reverting to the context of the original moment.

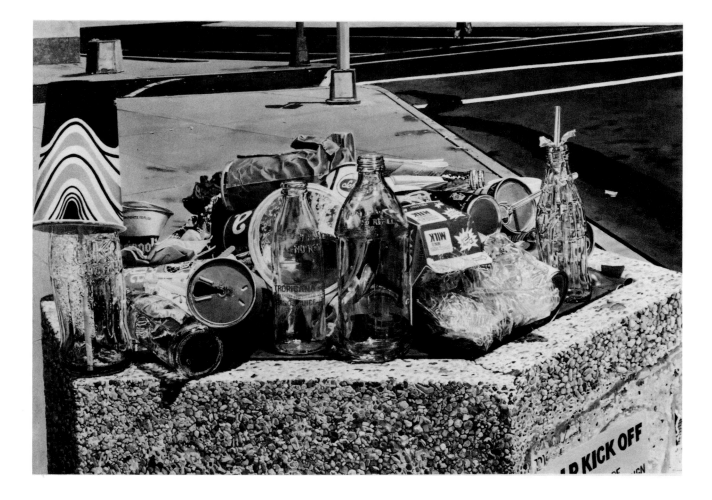

Idelle Weber, *Cooper Union Trash*, 1975, oil on linen, 64 x 45. Nathan Gelfman, New York, New York.

This is a highly refined art devoted to the pleasures of taste rather than to the proof of reality or the finite quality of objects. Yet it is important to these artists that this refinement be developed from a familiar world and not be spun out as a formal abstraction. For all the seemingly pragmatic method of procedure, there is a sense of mystery in this impersonal confrontation with an inelastic image of a man-made world. De Chirico once remarked that as a boy he was fascinated by illustrations in a text that purported to show what the world looked like before the advent of man; before, that is, there was an eye to see. By virtue of the intervention of the camera between the artist and the thing, there is a certain element of such an eyeless vision here. So far as the scene is concerned, we as observers are nicely removed from existence.

Such a premise of the disembodied observer would seem to underlie the precise but complex paintings of Richard Estes. Not dependent on size, as in Bechtle, but on intricacy, Estes's empty spaces are filled with reflections, unexpected transparencies, and an infinite quantity of precise and iso-

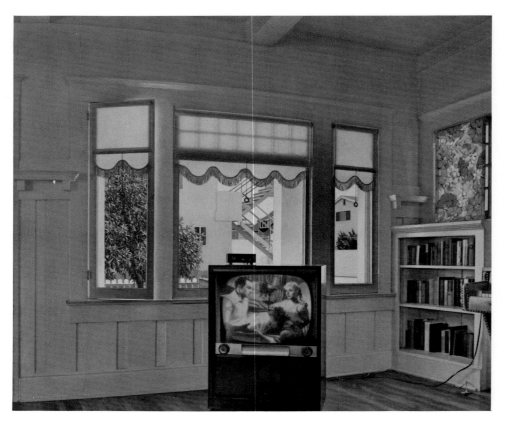

Maxwell Hendler, *Afternoon Television*, 1967, oil on hardwood board, 10 x 11¾. Collection of the artist.

lated detail. There is so much going on among reflecting surfaces and ambiguous spaces that one hardly notices that his busy commercial world rarely is inhabited with people. Like the others, Estes is an urban painter. It is in the man-made environment that he finds the visual fascination that makes him for the moment forget man. He does not transform his environment—it remains Forty-second Street or Broadway, and the street looks much the same after one sees an Estes painting as before—but draws from its image by subtle emphases and simplifications an individually satisfying engagement of looking. Complex as they are, his compositions have a formality to them that sets them apart. They rarely seem airless or lonely because they have a self-sufficient order of their own. As a result, the observed seems less alienated than in some such works. Not that he is in control of the situation and knows where he stands; he is simply allowed to get lost in the untroubled complexity of pure looking.

No less devoted to the subtle interplay of photographic lights and shadows and infinitely modified color, Robert Cottingham is even more emphatic in disassociating his superbly articulated compositions from a general environment. His raking views of signs are so much at home in their carefully proportioned format that one is not even tempted to reconstruct the part that did not get into the picture. There are no hidden meanings, no implied philosophical revelations in his images. His is a purely aesthetic pur-

Richard Estes, *Canadian Club*, 1974, oil on masonite, 48 x 60. Neumann Family Collection, Chicago, Illinois.

suit based on something less than aesthetic matter. But again the detachment of the photographic view has allowed him the freedom to explore values and shapes and forms that might easily be subsumed as secondary in a direct approach to things. The reality with which Cottingham deals is that of the works he creates, not the electric sign or the corner of a building that got him started. Beginning with a visual image, impersonal and momentary, he produces a concrete, permanent object that has a variety and beauty of its own. Yet we cannot help but marvel that the final work, so special in our experience, resembles a world we know almost too well.

An art that deals with the detailed representation of objects as seen has always had to face the problem of the simple effigy. No matter the intent, the result might appear simply a mindless copy. In a famous preface, Dumas *fils* rendered a gloomy verdict. Supposing that an artist sets out to make the

309

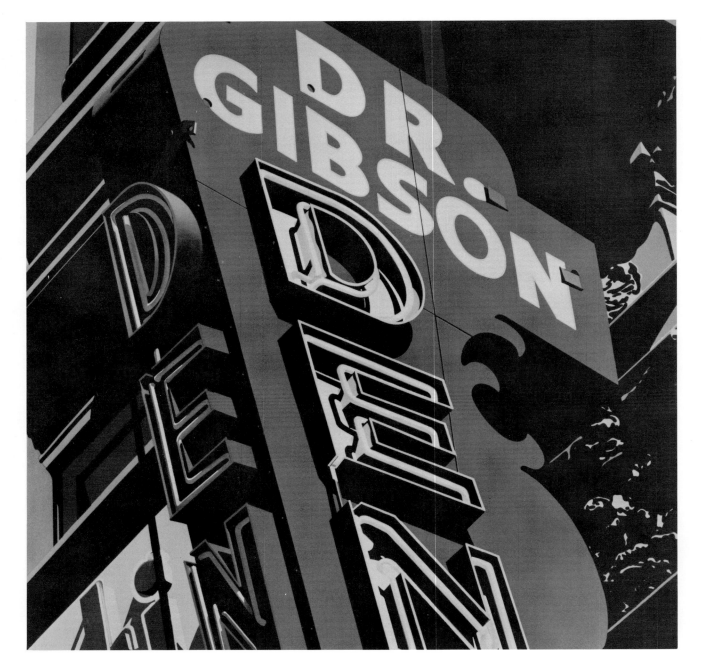

Robert Cottingham, *Dr. Gibson*, 1974, color lithograph, 34⅛ x 34. National Collection of Fine Arts; Museum purchase with the aid of funds from Mr. and Mrs. Jacob Kainen and the National Endowment for the Arts.

List of Illustrations, Arranged by Artist